Re-Engineering the Photo Studio

Bringing Your Studio into the Digital Age

Joe Farace

ALLWORTH PRESS
NEW YORK

Published by Allworth Press
An imprint of Allworth Communications
10 East 23rd Street, New York NY 10010

Cover design by Douglas Design Associates, New York, NY

Page composition/typography by Sharp Des!gns, Inc., Lansing, MI

ISBN: 1-880559-94-3

Library of Congress Catalog Card Number: 98-070402

Printed in Canada

Dedication

When my wife Mary and I opened our photography studio, the first people to offer help were Linda and Don Feltner. I had known Don from his writing and seminars before I moved to Colorado, but afterwards was lucky enough to have both he and Linda as friends. More than any other person, Don is responsible for getting generations of photographers to focus on the critical business and marketing side of their operations. His writing and audiotapes encouraged me to create this book, which I hope can help even a small percentage of those photographers Don has inspired over the years. That's why this book is dedicated to Don Feltner.

Contents

Recordable CD-ROM • Magnetic Tape • Image Management Software • Extensis Portfolio •
ImageAXS and ImageAXS Pro • Cumulus Desktop • Kudo Image Browser

Acknowledgments

I would like to thank publisher Tad Crawford for believing in me and the "re-engineering" concept, and for giving me the chance to write this book. A big thank-you also goes out to Ted Gachot, without a doubt the most supportive editor any writer could ask for. Thanks also to Don Fluckinger, copyeditor extraordinaire, for turning this manuscript into what you have in your hands today. Don, you are the best!

In producing this book, I had help from many people in the photographic and computer communities. I would especially like to thank Nancy Napurski and Sallie Mitchell from Epson America for making sure I had the equipment and information about inkjet printers and scanners. Special thanks to Dave Webb of the Hoffman Agency for taking the time to explain the ins and outs of Hewlett-Packard's rewritable CD-ROM technology and how it can benefit photographers. A mega-thank-you goes out to Craig Meserole of the now-defunct Power Computing Corporation for his help in getting me online with a computer powerful enough to work on this book plus several other projects—all at the same time. Thanks also to Power Computing's Norma Hernandez for her assistance in getting the Iomega Zip and Jaz drives I needed to produce, store, and back up all the images in this book. (As I was finishing this book, Power Computing was purchased by Apple Computer.) One of the most important components a photographer's computer can have is a high-quality, fast video board. I'd like to thank Julie Moe of Imagio for lending me an iXMicro Twin Turbo 128M video board for my Mac OS computer. As well as providing high-quality display on my 17-inch

monitor, the Twin Turbo made using image-editing software faster, easier, and more convenient.

I would also like to thank documentary photographer Tom Chambers for sharing his insights on establishing a Website. Special thanks also goes out to the "Ansel Adams of the Rockies," photographer Bill Craig, for allowing me to show his Website and fine-art images.

Books like this are never written in a vacuum and I would also like to thank my very own "Baker Street Irregulars," who alternately inspire me and bail me out of technical and creative problems. This includes Kevin Elliott, general manager of Cies-Sexton Photographic, and Denver Post photographer Barry Staver for his continuing friendship and inspiration. A special thank-you goes out to legendary camera technician and Windows guru Vern Prime. He has been a constant source of information and a helping hand whenever I needed one.

This is the fifteenth book I have either written or co-authored. I would have never been able to complete the first one—or this book—without the help of my dear wife Mary. She is my biggest fan and, for that, I will always be grateful.

JOE FARACE
Brighton, Colorado, 1997

Preface

The following telephone exchange, which I found on the Internet, purports to be the actual dialog between a (now former) WordPerfect Customer Support employee and a customer calling for help with his software. The story is probably apocryphal, but is interesting nevertheless. It was my intention in creating this book that you will never have a conversation like this:

"May I help you?"

"Yes, well, I'm having trouble with WordPerfect."

"What sort of trouble?"

"Well, I was just typing along, and all of a sudden the words went away."

"Went away?"

"They disappeared."

"Hmm. So what does your screen look like now?"

"Nothing."

"Nothing?"

"It's blank; it won't accept anything when I type."

"Are you still in WordPerfect or did you get out?"

"How do I tell?"

"Can you see the C-prompt on the screen?"

"What's a sea-prompt?"

"Never mind. Can you move the cursor around on the screen?"

"There isn't any cursor: I told you, it won't accept anything I type."

"Does your monitor have a power indicator?"

"What's a monitor?"

"It's the thing with the screen on it that looks like a TV. Does it have a little light that tells you when it's on?"

"I don't know."

"Well, then look on the back of the monitor and find where the power cord goes into it. Can you see that?"

"Yes, I think so."

"Great! Follow the cord to the plug, and tell me if it's plugged in to the wall."

"Yes, it is."

"When you were behind the monitor, did you notice that there were two cables plugged into the back of it, not just one?"

"No."

"Well, there are. I need you to look back there again and find the other cable."

"Okay, here it is."

"Follow it for me, and tell me if it's plugged securely into the back of your computer."

"I can't reach."

"Uh huh. Well, can you see if it is?"

"No."

"Even if you maybe put your knee on something and lean way over?"

"Oh, it's not because I don't have the right angle—it's because it's dark."

"Dark?"

"Yes—the office light is off, and the only light I have is coming in from the window."

"Well, turn on the office light then."

"I can't."

"No? Why not?"

"Because there's a power outage."

"A power . . . a power outage? Aha! Okay, we've got it licked now. Do you still have the boxes and manuals and packing stuff your computer came in?"

"Well, yes, I keep them in the closet."

"Good! Go get them, and unplug your system and pack it up just like it was when you got it. Then take it back to the store you bought it from."

"Really? Is it that bad?"

"Yes, I'm afraid it is."

"Well, all right then, I suppose. What do I tell them?"

"Tell them you're too stupid to own a computer."

Introduction

In 1839, Louis Jacques Mandé Daguerre introduced photography, as we know it, to the world. The reaction of popular media of the day to the daguerreotype was that, From this day forward, painting is dead. Obviously, this didn't happen. What photography did do—and what digital imaging is doing—was replace another medium in certain applications. Digital imaging clearly is the next wave in photography. It has already become a cliché to say that film is dead, but whether or not film is dead actually is relevant. I expect that silver-based imaging will be with us well past the millennium, but as time goes by, more and more imaging processes—both professional and amateur— will become digitally centered. That is one of the reasons that you will see the terms "pixography" and "pixographer" scattered throughout this book. If people who shoot video are called videographers, why can't digital imagers be called pixographers?

Like it or not, professional photography is an uncomfortable mixture of two contradictory disciplines: art and commerce. Photographers need the ability to produce salable, creative images and, at the same time, the ability to successfully manage the business associated with creating those images. Both skills—creativity and management ability—must be present, or a studio will fail. As an industry, we have too often fostered the image of the professional photographer as "starving artist" to the point that too many of us are starving and not enough are being artistic.

This book is written for the newcomer to professional photography as well as for the experienced shooter who feels he or she has yet to tap the power small computers can bring to his or her studio's operation. In here, you'll find information that will be useful for professional

portrait, wedding, and commercial photographers. My goal in writing this book is to provide studio owners and other professional photographers with a path to the next century using technology to get past obsolete practices that have been part of photography since Mathew Brady hung out his shingle. The guiding philosophy behind all these recommendations is that any new hardware or software tool must increase the studio's productivity and profitability. Digital imaging technology is fast moving. Industry insiders tell me that the half-life of digital cameras that cost less than $1,000 is now four and one-half months. That's why this book focuses more on concepts and classes of hardware rather than specific products—although real products will appear as examples from time to time.

Keep in mind that these are recommendations and not cast-iron principles. Feel free to use the ideas that you like, modify those that have some application for your studio, and don't be afraid to pitch the others in the recycling bin. In this information age we live in, there is so much information available that no single person has all the answers—and I don't either.

The pace of changes to digital technology—whether the Internet or digital imaging—can be dizzying, and you may, at times, feel like throwing in the towel. Don't. This book should make you think about the future direction of professional photography and how you can take advantage of new technology to make better images and more money. As Bette Davis once said in a movie, "Hang on. Fasten your seat belts, it's going to be a bumpy ride."

The Learning Curve

Every reader has a different level of computer literacy, but I expect many of you already know the basics—how to turn a computer on, use a mouse to navigate around the screen, and launch a program. I agree with Don Feltner that professional photographers, like skiers, can be classified into three groups—beginner, intermediate, and advanced. Photographers who use computers in their studios fall into similar categories.

- Beginners work alone in a small or home-based studio. Their software requirements include simple word-processing, spreadsheet, and graphics applications. They usually spend two hours a day or less at their computers.

- Intermediate users often work in groups, so networking solutions are important to them. Besides the above applications, they also use desktop-publishing software, shared scheduling programs, and database managers. These people spend four hours a day with their computers.
- Advanced users, sometimes called power users, spend more than four hours a day at their computer using profession-specific programs like Adobe Photoshop. These people need the fastest processors, the biggest hard drives, and make extensive use of peripherals like CD-ROMs, scanners, and modems.

There are, of course, always exceptions to these classes, but most computer-using photographers fit comfortably into one or another. The information found in these pages will enable basic and intermediate professionals to immediately increase their studio's productivity; advanced photographers should also find information on computer applications that will help enhance their studio's day-to-day operations.

No professional would think of photographing a wedding, business portrait, or other assignment with a point-and-shoot camera. Yet when it comes to digital imaging, some photographers seem to think they can use any computer and an inexpensive inkjet printer and get quality results. They are often surprised—even astounded—when I tell them what equipment they really need to produce the kind of images they need to deliver professional quality images to their customers. It's not just the lack of proper equipment, and it's not just the pros who are affected by believing the media hype surrounding digital imaging. In their impatience to become digitally literate, some photographers are stunned by the learning curve facing them. There is another side of the coin too. I have met far too many photographers who have spent an hour or two using Adobe Photoshop and after printing a few images, have declared themselves "experts." It's not that easy, but it's not impossibly difficult either, as you will soon discover.

How This Book Is Organized

Reengineering the Photo Studio shows commercial and portrait photographers how they can use digital imaging technology and the Internet to increase profits and make their studios more self-sufficient.

Accordingly, the book is divided into three parts: Changing from Silver-Based to Digital Imaging, Marketing and Management, and Using the Internet. These are not pie-in-the-sky concepts. All the hardware and software mentioned in the book is readily available at local computer or photographic dealers or through mail-order suppliers. In addition, all the products mentioned will be those that have professional applications. Here's what you will find inside these pages:

Part I provides a basic introduction to digital imaging, including the concept of image acquisition. This introduction explains how you can digitally create original images or convert existing photographs into digital form. Also featured in this chapter will be a checklist for buying—or upgrading—a computer for digital imaging. You'll also find a seven-step process for integrating digital imaging hardware and software into your daily operations, so that by the end of year one of the reengineering process, 50 percent of all images created by your studio will be digital. This section introduces readers to the three major classes of digital cameras and provide tips on what to look for when shopping for a camera. On the practical side, this part of the book will demonstrate how even a modest investment in digital photographic equipment—acquisition and output—can pay for itself in less than two years and can enable photographers to respond faster to client needs at the same time. You'll need to organize and store these digital images too. Part I looks at methods for keeping track of all the digital images that you have either created or converted. Also included will be a look at removable media devices and how they can be used to store images.

Part II includes information on using software to manage the studio more efficiently. In the past, many business programs were simply add-ons to existing word-processing and spreadsheet software, but a new generation of stand-alone programs is available to help you with your business planning, accounting, and marketing. You'll also find information on the nuts and bolts of integrating the technology of digital imaging into the business side of your studio's operation, as well as marketing. This part includes information about preparing a business plan and using the same kind of business-planning tools that Fortune 500 companies use to plan for the future. It presents a streamlined way of creating a business plan using any word-processing and spreadsheet program, but information will be provided on inexpensive off-the-shelf business-planning software.

Part III takes the digital imaging product and service that you have

developed and analyzed in the first two sections of the book and helps you develop an Internet strategy for marketing. Included will be an eight-point checklist of questions that will help you position the product for rollout on the Internet.

There are three appendixes that will help you get more out of this book. Since many studios begin—and stay—as home-based operations, appendix A contains some tips on both digital and nondigital aspects of setting up a home-based studio. Appendix B contains a glossary of digital imaging terms from A to Z—while much less complete than the author's own *The Digital Imaging Dictionary* (also from Allworth Press), it provides an introduction to some commonly used terms. Since new terms and acronyms crop up daily in the industry of digital imaging, this appendix includes some terms that are newer than the current edition of *The Digital Imaging Dictionary*. For example, two new words you will find are "cookie" and "spam." While this may sound like lunch, nothing could be further from the truth. Appendix B explains what they are and how they work. Appendix C contains a list of companies mentioned in the book. The list includes addresses, phone and fax numbers, as well as Internet Web site locations.

A Technical Note

This book is as cross-platform as I could make it, covering hardware and software for Mac OS and Windows computers. I've moved away from MS-DOS, because most IBM and compatible machines run Windows; Windows 95 effectively spelled the end of DOS. In a story about Microsoft's Windows 95, analyst Andrew Toller stated, "While many loyal users will stick with it for years to come, DOS will go the way of the dodo bird." I did not include information about computers like the Amiga. While this clever machine has its devout supporters, almost every studio uses a Windows- or Mac OS–compatible machine. While PCs are quite popular in corporate America, the split between Macs and PCs is much closer in small businesses, especially photography studios. The number of Amigas in use by studios, I'm afraid, is statistically quite small. So, no offense Amiga lovers, this book is aimed at the computers that are predominantly in use.

People always ask me what kind of computers I use, so here goes. The computers I used for this book are the same ones I use every day—a Power Computing PowerTower Pro 225 Mac OS–compatible with a 2

GB hard disk, 32 MB RAM, 16x CD-ROM drive, built-in Iomega Zip and Jaz drives, and an external Philips CD-R drive. My Windows machine is an IBM Aptiva "Stealth," with 32 MB RAM, 6.5 GB hard disk, 8x CD-ROM drive, and external Iomega Zip drive.

In the digital imaging universe, these are what I would call middle-of-the-road machines. I know photographers working with less complex computers and ones working with more extensive systems. Digital imagers working on systems with more power, larger memory, and higher capacity storage create images faster and more efficiently than I am able to, while those with smaller, slower systems may have to be more patient.

This book was written on the PowerTower Pro using Microsoft Word, and some editing was done on an Apple PowerBook 180 laptop computer using the same word-processing program. The original manuscript was printed on Brother HL-1060 laser printer, but a copy was provided on floppy diskette to the publisher. Digital images for the illustrations were provided on a CD-ROM that was produced on a Philips CDD-2000 CD-R drive. Print images were scanned on an Epson EC1000 flatbed scanner, and 35mm slides were scanned using Nikon's CoolScan film scanner. When necessary, both kinds of photographs were converted into black-and-white images and tweaked with Adobe Photoshop before placement in the final manuscript by the designer.

The Future of Your Studio

Photography, as we know it, is undergoing the first major change in direction and basic technology since the paper negative buried the daguerreotype process. Most changes since that time have been incremental, and gradual improvements have been made to existing photochemical reproduction of images. Now all that's changing—and changing fast. The democratization of photography has shifted professional photography from merely selling prints on paper to creating and selling images no matter what form they may take. Digital imaging technology can help you with that goal in many ways—as you will soon find out. Professional photography isn't about making pictures, it's about making a living for you and your family. That's really the goal of this book: to provide you with information and practices that maximize your studio's efficiency and profitability through effective use of personal computers.

Changing from Silver-Based to Digital Imaging

Digital imaging is one of the biggest technological changes photographers have faced since the invention of dry-plate. The biggest problem facing most photographers is that all the tools that you have grown comfortable with have changed. Gone are the old familiar tools, replaced with newer, more complex equipment. New digital camera equipment and computer hardware require a steeper learning curve than old analog tools. If you have the right attitude, the transition to digital imaging doesn't have to be difficult. Some of the best words of advice that I received on this subject were from Cies-Sexton's general manager, Kevin Elliott. "What I tell photographers is that 'you didn't learn everything you know about cameras and film overnight, don't expect to know everything about digital imaging overnight.'" That's the purpose of this first part of the book: to bring you up to speed on the basic software and hardware tools for digital imaging acquisition, enhancement, and output.

1

The Digital Image

We cannot see the future; we do not know what lies around the next bend on the Information Superhighway; we cannot predict where, ultimately, the Computer Revolution will take us. All we know for certain is that, when we finally get there, we won't have enough RAM.

—*Dave Barry, from* Dave Barry in Cyberspace ©*1996, Crown Publishers Inc.*

The digital imaging process consists of three major parts: acquisition, enhancement, and output. The first step is capturing—or "acquiring"—an image, which can be done in several ways. One of the easiest ways to acquire an image in digital form is to create a photograph with a digital camera. Another way to acquire digital images is to shoot photographs with print or slide film, then use a scanner to digitize the images. Scanners convert photographs into a digital form by passing a light-emitting element across the original image, transforming it into a group of electronic signals that are ultimately stored as a digital file. Kodak's Photo CD process uses a proprietary scanning and storage system to digitize and store images made with slide and negative film in formats from 35mm to 4 × 5 sheet film. Before examining the technical and financial aspects of digital imaging, let's take a look at some of the options for acquiring digital images.

The Importance of Resolution

No matter what kind of digital device you use—camera, scanner, or process—the resolution of the final file determines the quality of the final output. The best maximum resolution isn't always the best criterion for selecting a device since each photographic application has different needs. The best advice when considering any digital equipment purchase is to buy only as much resolution as you need. But what is resolution anyway? In general usage, resolution refers to an image's quality. Any discussion of resolution must look at two concepts: bits and pixels.

Because computers represent all data—including photographs—by using numbers, or digits, they are digital devices. The quantity of digits used is measured in bits (short for "binary digits"). Each electronic signal that a computer handles represents one bit. In order to represent more complex numbers or images, computers combine these signals into 8-bit groups called bytes. When 1,024 bytes are combined, you get a kilobyte, often called KB, or just K. A megabyte (MB) is really 1,024 kilobytes. Because you often find an image file or hardware device's color depth referred to as 24- or 30-bit, bits are important to digital photographs too. A 24-bit image contains 8 bits for red, blue, and green. A 30-bit image has 10 bits for each color of a monitor's RGB (red, green, and blue) color space.

"Pixel" is short for "picture element." An image's resolution is measured by its width and height in pixels. The higher an image's resolution—the more pixels it contains—the better its visual quality. An image with a resolution of 2,048 × 3,072 pixels has a higher resolution than the same-size image digitized at 128 × 192 pixels. Device resolution, on the other hand, refers to the number of dots per inch (dpi) that any given device, such as a monitor or printer, can produce. Device resolution for computer monitors varies from 60 to120 dpi. This should not be confused with screen resolution, a concept commercial printers use to describe how they reproduce a photograph—and refers to the number of dots per inch of the line screen. Screen resolution is measured in lines per inch (lpi). A photograph's image resolution also determines how big the file is. As in all computer applications, the resolution of a particular graphic image involves trade-off. As a graphic file's resolution increases, so does its file size. Working with larger files requires more storage area and horsepower for your computer system.

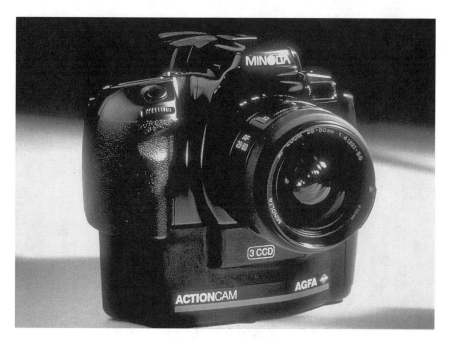

Figure 1. Based on a Minolta body, the Agfa ActionCam provides the simplest way for a photographer to acquire a digital image. (Photo courtesy of Agfa)

Image Acquisition

Digital photographers don't "shoot" photographs, they "acquire" images. There are three options available and most professionals will find that rather than selecting just one, they will—depending on studio structure—use all three.

Digital Cameras

The simplest and purest way to convert any image or object into pixels is to originally photograph it with a digital camera. When you connect a camera to your computer, you get a direct representation of whatever you photographed in digital form. The current generation of digital still cameras falls into three general categories: digital point-and-shoot, field, and professional studio cameras and backs.

Digital point-and-shoot cameras are built to a price point, so you get low price and speed—immediacy of imaging—but the quality is

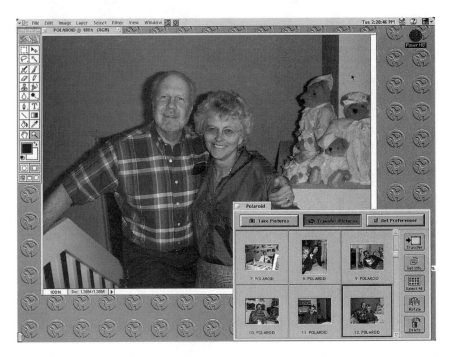

Figure 2. Photographs of Don and Linda Feltner acquired from Polaroid's PDC-2000 digital camera using an Adobe Photoshop plug-in. (Images © Joe Farace)

typically at the lower end of the digital imaging spectrum. That doesn't mean the quality is bad. Far from it. The current generation of digital point-and-shoot cameras costing less than $1,000 continues to improve in both features and resolution. Field cameras provide quality and speed, but prices can begin as high as $7,000. When you move up to studio cameras, the quality and speed components are emphasized; the cost of a typical camera in this class starts at $35,000 and after that the sky's the limit. The key point in selecting a camera is matching its resolution to the output—how you intend to use the final image. Since digital cameras are such an important part of the ree-ngineering process, they have their own chapter. In chapter 2, you will find a checklist of features to investigate when shopping for a digital camera.

Once acquired, these images must be downloaded from the camera through a cable connected between the camera and the printer or modem port of your computer. In computerese, "download" means "to receive information." The opposite term is "upload." How does this

work? Most cameras include software that allows you to view the images stored in the camera or a software plug-in that allows you to access those images using the import or acquire function of an image-editing program, such as Adobe Photoshop. During the acquisition process, thumbnail-sized images display on your screen to allow you to view and edit images. When you see photographs that you do not like, you can delete them from the camera's memory. For "keepers," just double-click the thumbnail to see the image full size. At this point you will have converted a real-world image into pixels, and can save the image in any file format you prefer.

Scanners

Since most studios already have an existing file of negatives, transparencies, and prints, a scanner is the best choice to turn these analog images into digital form. Most common and affordable scanners use a CCD (charge coupled device) array consisting of several thousand elements, arranged in a row, on a single chip. This array passes over the original print or film, which is then transformed into a digital image. Scanners used to be so expensive that only large advertising agencies and service bureaus could afford them. As hardware prices dropped, scanners have become an indispensable peripheral for anyone looking to acquire images from photographs, prints, or other artwork. There are several different kinds of scanners; you should select the type that fits the kind of photography you do.

Handheld scanners let you do the work of rolling the scanning element across the face of your original photograph. Hand scanners are inexpensive, but the width of the device's head limits the size of the scan. To overcome this liability, some scanners include software that allows you to "stitch" several scans together. How well this stitching process works depends on the steadiness of your scan and the software itself. Because they are the least expensive type of scanner, handheld scanners used to be the most popular. As prices have dropped on other kinds of scanners, they have become less popular.

Flatbed scanners look like small copy machines, and there are similarities in how these two types of machines work. Depending on basic design, flatbed scanners make one or three passes across a print lying flat on a piece of glass. Three-pass color scanners use a single

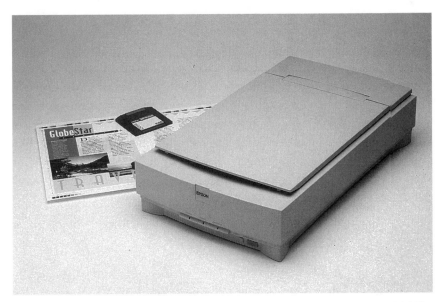

Figure 3. Epson's Expression 636 flatbed scanner offers an interpolated resolution of 4,800 × 4,800 pixels and a hardware resolution of 1,200 × 1,200 pixels. (Photo courtesy of Epson America)

linear CCD array and rotate a color wheel in front of a lens before each of the three passes is made. A single-pass scanner uses three linear arrays, each of which has filters for red, blue, or green light, and the image data is focused onto each array simultaneously. When scanning an original photograph, a single-pass scan is all most people require, but when scanning printed—or copied—material, a three-pass scan can usually remove the inevitable moiré (dot pattern). Flatbed scanners come in different resolutions, and the one that's right for you will match the resolution and quality of your final output.

Snapshot scanners combine elements of both flatbed and handheld scanners to produce a compact, desktop device that scans snapshot-sized photographs. The Epson PhotoPlus Photo Scanner is a typical example of this new breed. It offers several scanning options—24-bit color, 8-bit grayscale, line art, and business cards. The PhotoPlus accepts print sizes up to 4.1 inches wide and 10 inches long—big enough to scan a panoramic format print. The scanner can do all this in less than sixty seconds and is an ideal solution for scanning small prints—especially wedding proofs.

Film scanners allow you to scan negatives and slides. They are more compact than flatbed scanners, and their cost depends on the different film formats they can scan. Scanners that work with 35mm film are the least expensive but are typically still more expensive than flatbed scanners of equal or similar resolution. Some flatbed scanners offer what their manufacturers call a "transparency adapter" that lets you scan negatives and slides, but these adapters are expensive and often cost as much as the scanner itself. The latest trend is the "duo" scanner, an example of which is the DuoScan series from Agfa. These have a tray underneath the top glass that allows the scanner to digitize slides and transparencies.

When quality is important—and cost not an object—drum scanners produce the highest possible resolution scans from your photographs. The photomultiplier tube commonly used in drum scanners is more sensitive than a flatbed scanner's CCD and can output resolutions up to and beyond 8,000 dpi. To make a scan, your original photograph is mounted on a drum that spins and a scanning head travels along the length of the image. Light is directed from the center of the drum when slides and transparencies are scanned, and a reflective light source is used for prints. Because of their high cost, you are more likely to see drum scanners at a service bureau or printer than in a photographer's studio.

TIP: Dynamic Range

One of the key features that you will be looking for in a film scanner is dynamic range. A scanner's dynamic range depends on the maximum optical density that can be achieved and the number of bits captured. In simple terms, the greater the density range, the better the scanner. Until recently, only expensive slide scanners offered a density range of more than 2.5. Now, more affordable scanners can perform at 3.0 or higher. By comparison, a standard Photo CD scan has a dynamic range of 2.8 and a Pro Photo CD scan is 3.2.

Real versus Interpolated Resolution

These days, scanners are measured by both their optical and interpolated resolutions. "Optical resolution" refers to the raw resolution of the scanner that is produced by the hardware, while "interpolated resolution" refers to the maximum dpi specification the

scanner and its driver software can produce for a selected image size. For example, the Epson Expression 636 flatbed scanner has a maximum interpolated resolution of 4,800 × 4,800 dpi. This resolution is selected in the TWAIN module and works for color, grayscale, line art, and halftone images. This higher resolution is produced by the scanner's driver software when the image is scanned and delivered to the imaging application. When the resolution specified exceeds the optical resolution, the software interpolates the data by resampling the existing data using algorithms to fill in the area—adding pixels, really—between existing pixels. While the method of interpolation can vary depending on scanner manufacturer, Epson uses a method similar to the bicubic or bilinear interpolation a user can select in Adobe Photoshop. If you start with a poor scan that is not sharp or clear enough, interpolation is only going to make the image look worse—not better.

The big question on many scanner users' or buyers' minds: Is an interpolated scan as good as a scan made on a scanner that has the optical resolution of the interpolation? When a flatbed scanner has an "uneven" optical resolution specification, such as 600 × 1,200 dpi, it is theoretically capable of capturing more data by a technique called "microstepping." A scanner head has six hundred elements in 1 inch in the horizontal direction. Most flatbed scanners use a five-thousand-element CCD—600 dpi multiplied by an 8.5-inch width equals 5,100 pixels of data. The scanner head can move in $\frac{1}{1,200}$-inch increments in the vertical direction (back to front). When 1,200 dpi is selected, it can slow down the scanner. The scanner may pick up some additional detail in the vertical direction, however, software interpolation occurs horizontally to create a new square pixel. Usually there is no visible difference between a "raw" or interpolated scan. You would have to be zoomed in at a 1:1 pixel ratio or even 4:1 to see any difference in quality.

TIP: Improving an Interpolated Scan

Differences in quality for an interpolated scan that is two times the optical resolution should not be noticeable in color images. Sharpening the image using Photoshop's "Unsharp Mask" filter can add edge definition and crispness to the photograph.

The question remains: How does someone shopping for a scanner know the quality of the interpolation? The short answer is, it depends on the manufacturer. To avoid direct comparisons, some scanner

companies avoid explaining the methods used to provide interpolated resolution. The safest measure of quality for a scanner is the horizontal optical resolution. The best way to test a scanner is to evaluate the unit at its highest optical resolution using different kinds of originals, such as color photographs, transparencies, negatives, and black-and-white line art.

Lab Processes

One of the easiest ways to have images digitized is to have someone else do it for you. Having images digitized with a lab process like Kodak's Photo CD is probably the least expensive way to get started with image acquisition. One of the major advantages is that Photo CD does not require much of an investment in additional hardware. All you need is a CD-ROM drive and you can use the cameras and film you are already using. Unlike the other forms of image acquisition, Photo CD images are color-corrected while they are being digitized, making them a big time-saver.

To produce a finished disc, a Photo CD transfer station converts your analog images to digital using a high-resolution film scanner, a computer, image-processing software, a disc writer, and a color thermal printer. Each image is prescanned and displayed on the monitor. The operator checks the orientation (portrait or landscape) of the image, and begins a final, high-resolution scan, which produces an 18 MB file. The digital image is adjusted for color and density. Each photograph is then compressed to 4.5 MB using Kodak's Photo YCC image format, and is then written to the CD. A thermal printer creates an index sheet showing the images transferred to disc and is inserted into the cover of the CD's jewel case.

The Photo CD Master disc format is designed for 35mm film. Each disc holds one hundred high-resolution images. For each image on the CD, the disc writer burns five different file sizes (and five different resolutions) into a single file, the format of which Kodak calls Image Pac. On a Photo CD Master disc, these are:
- Base/16—128 × 192 pixels
- Base/4—256 × 348 pixels
- Base—512 × 768 pixels
- Base*4—1,024 × 1,536 pixels
- Base*16—2,048 × 3,072 pixels

A subset of this disc type is the Pro Photo CD Master disc, which accepts images from 35mm, 6 × 4.5-inch, 6 × 6-inch, and 70mm rolls, as well as 4 × 5 sheet film. The Pro format disc offers a sixth, Base*64 resolution image that yields a size of 4,096 × 6,144 pixels. More importantly, the scanner used by the Pro system produces a dynamic range of 3.2, instead of the 2.8 produced by the standard Photo CD scanner. (A scanner's dynamic range depends on the maximum optical density that can be achieved and the number of bits captured. In simple terms, the greater the density range, the better the scanner.) This is one reason why scans from 35mm film cost more—even at five resolutions— on a Pro Photo CD disc.

Assembling an Appropriate Digital Imaging Computer

There is only one reason to have a computer in your studio: to increase productivity and net profits. The amount of money new equipment contributes to your bottom line is called return on investment (ROI). You might be surprised to learn that the kind of computer you purchase can have a direct effect on ROI.

Even the most advanced personal computer is obsolete in eighteen months. Maybe you can stretch it to two years, but that's the sad truth. There are several reasons for this: Technology is changing at an ever-increasing rate. What was a fast computer two years ago is a "dog" now. (No offense to Canine-Americans.) New developments, like Intel's MMX technology, have a multiplier effect because new software is designed to take advantage of the latest processor, hard disk, and CD-ROM technology, not the computer you've been using for the past three years. This means new software, instead of making you more productive, can have the opposite effect. Over time, users tend to add shareware and commercial utilities to make their computers easier (or cooler) to use. All these bits and pieces start taking a toll by reducing the amount of available resources.

Sooner or later you will reach the point where the best way to increase productivity is with a new computer. You don't have to throw the old one out or sell it. Since you won't get much money for it anyway, the best solution is to take all the graphics software off the computer and pass it along to someone else in the studio who can use it. Ultimately you will get to a point where one person's upgrade trickles

down to upgrades for other users, finally computerizing someone who didn't have a computer to start with.

Mac OS or Windows?

The number one question that photographers ask me is, What kind of computer should I buy? The Mac OS versus Windows question is a quagmire, and photographers tend to be as passionate about their choice of computer systems as they are about their camera systems. People have been arguing about the merits of Nikon versus Canon cameras for years, but photographers all over the world are creating great-looking images using both kinds of cameras. Choosing the right computer for digital imaging is not just a hardware decision. The process starts by finding the right operating system.

Windows users often tell me that their graphical user interface (GUI) is the same as that of the Mac OS; that's partially true. The functionality of most cross-platform digital imaging programs, like Adobe Photoshop, is almost identical. This leads many photographers to believe that there is no difference between the platforms. The Mac OS, while certainly not the first GUI (Xerox has that honor) was the first to popularize the use of icons and mice. Because Apple Computer specified this kind of interface from the beginning, software developers adopted standards, even between different kinds of programs, that allowed programs to look and work alike. In addition, the Mac OS, unlike previous versions of Microsoft Windows, lets users take advantage of the maximum amount of RAM (random-access memory) installed without having to write scripts or run Microsoft's Memmaker utility. This is important to pixographers because the software that manipulates photographic images works better the more RAM you throw at it. Windows 95 overcomes this limitation, and Windows 98—when it finally ships—should be even better.

A three-year study of graphics and design professionals conducted by Gistics, Inc., may shed some light on how the choice of computer systems affects productivity and return on investment. The study covered 3.7 million design professionals, of which 49.8 percent used Mac OS computers, 37.6 percent used Windows, with the remainder using UNIX-based workstations. Of the top 10 percent of income earners, 63 percent use Mac OS, 20 percent use Windows, and 17

percent use UNIX. The study also showed Mac OS–using professionals produced $14,488 more net profit per person than a Windows user of comparable skills engaged in similar work. This increase in productivity enabled a company to recover the cost of Mac OS hardware in 4.59 months, while a Windows system took 12.58 months to recoup its investment. Interested readers can visit Gistics' Web site at *www.gistics.com.*

Apple Computer hung on too long to hardware and software that was too closed. The Windows platform, on the other hand, was so open that often things were not compatible. Enter Microsoft's attempt at making sanity out of chaos with Windows 95's plug-and-play architecture. When it works, it's wonderful, when it doesn't, it's closer to "plug-and-pray."

The real differences between platforms lie in the way each operating system performs basic digital housekeeping. If you are undecided about which system is right for you, go to a store that sells both Windows and Mac OS–compatible computers and ask to see how each computer handles the following operations:

- Insert a floppy disk and search its contents.
- Look at the contents of a hard disk and try to locate a specific file.
- Launch that file and the application that created it.
- See what steps are required when installing new software.
- Ask what is involved in installing useful peripherals such as Iomega's Zip drive, and ask what a user has to do if he decides to install this equipment himself.

Seeing these operations in action and getting these questions answered will help you decide which system operates the way you do and can do much to minimize buyer's remorse after buying a computer.

So what kind of computer should you buy for digital imaging or studio management? The answer is as simple as it is old. Find the system that runs the software you need, and buy that computer. Neither platform—Mac OS nor Windows—is perfect, and when you make a choice, you get the baggage that comes with that choice.

Figure 4. A computer's interface is more than just a pretty face, it is a gateway to usability. Here's what the author sees with his Power Computing machine running Mac OS enhanced by a shareware extension called BeView.

Configuring the Digital Imaging Computer

The first step in purchasing your first computer or upgrading the one you already have is establishing the configuration your machine will have, regardless of which platform (Mac OS or Windows) it will be. The size and type of components used in a system define a computer's configuration. To help make your decisions, I've prepared a checklist that will guide you toward making an intelligent purchase.

- *Memory* Microsoft recommends a minimum of 8 MB RAM for Windows 95, and Apple recommends 16 MB for Mac OS 8. (Windows 98 memory requirements are not available as I write this.) If you look at the system requirements of digital imaging programs like Adobe Photoshop, you will see that anything less than 32 MB will be inadequate for any kind of professional application. If you can afford 64 MB, go for it! My rule of thumb

for RAM requirements remains the same: Buy as much as you can afford—and twice as much as you think you need.

TIP: For RAM-Starved Mac OS Owners

Because photographic images demand large amounts of memory, I've been using Connectix's RAM Doubler software. This program effectively doubles the amount of RAM available on your system. RAM Doubler works by compressing the data in RAM being used by inactive applications and reallocates this space for something else. If you switch back to the compressed application, it's decompressed on the fly. If that doesn't work, the program sends data in RAM out to disk. I've found the latest version of RAM Doubler to be more stable than previous versions, and it doesn't seem to hog as much hard disk space as Apple's own Virtual Memory scheme.

TIP: Choices of RAM

RAM used to be so simple. You had RAM, sometimes more correctly called DRAM for dynamic random-access memory. New standards are on the horizon that will have an effect on the kind of memory your next computer will be using. For example, there is FPM (fast page mode) DRAM. Right now, FPM DRAM is the most common type used in Mac OS systems because it speeds the overall readout of data, but does introduce a wait state. EDO (extended data output) DRAM is popular in Windows-based computers. EDO DRAM sends out data even if a controller loads more data in vacant addresses. A newer, faster type of memory is called synchronous DRAM or SDRAM, which is expected to be used as a substitute for video RAM (VRAM). This is not to be confused with SRAM (static random-access memory), which is used in caches.

- *Hard disk* A corollary to my RAM rule of thumb applies to selecting the size of your hard disk. This, another of Farace's immutable rules of the computing universe, is that you never have enough hard disk space to add the program you just bought. Like RAM prices, drive prices have steadily declined as hard disks grow bigger and faster. Do not consider any system with a hard drive smaller than 2 GB. Because you never know what the computing future has in store, make sure the computer you are considering has room to install additional drives.
- *Removable media* I strongly suggest you add a removable-media drive, like Iomega's Zip, to your computer system. These drives are similar to the hard disk inside your computer, but the disk itself is encapsulated in a plastic shell, making it removable.

Iomega Zip drives and cartridges are found in 100 MB capacity; 1 GB Iomega Jaz drives are also available. I have a Zip drive installed on both my Power Computing and IBM computers. My Mac OS machine has a built-in drive and my IBM has an external model. When I create an image or series of images, I copy them temporarily onto my hard disk and insert a Zip cartridge that I take to my photo lab for imaging or keep in the office for offline storage. If you have a computer in a home office as well as your studio, a removable-media drive makes it possible to bring work home by slipping a cartridge into your briefcase instead of carrying an external hard disk back and forth to the studio. While I remain a fan of the inexpensive Zip drive, in chapter 3 I will introduce you to alternatives.

- *Video boards* A display is made up of two components—a monitor and a video board or card. These days, some Mac OS– and Windows-based systems come with video capabilities built into the computer's motherboard. Sometimes you'll need to install a different board in order to make your photographs display on your monitor like "real" photographs and not like pixellated messes. Many inexpensive computers come with an 8-bit color system. While this is adequate for working with black-and-white images, it's barely sufficient for working with and appreciating high-quality color photographs. I use an iXMicro Twin Turbo 128M video board for my Mac OS system. It has 8 MB of onboard video RAM, allowing me to provide $1,024 \times 768$–pixel resolution at 24-bit color depth on my 17-inch Power Computing monitor. Having 8 MB of VRAM provides for faster screen redraw, which is especially useful (and timesaving) when working with image-editing programs.

 Keep in mind that only a 24-bit system will allow you to see the nuances of photographs and, more importantly, let you see the effect of any changes you make to these images. High-quality video boards and color monitors are getting cheaper, but still aren't cheap. Trying to cut corners with your video hardware could result in some unpleasant surprises later.

- *CD-ROM drive* Most computers these days are delivered with a CD-ROM as standard equipment. I strongly recommend you get a CD-ROM changer too. Sometimes you will find that you will be

working with multiple image files that may be on two or more different discs. This is especially likely when creating promotional material or sell sheets. Having access to more than one CD-ROM disc at a time can give you a productivity boost. Much like the audio CD changers available for home use, a CD-ROM changer lets you keep five to seven discs online at one time. Some drives, like the Pioneer changer, even use the same cartridges that are used to hold music CDs. Others, like inexpensive NEC drives, don't use cartridges at all.

TIP: Backing UPS

No matter what kind of computer you buy, make sure you get an uninterruptible power supply (UPS). A UPS provides backup power when electrical power fails or drops to an unacceptable level. Depending on their size—they vary in capacity and price—UPS systems can provide battery power to your computer and monitor for a few minutes or an hour or more. This additional time will enable you to save the project you are working on and shut down the computer in a proper manner. Don't leave the computer store without one.

Purchasing Perils

Shopping for a new computer or peripheral is not without a few perils. Stores stacked with merchandise that is not connected—being sold by people similarly disconnected with information about those products—can make buying your next computer more complex than it has to be. Here's a look at some common traps and tips on how to avoid them.

Monitor Rip-Offs

Just as car dealers use clear lightbulbs to illuminate their lots at night because they minimize flaws in the body work, some computer dealers stack the cards against you by their practices. Take monitors for example: According to *Zap: How Your Computer Can Hurt You—and What You Can Do About It* by Don Sellers, the top of a monitor screen should be at eye level or slightly below. So why do some dealers place monitors on high shelves, like television sets in a bar? There are two possible answers here: Store employees may tell you that they do this

to keep people from fiddling with the controls, but I suspect the real reason for placing monitors farther away is to make them appear smaller. Why? I expect it's so they can sell larger and more expensive monitors. I applaud stores like CompUSA that have a "wall" of monitors displaying the same signal on many screens, allowing you to evaluate different brands at the same time. Not all retailers do this, but I think they should.

Why is it that not all the computers you see in a store are connected to monitors? When shopping for a Compaq computer, I discovered that the model I was interested in was not connected to a monitor. The space where the monitor was supposed to be was empty. When I asked the salesperson how can I tell what I'm buying if there is no monitor attached, he replied that the monitor is the same as the Compaq model next to it. His statement ignored the fact that the computer that had no monitor was a 200 MHz model, and the one with a monitor equipped was a slower model with a different video configuration. It made me wonder what he thought I was going to learn by this comparison? While it may be asking too much these days to find salespeople that have any product knowledge, you can't let them get away with laziness. Ask to have a monitor connected or ask for the manager.

Evaluate your monitor the same way you would at home or in your office. Position yourself between 18 and 24 inches away from it and make sure it is at eye level or slightly below. Although the ambient light in the store is probably too high, evaluate potential glare problems. If in doubt, don't be afraid to spend a few bucks on a glare shield. If you can afford it, NEC monitor buyers should spring for one of the company's high-quality offerings. Your eyes will thank you for it.

Test It Fully Loaded

It is not uncommon to go into even large computer stores and find rows and rows of computers—Mac OS and PC-compatibles—turned on, but few of them actually working. Why? One of the most common reasons is that many of them do not have any software on them. Dealers will tell you that the reason they do this is because "kids erase the stuff" and provide similar reasons, much of which I am sure is true. But that's a store management problem, not yours. With the proliferation of low-cost, high-volume removable storage devices like Iomega's Jaz, I think

it would be possible to back up computers when they are first set up and restore the software when necessary. There seems to be a reluctance to do this, but how does the retailer expect you to evaluate a computer unless you can actually use it?

The way some dealers are protecting against "kids erasing the stuff" is through the use of passwords. The biggest problem with passwords is that, much too often, the person who knows the password is either not in the store or doesn't work there anymore. In both situations, you have a choice. If the price is right, ask a manager to get the system online. The best solution in a competitive market may be to go somewhere else. This ultimately sends the company a message. Radio Shack spent millions of dollars on seventeen Incredible Universe stores that sold everything from computers to toasters, but did not provide enough customer service to make the operations profitable. After less than a year, all these giant stores are up for sale. Before the news of the chain's demise was formally announced, my neighbor Debbie bought a Compaq from Incredible Universe that never worked properly. Luckily, she exchanged it right away for an IBM Aptiva because the store is now a Sears Great Indoors operation—not a computer in sight.

Printer Problems

For some reason, too many computer retailers think printers are not really part of a computer system. They stick them off in their own sections—like toasters at an appliance store—unconnected to any computers, the way they would be in the real world. Since the printer you may be considering is not connected to a computer, you have to rely on the infamous "test print" to decide if you want to buy it. Would you buy a car that the dealer would not let you drive off the lot? That's exactly what many computer retailers expect you to do when shopping for a printer. Don't stand for it. Your own product knowledge is the best start. Start by reading magazine reviews. Want to see actual output? Fight back with your own personalized test disk. Make a floppy diskette that contains the kind of real-world output you normally produce. It does not matter if it's desktop publishing or graphics or text, create a file that will fit on a floppy disk and ask the salesperson to print it.

Locking Up the Silver

You have to wonder what makes stores security-crazed about some products and not others. Take removable media, for example. Both Computer City and CompUSA routinely keep SyQuest cartridges and CD-ROM Recordable discs locked in glass-doored cabinets behind an attended counter. Yet at the same time, Zip disks are placed on the standard store shelves to be handled like floppy disks. Sometimes tape cartridges are given the same "glass door" treatment, and sometimes not. If their reason for all of these security measures is to prevent theft, why aren't other products and peripherals given the same treatment? CompUSA also locks up PCI-based SCSI cards along with its CD-R discs, even though a CD-R disc costs less than 10 percent of what the Zip disks sitting around the corner do. Why is removable media so special? Someone needs to bring some sanity as to what products customers are allowed to handle and what they are not. My guess is that this practice goes back to a time when 44 MB SyQuest drives were the dominant removable media and cartridges were expensive. News flash: The face of removable media has changed dramatically in the past two years, and it's time retailers reflected that change in their security practices.

Dirty Computer-Store Tricks

So, I'm talking to this salesperson, see? He is giving me this pitch about a 200 MHz IBM Aptiva "Stealth." I admit it's pretty cool, but the price is just a little steep. I am picky about my keyboard and mice, and while I like the keyboard, the cordless mouse seems jerky to me. As the guy is telling me why I should buy the computer, he was leaning in front of a bright green sign, but I could only see the very tip of its corner. My wife, who was shopping with me—even though she hates computer stores—asks, "What does that sign say?" "What sign?" says he. Slowly he turns to reveal the 166 MHz version of the same computer. What's this? The sign says it was on sale today at a price substantially less that the 200 MHz model and it had a conventional corded mouse. Yes, I did buy the Stealth, but from another dealer.

Price Matching and Protection

Let's say a few words about the good guys. Last year, I went into a local CompUSA to buy a Power Macintosh. I needed to upgrade and had done all my homework and knew the cost of the computer I wanted. The reason I went to the store was twofold: it had a six-month "same as cash" sale and a policy of matching other dealer's prices. I walked in, asked for a salesperson and told him exactly what I wanted. He walked me over to the Mac section and showed me the computer. It was priced at $4,295 but I had been quoted $3,995 by a competitor just hours ago. When I asked him if he would match their price, he said he would, but would have to call to verify that price. After a short wait, he came back and said he was quoted $3,795! I was dumbfounded, but no more dumbfounded than by what he said next. "How about $3,495 for the computer?" I was so happy, I spent all the money I saved on a more expensive monitor. CompUSA and some other retailers also have a price protection policy. If they lower the price of a computer you bought within thirty days of your purchase, they will credit you the difference. It's up to you to track this, but eight days after I bought an IBM Aptiva "Stealth" at CompUSA, I saw their ad for a $100 lower price. I clipped the ad, went back to the store's customer service people, who promptly applied the price difference to my credit card.

Not every store has a price-matching policy, but I have found that it is better to shop at one that does. The same goes for price protection. With computer prices dropping all the time, the worst feeling of buyer's remorse is to see your new computer on sale for less than you paid just a few weeks ago. Before you buy anything, ask the store if it matches prices and provides price protection. If it does, this should give you some idea of the kind of retailer the store is. That's why using a credit card is a good way to purchase a computer. Getting a credit on your account is much simpler than a store having to give you cash or write you a check.

Product Knowledge and the Lack Thereof

Computer salespeople seem to be divided into two groups: those that know everything about computers (or think they do) and bury purchasers with more technical detail than they can digest, and those salespeople who don't have a clue. The only protection against either

kind of salesperson is to be armed with product knowledge. Read publications such as *ComputerUSER, Macworld,* and *PCWorld* to get information about products or a class of product. Visit company Web sites and get the scoop directly from the source. An hour or two spent on the World Wide Web can arm you with enough information to help make an informed purchase.

Why, you may be asking, must I do all this preparation? If you do all this, you might as well purchase by mail order. You, my friend, have just answered the question of why mail-order purchase of computers and peripherals is so popular. Mail-order companies do an excellent job of producing catalogs that allow you to compare systems and other hardware to find the exact item you want.

There are good reasons for purchasing locally. You may want to help the local economy and support these dealers, their employees, and their families, who have taken the time and investment to build a local store and pay local taxes. The other reason is that many stores have a no-hassle return policy if you bring the item back within a certain amount of days with all original packaging material intact. To many, including myself, this is an important consideration. I have returned a PC-compatible computer to CompUSA for a full, no-questions-asked refund after trying to use it. Before purchasing any expensive item, be sure to find out the store's policy on returns. Some require that all the original packing materials—including the plastic bags—be intact, and that the product be returned within a certain limited amount of days after purchase. Others charge a 10 or 15 percent restocking fee if you choose a refund instead of an exchange. Before plunking down your hard-earned cash on any computer or peripheral, take a few minutes to ask about a store's return or exchange policies. You'll be glad you did. Caveat computer user.

How Much Will All This Cost?

Whatever you do, don't go into heavy debt on any of these suggestions. Start with a basic box that uses a current-generation micro-processor such as a Pentium-powered PC or PowerPC Mac OS system—the faster the better. Nothing gets in the way of productivity more than a slow computer. Be sure to order it with as much RAM as you can afford and with at least a 17-inch monitor. After you've gotten

familiar with the system, that's the time to add removable-media drives, CD-ROM changers, and other "necessities" as time and budget permits.

There is a myth that the only way digital photographers can create striking images is by owning and using the newest, hottest computer systems. This myth is perpetuated by colorful advertisements and glossy brochures from manufacturers extolling the virtues, speed, and features of their latest boxes. The truth is that even if you purchase the best, most expensive, new computer available for digital imaging, there's a good chance that within a few months it will be replaced with one that's better and cheaper. That's why a used computer can be an excellent bargain for budget-conscious shoppers.

New or Used?

You probably already know that a used camera can be a good buy. This is especially true if the previous owner only used his Hasselblad to take vacation pictures and switched to a Sony camcorder. If the previous owner photographed kids in a high-volume operation and ran four hundred rolls of film a week through her Mamiya RB-67, it might not be such a good idea. Unlike automobiles, computers require only a modest amount of maintenance and often are not used very much. Since silicon chips don't wear out with use, a used computer works the same as a new one. The major "wear and tear" items on a computer are its floppy drives and power supply, and you don't have to win the lottery to replace either one.

The ongoing avalanche of new computer models means there are bargains to be found in recently discontinued models. If you can live with the fact that you don't have the latest gee-whiz model computer magazines are drooling over, chances are a used machine can give excellent service and save you big bucks. Price guides are available to help the used-computer shopper discover what specific models cost.

There are two basic places to look for used computers. The first is the classified ads of your local newspaper. Although some sellers have inflated ideas of what their computers are worth, this is still the best place to find bargains. The equipment may be for sale because the owner needs cash, or perhaps she bought it intending to use it and discovered that computers are not as easy to use as salespeople pretend they are. Either reason can result in a good buy.

The alternative is shopping at one of the used-computer stores that are springing up in cities all over the country, but be prepared to pay slightly higher prices than those you will find in the newspaper ads. However, most dealers offer some kind of guarantee, which can be a significant advantage over buying a computer from someone you discovered in the classifieds. Most used-computer stores I've visited have been staffed with knowledgeable, friendly people, but when buying any used item, caveat emptor. Lastly, magazines like *Macworld* print the American Computer Exchange used-computer prices in the back of each issue. You'll also find listings from the National Computer Exchange in publications like *ComputerUSER*. Local conditions can lead to higher or lower prices than the exchanges list, but they are an excellent guide for price trends.

Clone or Brand Name?

This decision usually breaks down to a choice between cost and comfort level. Originally, IBM-compatible computers were called "clones," although companies like Compaq Computer and Dell sell more IBM-compatible personal computers than IBM does. The choice of a brand name, like IBM or Compaq, may make computer users feel better about their purchases, but value-minded shoppers should take a look at the cloners. One of the advantages of local "clone shops" is that they can custom-build a computer for you. You can specify what kind of microprocessor you want, how large a hard drive, how much RAM, and what speed CD-ROM drive. This process often lets you get higher-performance equipment for prices that are less than an off-the-shelf model. More importantly, the hard disks of the clones are seldom loaded with useless software that eat up space. My IBM-PC "Stealth" was delivered with a 2.5 GB hard drive, but only 1 GB was free. Even after deleting a lot of useless junk, I still ended up having to install a larger, additional (4 GB) drive within nine months.

Take Two Computers . . . Please

After all of the above analysis, you may decide that you might need to have two computers. You should have a main computer and another one—perhaps less expensive, perhaps used. Since it will be obsolete in nine months, your main computer should be the fastest, biggest, baddest one you can afford. If you do not buy a Terminator-like computer, after it is obsolete you will spend all your time berating yourself for not buying the best you could have afforded. Take advantage of the six-

month "same as cash" promotions offered by computer superstores to buy your powerhouse. If you have computer problems, you still need to get work done. That's why you will need a backup computer. Assign the second computer duties such as e-mail and use it as a test bed for installing programs that might be a little flaky and might crash your workhorse machine.

Mac OS users—I know this is heresy to some of you—should consider a Windows computer as a second machine. This is no more expensive than "PC on a card" options and faster than software emulations of Windows on the Mac OS. Having a Windows machine will give Macheads access to programs not available for the Mac OS and provides cross-platform flexibility. By the same token, Windows 95 users might consider a Mac OS machine as a second computer. Powerful, inexpensive models are available via mail order or from local retailers specializing in used computers. To make interaction between the different operating systems easy, Mac OS users should install a copy of DataViz's MacOpener on their Windows computer. This indispensable utility lets Windows users read and write Mac OS floppy disks. MacOpener supports SyQuest, Iomega Bernoulli and Zip, CD-ROM, Sony MO, and Mac OS hard drives. When running MacOpener with Windows 95, the full file name is retained when moving files from a Mac disk onto the PC's hard disk. Users can also preview Mac text and graphics files before copying them.

TIP: Back Up, Back Up, and Back Up—Every Day

It is insanity not to do so. Get two Iomega Zip drives—one for each machine. Get one internal and one external model, so it can be swapped back and forth or carried to a service bureau or client's location. Zip drives and disks are inexpensive and both Mac OS and PC-compatible versions are bundled with backup software. Put a weekly backup disk off-site in a safe-deposit box. If you do not already have one, talk with your personal banker and get one. Many checking- and savings-account plans offer packages of services that include a free safe-deposit box.

Preventative Medicine

One of digital imaging's often overlooked and hidden costs is maintenance. Like other photography tools, computers and their components can break down and wear out. When that happens, the

usual response is to rush the victim to the emergency room of your local computer store and beg the usually overworked technicians to fix your machine—fast. Yet, there are steps you can take to minimize, even eliminate, many of the typical problems that plague computers. Here are just a few precautions you can take to ensure you have a healthier computer system.

- **Virus alert** Viruses are software bugs created by malevolent and misanthropic hackers designed to produce problems for you. With more than a hundred new viruses created each month, installing virus protection software on your computer is the best method of protecting your hard drive. The best software companies provide periodic updates—virus creators never sleep—containing remedies for the latest infections.

 On my Power Computing Mac-compatible, I use Symantec's AntiVirus for Macintosh (SAM). The way the program works is simple. During installation, SAM scans your hard disk for viruses and notifies you about them. If it discovers any viruses, the program can usually repair them. Next, the software sets up a "Safe Zone" on your hard disk so that any new files saved onto it—either from e-mail, download, or whatever—are automatically checked for contamination. Lastly, SAM automatically scans any new disk inserted in your floppy drive for viruses. On my IBM Stealth, I use Norton AntiVirus for Windows 95, also available from Symantec. The company maintains a research center whose only job is to find and cure viruses for many different computer platforms. Each month Symantec posts updates for each of its virus protection software packages on its Web site (*www. symantec.com*) so you can maintain up-to-date protection. One of the best virus protections is, of course, to be wary of disks from other people, as well as downloads and files attached to e-mail. You can innocently contract a virus from your friends, or even a service bureau or lab providing services for your studio. While most service bureaus maintain a high state of virus awareness, not all do. That's why one of the best ways to send data to a service bureau is on a recordable CD-ROM (CD-R) disc. Since the service bureau—or anyone else—can only read what you have sent, no one can write to it, which protects your original data from contamination.

- *Hard disk woes* The most common computer problems relate to nonviral problems with your hard disk. Occasional crashes and more occasional boneheaded mistakes can wreak havoc with a hard disk's directory. If problems accumulate, your computer may refuse to acknowledge that your hard drive even exists. Problems should be fixed when they are small, which requires some type of hard-disk utility. Like virus programs, there are many different packages available, but the classic hard-disk repair tool is Norton Utilities from Symantec. The package, available for both Macintosh and Windows computers, is a collection of many different utilities, but the most important diagnostic tool in the group is the Disk Doctor. If you run "the Doctor" immediately after a crash, or when your computer starts behaving oddly, you will find that it usually makes these problems disappear. Even if you are not having problems, it's a good idea to run the Norton Utilities once a month. This kind of vigilance keeps little problems from turning into big ones. Disk Doctor provides an Emergency (floppy) Disk, and if your hard disk refuses to boot, you can use the disk to start the computer and repair any problems. The Windows 95 version of Norton Utilities is more comprehensive than the Mac version and may appear more intimidating to the nontechie. If you are an average user, consider installing Symantec's HealthyPC, which is a simple diagnostic tool. That's what I use on my Stealth.
- *Backup hardware* When you take your sick computer to the computer store, the first question the technician is going to ask you is, Do you have a backup? Nine times out the ten that answer is no. You are then in the unenviable position of having to pay "whatever it takes" to rescue your computer's data. CD-R provides an inexpensive method for backing up your data. The cost of a CD-R disc is now less than $5, and with a storage capacity of 600+ MB, it provides excellent price performance. What is more, prices for CD-R drives are more affordable than ever. Lately, I have been using a Philips CDD2000 CD-R drive.

When you install a new hard drive or have a hard disk go bad, the best way to transfer data to the new drive is to have the entire contents of your drive backed up. It's also a good strategy to back up all of your

data along with the utilities and plug-ins that are important to your operation but often are overlooked in incremental backups. The most cost-effective media to use for backing up gigabytes of data is the Rodney Dangerfield of removable media—magnetic tape. The main drawback of any tape system is slowness. Since magnetic tape's format is linear, the drive must fast-forward to reach data, so access times can be thirty seconds or more. When using software such as Retrospect from Dantz, backup time is minimized because the software only copies data that has changed since your last backup.

Another option is the RAID (redundant array of inexpensive drives) system, a multidrive setup that "mirrors" one hard disk (or disks) with another. When using a RAID system, whatever you write to one drive is automatically written to the other. If one drive crashes and is not recoverable, you have an automatic backup sitting there. RAID systems can be expensive, but are much cheaper than paying a technician "whatever it costs" to recover data from a crashed disk that lacks recent backups. If one or more of your main drives crash, RAID software from companies like Data Technology Corp. (DTC) automatically switch over to the backup drive and continue working. When you replace the defective disk, DTC's HardCopy software helps rebuild your data onto the new drive.

Take care of yourself—and your computer.

You Need Software Too

Software comes in three flavors: commercial, shareware, and custom designed. Building a library of programs will help you maximize your investment in your computer. Commercial software is the glossy, shrink-wrapped boxes you see on the shelf at your friendly CompUSA or Egghead store. Prices for the different programs that will help you run your studio vary from not-too-bad to outrageous. Software pricing is one reason people like to buy from mail-order companies like PC Connection and MacWarehouse. My experience with both of these firms has been great. Make sure you're on the mailing list for these companies. But finding the right software for your studio can be almost as frustrating as finding the right computer. My advice: take it slow. Don't run out and buy stacks of different kinds of software, then try to learn it all at once.

Unless you're experienced, this can result in overload and, eventually, disillusionment. Focus on just one kind of package at one time, then gradually add others—just like you did with your camera system.

COMMENT: Software Piracy

It's exceedingly easy to copy a friend's program and install it on your computer. Because it's so easy, there is much temptation to do this. Don't! It is stealing, plain and simple. I've heard photographers complain about customers who, violating their copyright, blatantly make copies of prints they purchased from their studio. Then I've watched these same photographers make copies of programs and swap them among themselves. Their rationale: "Those companies have plenty of money, they won't miss the few bucks that my copying the disks cost them." They would be surprised to be sitting in the kitchen of one of their customers who are saying exactly those same words about their photographs and their studio. Those same copyright laws that protect photographers against illegal copying protect the creator of software too. Don't steal. It's not nice, it's stupid, and it's illegal. In the end, piracy tends to destroy the motivation of creative people to produce the software we need to run our business.

Commercial software has one major advantage over the other kinds I'll mention: the stuff is (usually, but not always) rigorously tested and free from viruses. You can get computer viruses the same way that you get the human variety—through contact with a contaminated computer. It's possible that such contamination can be introduced into the manufacturing process, but it is quite rare—although I have heard of a few cases. Commercial software includes complete documentation, including manuals and tutorials. Unless you're really experienced, take a few minutes after installing a program and work through the tutorials. Commercial software almost always includes some form of customer support, so if you have a question about something you're trying to do, you can usually find a kind soul to listen to your problem and suggest a solution. If you've noticed that I've thrown a lot of qualifiers in these statements, there's a good reason—customer support from large and small companies varies from great to awful. I've had both positive and negative experiences, and your own may be good, bad, or ugly depending on the company, product, and whether the moon is in Aquarius. Take some advice: Before spending money on a long-distance call, read the manual first. If that doesn't work, call a friend and ask him or her. Only when all else fails should you call the company.

Shareware may be the best software bargain available. Shareware is based on two ideas. First, the talented people who create these utilities and applications believe that users should be able to try their programs before they pay for them. The second part is an honor system that trusts users to pay for any program they use regularly. If you keep any shareware programs on your hard disk, remember to send in your shareware payment. Only your support, in the form of a check, will make sure these authors improve their programs and create exciting new ones. Freeware is a subset of shareware and is exactly what it sounds like—the software doesn't cost anything. Before you scoff at this idea, let me tell you that two programs that are among the best available for the Macintosh are freeware. Disinfectant is a freeware virus killer that is updated regularly by its author and available on all the usual online services. NIH Image is a freeware color-image enhancement program that would be great even if you had to pay for it.

Then there's custom-designed software. Back in the bad old days of computers, the only way you could get any kind of software was to write it yourself—or pay someone else to write it for you. Even today I find this attitude is quite prevalent among a certain class of computer users, but in most cases they're dead wrong. Consultants abound that, for a fee, will create custom software for your studio. I'm sure that there are many consultants out there who will do a good job, but my experience in this area has not been good. Meanwhile, before you run off and spend big bucks creating custom-designed software—or worse yet, paying someone to do it—stay active in your user's group and read the latest computer magazines.

Seven Steps to Digital Freedom

I call this "seven steps to digital freedom" because I honestly believe that the digital imaging revolution frees studios from some of the adversarial relationships they often have with suppliers. (Just because your color lab tells you it is too busy to deliver your order when you need it doesn't mean that you don't have deadlines too.) What's more, by integrating digital images into the list of services that you offer, you can provide a level of rush services that would have been undreamed of just a few years ago. One of the guiding principles is to accomplish this migration to digital imaging services with the least-cost solution.

1 *Analyze the services you currently offer.* The purpose of this analysis is to find a time-sensitive service—one that your clients need. Ask yourself which type of client is always in a hurry and needs to get images as soon as possible. Freelance photojournalists may find a magazine that, all to often, requires that they drop everything, shoot something, and FedEx the film to them. Portrait photographers may find that people who need public relations glossies often need them "right away." Special-event photographers have too often had to pay photo labs to stay open during extra hours at night and weekends to deliver prints for meetings and conventions. All of these are perfect applications for conversion to digital image making.

2 *Pick a test market.* After analyzing the potential client applications for digital imaging, pick one—and only one—to use as the first completely digital service that you offer. The reason I suggest that you focus on one service is that it will keep you from being distracted from competing elements of other services. After you gain experience, you will be able to apply what you learned in one area to all the others.

3 *Determine resolution requirements.* Once you know who your potential clients are, determine the resolution needs that this type of client requires. Knowing the resolution requirements will tell you what kind of equipment—camera and printer—you may need to purchase or rent. The next chapter includes information on how to shop for a digital camera. Use the information in that chapter to find the right camera and printer for your application.

4 *Do a cost analysis.* Determine what your rates will be for this new service. If you don't already have a cost of sales for the service the way you are currently doing it, produce one on your film-based system before getting started on your digital analysis. Be sure to include all the costs, such as travel time to the lab. Many photographers overlook this particular cost, which includes not only your time, but wear and tear on your vehicle. Ask yourself how many billable hours you are wasting on such trips and include that as a penalty for the "doing business as usual" plan.

5 *Don't practice on clients.* Begin a testing period to use the equipment to make images similar to those that the client needs. During this testing period, make sure that the quality of the output is

adequate and use the time to become acquainted to working with your new digital tools. Show the sample images to friends and neighbors, as well as to trusted clients, and get their impressions. Don't be afraid to run a film-versus-digital comparison and test the images on your same "beta testers," asking them which one looks better. You may be surprised at their responses.

6 *Market the service.* Now's the time to let everyone know that you are the first studio in the area, city, or state to offer a completely digital service. Start by doing a mailing to all the clients you have that are currently using your analog-based services. Send them a sample print or image so they know that there will not be any quality difference, and emphasize the speed that you will deliver the images that they need.

7 *Deliver the service.* Shoot the assignments and enjoy the freedom that comes from being in total control of the imaging process from beginning to end. As you work with actual clients, use the experience to refine your techniques and procedures, and make them even better for the next assignment. When you have this type of project completely digital, take a look at other service offerings of the studio and start at step 1 again.

Image Acquisition

Image manipulation is not just a combination of tools and techniques that you use when you want to create a photograph of cowboys roping ostriches on the moon. Yes, it's true that digital imaging techniques can be used to create images that can only be imagined with the mind's eye, but there are many more down-to-earth uses. If a portrait studio wants to print fliers for a Valentine's Day frame sale, an attractive digital image will help generate more sales. When you're publishing a newsletter for clients, using digital photographs can make the publication look more attractive, without having to pay your printer for the additional cost of halftones. Photographs used for any of these practical applications can be improved by using basic image-manipulation techniques. This chapter provides information on the three basic classes of digital cameras and includes tips on what to look for when getting ready to purchase your first digital camera.

In conventional photography, the quality of the final image—whether it is a color print or magazine ad—depends of the quality of the camera, processing, and printing. The same holds true for digital imaging. Anyone who has seen digital images reproduced, in any way, that looked pixellated and lower in quality than an enlarged section of an 11 × 17mm disc camera photograph are victims of the media hype surrounding digital photography. Too often, stories in computer and photography magazines show the results of photographs made with low-resolution acquisition devices and compare them with high-resolution professional cameras, muddying the digital imaging waters even more. In the computer world, there's an old saying, "garbage in, garbage out." If you exercise the same care in producing an image with studio-quality digital imaging tools and techniques that you use for silver-based photographs, results will be comparable.

Digital Camera Myths

In the short time that digital cameras have been readily available, many myths have grown up around them. Before taking a look at how to buy a digital camera, let me dispel a few of these myths.

Myth #1: Film is cheap and provides better image quality than digital cameras. Fine-grained, silver-based film can resolve images far greater than all but the most expensive digital studio cameras.

While both statements are true, they fail the real-world test. High-end, professional digital studio cameras and backs can produce results indistinguishable from film. What about the resolution of the high-speed and grainier films that many sports photographers and photojournalists use? The available midlevel 35mm-style digital field cameras can meet or exceed the results from this kind of film. A short time ago, I wrote a series of articles for an amateur photographic magazine that sparked a controversy over a comparison of pixel-versus-film resolution that was never settled. The question seemed simple: How many pixels would you need to equal the quality of a 35mm black-and-white negative film? Nobody from Eastman Kodak was ever able to give me an answer to this question and readers, using many different methods, came up with widely divergent answers.

The real question is, How much resolution do you need? The ulti-

mate test for image quality should be based on how a photograph is used and viewed. Once again, real-world comparisons are called for. A photograph made with the finest grain film, latest lenses, and highest quality processing throws away most of its resolution when it is printed in a newspaper. Yet, the average person will find it difficult to tell the difference between a conventional 4 × 6-inch color print and an image made with a digital camera (with the resolution of a camera similar to Polaroid's PDC-2000) and printed on Epson 4 × 6 Photo Paper by an Epson Stylus Photo inkjet printer. All the above equipment is moderately priced, yet the results are truly photographic. This challenge introduces yet another variable—the experience of the viewer—into consideration when evaluating the quality of any photographic image.

Compared to a CCD chip, film is cheap and can hold lots of data, but how much data do you need? In commercial photography, the decision as to what equipment to use for a specific assignment is based on matching the hardware required for the shoot to how the photograph will be used and viewed. If the ultimate image is required and cost is not a factor, the final image might be a platinum contact print made with an 8 × 10 view camera. That last sentence contains the essence of why film will never die. The lustrous image created from such a combination is perfect for fine-arts applications, but is clearly overkill for photographs for newspapers, magazine advertisements, and the kind of documentary photography that many pros view as bread-and-butter work.

Myth #2: Digital cameras are expensive.

Far from being an all-encompassing and true statement like, All Porsches are expensive, not all digital cameras are expensive. Point-and-shoot digital cameras are available at prices competitive with the current breed of Advanced Photo System (APS) point-and-shoot cameras. In fact, one major camera manufacturer told me it has made a decision not to pursue the APS format because it feels that digital imaging—not Advanced Photo System—is the wave of the future. All its research and development efforts are being funneled into digital cameras, not APS.

One aspect of digital photography that is expensive is the cost of the devices that digital cameras use for image storage. Film is cheap when compared to the cost of PC cards, and while I am sure their manufacturers can justify the high prices they charge, they seem expensive to me. Such

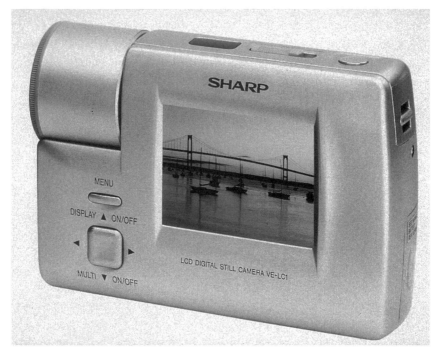

Figure 5. The prices of new digital cameras, like this Sharp VE-LC1, are competitive with cameras that use Advanced Photo System film. (Photo courtesy of Sharp Electronics)

high media costs expose these companies to the same kind of competition that abounds in other forms of removable media. Sony's response to this digital dilemma was a camera that uses conventional floppy disks, and I am sure that the adoption of other conventional, computer-based media may be in the not-so-distant future. A little later, I will look at the pros and cons of the storage devices that digital cameras use. In the short run, storage costs for digital media may be high, but historically, trends have been toward lower cost, higher efficiency media.

Myth #3: *Digital images are not archival.*

Film—especially color film—is not inherently more archivally stable than most forms of digital media used for storage. There are too many variables that affect the stability of silver-based images, including the age of the original film before it was exposed, how it was stored before processing, how it is processed, the freshness of the chemistry used in processing, and how it is stored after being processed. Any miscues in

one of these steps affects the long-term stability of any film-based image. It is certainly true that black-and-white film can be handled from start to finish using materials and processes that guarantee archival quality, but because of the inherent instability of the dyes used in color film, it is much more difficult to do when working with color images. The stability of some color films, notably Eastman Kodak's Kodachrome family of transparency films, is better than some of the company's other color film stock; but archiving color film is never a cakewalk.

It is possible to create an almost perfect archival image using conventional silver-based technology. If you want to create an image for the next millennium (3001), you should shoot it using black-and-white film and process and store it under museum conditions. Doing this is much more expensive and painstaking than what the average professional photographer needs to do. Most commercial photographs are short-term affairs and tend to be out-of-date before any kind of image degradation sets in. Portrait photographers have a heavier burden since they are, in effect, recording family histories, but they cannot control how their clients will store and display the images that they create for them.

Film processed at your local photo lab may not be archival. Nevertheless, there are steps you can take to prevent deterioration once the film is back in your hands. Contact Light Impressions (800-828-6216) for its catalog of archival storage materials. Similarly, there are steps you can take to assure the longest possible life for your digital images. The simplest is to store your images on magneto-optical (MO) cartridges. Right now, MO carts provide the greatest stability of any removable media. I know they are slow, but prices of MO drives are finally competitive with magnetic media drives and the trade-off in disk performance versus stability seems fair to me. You might want to consider purchasing a MO drive specifically for archival storage of images. According to an Olympus representative I spoke with, the company's current generation of 230 MB cartridges have a ninety-nine-year life. By comparison, CD-ROMs have a thirty-five-year life. If you are serious about ensuring your digital images will last that long, the cost of an Olympus—or any other manufacturer's MO drive—won't break your bank account. As one of my friends pointed out to me, in ninety-nine years there probably won't be machines that will work with any of these drives. The truth of the matter is that image conservation—digital or otherwise—is a constantly moving target and whatever form

of archival storage you chose, it must be constantly reevaluated and, if necessary, changed.

Digital Camera Nonmyths

All is not rosy for digital camera purchasers. One of the key problems of living with a purchase decision is the unrelenting rollout of new products. Each new camera that is introduced is better and less expensive than the one preceding it. One industry insider told me that less-than-$1,000 digital cameras have a half-life of four and one-half months! In real-world terms, this means that just about the time you hear about a new camera, the company is getting ready to replace it. What usually occurs is the company keeps the old camera in the product lineup and lowers its price so it can move remaining stock. After that, the camera is long gone and the company is into another product introduction cycle. Unlike silver-based cameras, whose prices are continually rising, digital camera prices are constantly dropping—while capabilities are increasing. This means early adopters are making a high-price investment and are left with a camera with little resale value. When you make a purchase decision, try to be able to use the camera to extract the value as quickly as possible before upgrading. But beware the onslaught of buyer's remorse. Ignore it and get to work.

Digital camera manufacturers are in a tough spot. They have to keep raising the technological bar to improve their products because if they don't, their competitors will. Unfortunately, this leaves many potential purchasers waiting for them to "perfect" the technology, just as some wary consumers are still waiting for television companies to perfect color TV. On one hand, there is a pool of potential buyers waiting for the market to stabilize. On the other, actual purchasers feel they are being burned by buying a new camera, only to see the price drop a few months later. There is no solution to this dilemma as free-market forces work to shakeout digital camera manufacturers. While film and electronic manufacturers were first to market popularly priced, digital point-and-shoot cameras, traditional camera manufacturers were late to the table. Now they are in it with a vengeance, although there probably is a smaller number of potential buyers for a $15,000 digital Leica than for a $300 Casio. Although, who knows? Leica buyers have always been a special group of people.

Then there is the problem of the lack of standardization for image storage media. Cameras are being delivered with several different kinds of storage media options, and the lack of a single, inexpensive choice hurts the wider acceptance of digital cameras. It would be better for consumers if companies would get together, like manufacturers of competing DVD (digital video disc) formats did, and settle on a standard format instead of refighting a kind of Beta versus VHS war. Based on digital camera manufacturers' performances in the past, I am not optimistic about this one.

Like it or not, the digital genie is out of the bottle. Despite the faults, problems, and missteps that some companies are making with the way new digital cameras are brought to market, there is no turning back. Many users simply do not require the permanence of film, and prefer the speed and convenience of digital cameras. Far from being toys, digital cameras expand the democratization of photography like no technology ever before. For any neo-Luddites reading this, I have four words of advice: Get used to it.

Going Shopping

Now that you've heard the good news—and the bad—it's time to look at how to buy a digital camera. The process is different from purchasing or adding film-based cameras to your equipment inventory, but it is not overwhelming. You need to use the same kind of analysis; in this case, you have to go back to the basics.

One of the biggest advantages of using filmless cameras is that they don't require film or photochemical processing. After you've created your digital images, you simply download them from the camera to your computer, where you can manipulate them, send them over the Internet, or incorporate them into desktop-published documents. Some video-friendly digital cameras allow you to connect the camera to a television monitor so you can get continuous preview of the image you're about to make. Whenever making a purchasing decision, don't forget the old photo lab maxim: "speed, quality, price—choose any two." These words of wisdom apply to digital image making as well.

Digital still cameras fall into three general categories: point and shoot, 35mm-style field models, and studio cameras and backs.

The first category is the digital equivalent of the point-and-shoot

35mm cameras used by many nonprofessionals to capture images where ease of use and low cost are more important than image quality. Digital point-and-shoot users tend to be people such as real estate agents, insurance adjusters, and other documentarians who paste their photographs into desktop-published documents that are printed on laser or inkjet printers. Digital point-and-shoot cameras are also just for fun. If you want to take a picture of your new baby or boat and include it in a letter to grandma, these cameras can't be beat.

The next step is pro-quality digital field cameras, many of which are based on conventional 35mm camera bodies—or at least resemble conventional cameras. Field cameras typically use the same lens mount that matches the film camera system that most pros are already using, so they can easily be integrated into your studio's operations. Costs for these cameras have been steadily dropping, and as I write this, professional models are available starting at $7,000. Not cheap, but the gap between digital cameras and professional 35mm and medium-format equipment is narrowing.

Studio cameras and backs are aimed at advertising photographers creating photographs from art directors' sketches, and who sometimes convert finished images directly into separations for four-color printing. Some studio cameras require high-output lighting to minimize image capture time and must be directly connected to a computer. These expensive ($50,000 is not an unheard-of price) cameras and backs deliver the film-like resolution that is needed for advertising and catalogue work.

Point-and-Shoot Cameras

The image quality of all but the highest-end point-and-shoot cameras falls short of what is generally required for professional applications, but there are applications for these kinds of cameras as you move your studio into the next century. In fact, a digital point-and-shoot camera may be the perfect way to test the digital waters without spending too much of your studio's operations budget. You may also want to consider a point-and-shoot camera for your personal use, so here's a quick look at what to look for.

Although this trend seems to be changing, one of the most striking features of most digital point-and-shoot cameras is how little they look

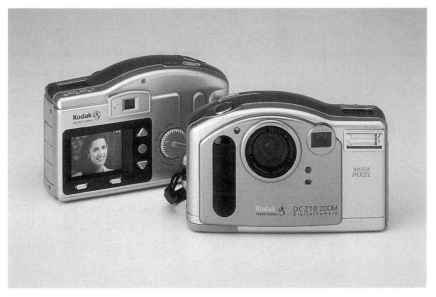

Figure 6. Kodak's DC210 is one of the highest-resolution digital point-and-shoot cameras available. (Photo courtesy of Eastman Kodak)

like cameras. Manufacturers have thrown convention to the wind, giving us a collection of cameras that look like everything from piccolos to handheld scanners. How well these cameras fit your hands can be tested by a hands-on comparison in a camera or computer store. Farace's first law of shopping for digital cameras is, If you don't feel a hundred percent comfortable with the camera right away, you're going to hate it later.

Thirty-five millimeter film is defined by its 24 × 36mm dimensions. Similarly, you measure a digital camera's resolution by the size of the image—in pixels. In this category, choices range from 320 × 240 pixels to 1,600 × 1,200 pixels. The greater the resolution, the better quality the image will be, and the more expensive the camera. Some manufacturers, especially at the low end, tend to slightly overstate their camera's capabilities. Resolution is less important when printing with a laser or inkjet printer than having a 4 × 5 transparency produced on a film recorder. A good rule of thumb is that your image resolution only has to match the resolution of the output device.

A digital camera's light sensitivity can vary from an ISO equivalent of 100 to up to 1600. This is one reason (among many) why a digital point-and-shoot camera would not be the best choice to shoot an indoor

hockey or basketball game. Unlike conventional point-and-shoot cameras, which always include a built-in flash, this feature is not always present in low-end digital cameras. In its place is greater light sensitivity, and just as in silver-based photography, a higher ISO equivalent does not always enhance image resolution.

The computer industry has a name for it: WYSIWYG (what you see is what you get). Users familiar with conventional point-and-shoot optical viewfinders will be comfortable with their digital equivalents. To overcome WYSIWYG concerns, some cameras replace the viewfinder with a color LCD (liquid crystal display) panel much like that of a camcorder. Casio started this trend, and more and more cameras are either using an LCD panel or offering one as an option. Making pictures with a LCD-only viewing system entails using an extended-arm shooting technique you may like or hate. Nevertheless, it's fun to use the built-in screen to preview images and delete the ones that didn't turn out so well.

How many images you can store in a camera's memory is limited by how much memory it has and the resolution of each image. Higher-resolution photos take more memory. Many cameras offer more than one resolution option, allowing the photographer to select from good, better, and best—depending on how the image will be used. A digital camera can store images two ways: built-in or removable storage media. Users who shoot a lot of images need removable-media capability; cameras with this feature usually cost more.

How the camera connects to your computer is important. The most common connector is a serial port, but it varies by camera. (Polaroid's PDC-2000, for example, uses a SCSI-2 interface.) Before walking out of the store with the camera, make sure you have all the cables you need even if you have to make a separate purchase. A camera with an NTSC (National Television Standards Committee) or Y/C video-out is valuable for many users because it allows you to preview images on your television or even present them as a "slide show," however this feature is less common on field cameras than it is on digital point-and-shoot cameras. With more TVs including front-mounted camcorder jacks, why not use them to preview images made with your digital camera? Nikon's E2N provides a spin on this capability by providing a continuous video mode that allows photographers to view their images directly on a video monitor before clicking the shutter. This instantaneous preview image

will be useful for studio photographers who want to check their lighting or show clients what an image looks like before it is captured.

Every digital camera includes software that allows you to transfer image data to your computer. The software varies greatly from manufacturer to manufacturer, so make sure you get a demonstration of how the software works before buying. Some cameras bundle commercial software like Adobe's beginner-level PhotoDeluxe manipulation software or MetaCreations's fun special-effects package, Kai's Power Goo. Consider the inclusion of these programs a plus.

While prices for digital cameras continue to drop, few could really be called inexpensive. At one end of the spectrum are cameras such as Kodak's DC-20, with a street price less than $300, and at the upper end you have the digital equivalent of the titanium-bodied Nikon 28Ti and its brethren—the Polaroid PDC-2000 or PDC-3000. With a price range of $2,995–$4,995, the PDC-2000 and PDC-3000 delivers 1,600 × 1,200 pixel images in a svelte, Porsche-like camera body.

When making a decision about a camera:
- Shoot test images in the store. Take them home on a floppy disk and print them with the same output device you plan on using.
- If you have an understanding salesperson, print an image using one of the store's printers.
- If these alternatives are not possible, buy it and try it. Most computer superstores allow you to return equipment after a reasonable time; make sure you get that policy in writing.

Bridge Cameras

One class of camera that falls through the crack between point-and-shoot and field cameras is the "bridge" camera. The bridge camera concept is nothing new. Examples abound in film-based cameras ranging from the Nikon 28Ti to the Contax T2. These precision—but non-SLR—film-based models have their spiritual roots in cameras like the classic Rollei 35. Like their analog cousins, digital bridge cameras are of non-SLR design, feature quality lenses, and offer resolution capabilities similar to those obtained with some less expensive, digital field cameras. Polaroid's PDC-2000 and PDC-3000 are perfect examples of this concept. They look like point-and-shoot digital cameras but have an 11mm glass lens (equivalent to 38mm in the 35mm format) and deliver photographs

at up to 1,200 × 1,600-pixel resolution. Both cameras offer an optional, 17mm (60mm equivalent) interchangeable lens. The cameras offer a single ISO equivalent—100—but when combined with a built-in flash, they provide good performance for many applications, such as event-oriented portraiture.

The Olympus D-500L and D-600L are a pair of bridge camera alternatives that use an SLR configuration. These SLR cameras provide relatively high resolution (1,280 × 1,024 pixels for the D-500L; 1,024 × 768 for the D-600L) and a 1.8-inch LCD preview panel for viewing, deleting, and tagging of images for printing. The zoom lens of the D-500L goes from the 35mm equivalent of 50mm to 150mm. The D-600L features a zoom lens of 36mm to 110mm focal lengths. The camera's macro-focusing capability permits close-up views from 11.8 to 23.6 inches. If the price tags of field cameras seem too high, a bridge camera may be all you need.

Field Cameras

Unlike the lower-priced point-and-shoot models, digital field cameras look and feel just like 35mm pro-level SLRs. They should, because many of them began life as conventional cameras and have been adapted by film companies such as Agfa and Kodak to add a digital back for image capture. One exception to this rule is the Nikon/Fujix twins. (Nikon calls its models the E2 and E2S, while Fuji calls them DS-505A and DS-515A.) These sibling cameras have been designed from the ground up to be digital and lack the motor drive-like appendages found on the rest of the currently available field cameras. If you like the way their analog versions feel, you'll like the way their digital field cameras handle. Except for the additional bulk that the digital back adds to most models, it won't take long for you to get used to whichever digital field camera you choose.

The next decision you have to make is what lens mount matches your existing camera system. Having a digital camera that uses the same lenses as your film-based camera enables you to double the use of these lenses. Nikon appears to have more choices in this category, with several Nikon-bodied models available from Kodak as well as the all-digital design developed in conjunction with Fuji. Kodak also makes two Canon-based cameras. Minolta fans can use a camera Minolta jointly

Figure 7. Polaroid's PDC-2000 is a perfect example of the bridge camera concept that falls somewhere between the point-and-shoot and digital field cameras. (Photo courtesy of Polaroid Corporation)

developed with Agfa. Before assuming your existing lenses will work with a same-mount digital camera, take the time to ask a few questions about lens compatibility. Lenses with maximum apertures smaller than f/4 can cause vignetting, so you may not be able to use every lens you own. Also be aware that the format of the CCD image chips in many of these cameras is a different size than the standard 24mm × 36mm format. (One exception is the Nikon/Fujix twins.) This means the effective focal length of your existing lenses will be different—longer—than what's imprinted on the front. Until you get the hang of it, make a sticker with translations for digital focal length and attach it to the back of your digital camera. Since the actual size of the CCD chip can vary for each camera you may be shopping for, check your user's guide for focal length translations.

Digital field cameras have better resolution than point-and-shoot models. The resolution of the current versions of Kodak's DCS field

cameras range from 1,268 × 1,012 pixels for the DCS 3 Canon-based model to 3,060 × 2,036 pixels for the DCS 1 (Canon) and DCS 460 (Nikon) cameras. Both of these latter models deliver resolution similar to the largest image size available from Kodak's Photo CD process. By comparison, the Minolta RD-175 has a resolution capability of 1,528 × 1,146 pixels, while the Nikon/Fujix SLRs, including the E2N, offer 1,280 × 1,000-pixel resolution.

With any digital camera purchase, it is important to match the resolution of the camera to how the image will be reproduced. Photo-journalists working for newspapers will have different requirements—because their resolution needs are less—than magazine shooters and portrait photographers. A good rule of thumb is to get as much resolution as you can afford.

A digital camera's typical light sensitivity can vary from moderate to quite high, letting you shoot in low-light conditions. Most field cameras offer a choice of ISO equivalents that vary from a sensitivity of ISO 100 up to 6400. As in everything digital, the higher the equivalent ISO film speed—or the more choices you have—the more expensive the camera will be. Kodak's low-cost DCS 410 provides only a single choice—ISO 100, while the more expensive DCS 3 provides choices from 400 to 6400. As in silver-based photography, though, there's no substitute for good lighting—along with higher light sensitivity comes lower image quality. This shows up in ways not dissimilar to conventional photography: reduced contrast, image noise, and muddy colors. Unlike silver-based images, these effects are lessened when a camera produces higher-resolution digital photographs. In this way, changes in resolution may be similar to changes in film format; what would look unacceptable when shot in a 35mm or Advanced Photo System camera will be more than acceptable if shot on 4 × 5 or 8 × 10 sheet film.

Few pro-level digital field cameras offer built-in flash. Nevertheless, all of them are compatible with the high-end sophisticated shoe-mount flashes, like Nikon's SB-26, that the camera manufacturers offer as options, Since these cameras are going to fit into an existing system, chances are you already have the kind of shoe-mount or studio flash you need. Of course, there will be a PC-type connection that enables you to plug your electronic studio flash units into the camera with a conventional PC cord.

TIP: ISO Standards

Don't forget that the same technology used to set ISO equivalents for digital cameras were originally used to set the original ISO ratings for film. Do you shoot 100-speed film with your meter set at 100? Most professional photographers don't. This means initially you will have to test, test, test the ISO film equivalents for your new digital camera to establish an effective exposure index.

Other Considerations

As mentioned earlier, every digital camera is bundled with software allowing you to transfer image data to your computer. Most cameras come with commercial image-editing software or TWAIN or Photoshop-compatible plug-ins that allow you to access images from the camera (or PC card reader) directly from within your favorite digital imaging program. Importing images directly into enhancement programs can be important because you will inevitably have to make some kind of minor correction.

Reports have shown that cameras—even from the same manufacturer—can exhibit color shifts. Kodak's Canon-bodied DCS 5 tends to have a slight green color shift, while its Nikon-bodied DCS 420 exhibits a slight magenta orientation. The same results can occur with bridge cameras too. Photographs I made indoors using Polaroid's PDC-2000 with built-in flash exhibited a slight cyan shift. All of these color shifts are easily corrected using the editing tools built into programs like Adobe Photoshop.

Even though these cameras are expensive, don't expect perfection. Just as you might have to manipulate a conventionally made image in the darkroom to make it look the way it should, you will have to do the same thing with your digital camera. While prices for digital cameras continue to drop, few field cameras could really be called inexpensive. At the low end of the spectrum, expect to pay $7,000, with higher-end (and higher-resolution) cameras priced close to $28,000. Although only you know how much you can afford, consider resolution to be the number one consideration. With these prices, you need to realistically consider how much resolution you really need. More money always buys better resolution, but if the bulk of your digital imaging is for newspapers or online publications, you may be able to get by with a camera similar to a Kodak DCS 410 or Minolta RD-175. If your needs

are only occasional, a bridge camera like Polaroid's PDC-2000/3000 (under $4,000) or Olympus's D-500/600L may be all you need.

Purchasing a digital field camera involves the same trade-offs that go into purchasing any top-of-the-line SLR: convenience, lens mount, and applicability to the way you shoot and work. All of these considerations have to be balanced by the cost of the camera and how quickly it can be amortized.

Studio Cameras and Backs

While the most expensive digital alternative, this category is going through many changes with new models being launched on a regular basis.

When shopping for studio cameras you will notice there are two different types of imaging systems used: CCD chip and CCD linear array. (A charged coupled device is the same kind of light-gathering device used in video camcorders to convert the light passing through the lens into the electronic equivalent of the original image.) Often you will hear CCD chip cameras referred to as "one-shot" cameras because they make an instantaneous digital exposure. CCD linear array backs—sometimes called scanning backs—are, in essence, mini-scanners. To understand how this kind of digital camera works, you need to understand how scanners work.

Scanners use an array of several CCD elements arranged in a row on a single chip. Three-pass CCD scanners use a single array and rotate an RGB color wheel in front of the elements before each of three passes are made. A single-pass scanner uses three linear arrays, which are individually coated to filter red, blue, and green light. Instead of a single, large CCD chip, scanner backs use a linear array of sensors that move across the image area. Photographers used to instantaneous exposure will have to get used to a longer "click" of the shutter when using a scanning back. It can take three to twelve minutes for a scanning back to make an exposure, which limits your choice of subjects to studio still life. Lighting requirements become more critical too. The more light you can add, the shorter the exposure. The Phase One Studiokit back, for example, takes about three minutes to make an exposure. This may not be a problem for studio still-life shots, but would not be the ideal setup for photographing models.

Up until a short time ago, most digital studio cameras weren't cameras at all, but interchangeable backs that slipped behind the ground glass back on a 4 × 5 camera or snapped onto the back of Hasselblad body. Some large-format models from companies like Phase One have a form factor similar to a sheet film holder, and you simply insert it into a camera's back. Medium-format models snap onto the rear of a camera much the same way a roll film or Polaroid back might—they're just bigger. Phase One's Power-Phase digital back, for example, fits five different medium-format cameras. But now the game is changing.

Now cameras are being built specifically to be digital. At photokina '96, Linhof introduced the M679 for image formats up to 6 × 9 inches, and it's been designed to accept a wide range of digital backs. Sinar built the Kodak DCS465 digital back into a compact view camera, but used another approach with its new Digital Sinarcam. This camera is essentially a Leaf digital back fitted with a front lens panel that accepts medium-format or 35mm lenses. Removing the lens panel and attaching the unit to the back of a Sinar P.3 view camera turns the Sinarcam into a full-movement monorail.

Digital "Film"

Digital cameras typically provide two options for image storage: internal memory or PC cards. (These used to be called PCMCIA—Personal Computer Memory Card International Association—cards, but the acronym got to be too bulky. "PC card" may be easier to remember, but doesn't roll off the tongue the way PCMCIA does.) Often, the amount of built-in memory is fixed, but PC cards are the equivalent of removable hard disks and are available with different memory capacities. When a card is filled, you can pop another one in, much as you would change a roll of film. Larger-capacity cards allow storage of more images. Although these cards can vary in capacity—and price—cameras that accept PC cards can use one of any size.

Most current digital field cameras offer PC card capability, but the next generation of field cameras is increasingly using the CompactFlash family of memory cards. First introduced at photokina '96, these tiny (they're smaller than a standard 35mm slide mount) modules are currently being used by Kodak's DC25 point-and-shoot cameras, but their small size makes them an ideal "digital film" solution for field

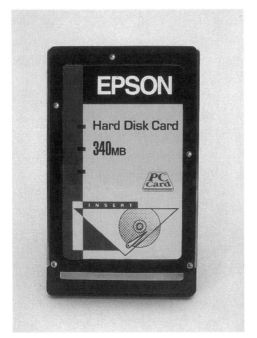

Figure 8. Many digital cameras accept PC cards, similar to this 340 MB hard disk card manufactured by Epson. (Photo courtesy of Epson America)

cameras as well. Kodak calls its version of the modules "picture cards," and currently offers them in 2 MB size, which allows for storage of thirteen or twenty-six images, depending on resolution. Most CompactFlash cards are packaged with an adapter, allowing them to be read by desktop PC-card readers or the PC slots found in most contemporary laptops. For field camera users, PC cards are currently the best option for image storage. They enable you to keep working, instead of having to stop and download images to a laptop. In order to interface with most desktop computers, you may have to purchase a separate card reader. Readers are available from several companies; Kodak offers a Picture Card Reader/Writer for CompactFlash cards for about $100.

Challenging both PC card and CompactFlash formats is Iomega's Click micro disk. Iomega, which changed the face of removable desktop storage with its Zip drive, is positioning Click disks as a lower cost alternative to CompactFlash. The disks measures 1.875 inches square and use magnetic technology similar to the company's Zip disk. The cost of each 20 MB Click disk is expected to be $10, yielding a cost-per-megabyte of 50¢. By comparison, the cost per megabyte for Compact-

Flash cards varies from \$20 to \$50, depending on the size of the card. Iomega's price advantage makes this a format to watch for in the future.

Image Acquisition Options

While digital cameras may be able to take care of some of your immediate imaging needs, what—you may be wondering—can you do with existing negatives or transparencies? Fortunately, there are many digitizing options available for your library of images or those assignments that, during this interim period, are shot on film. There are processes and tools that enable you to digitize these images in-house as well as those that can be sent to an outside lab. Since the thrust of this book is on becoming as self-sufficient as possible, let's take a look at what you can do in-house.

Let's Make a Scan

Using a scanner to digitize images is no more difficult than transferring an image from a digital camera. The scanner manufacturer usually includes software similar to what you would get with a digital camera. Since you can place any size image on a scanner, you need to set the scanner so it only scans the artwork you place on its glass surface. This is done by prescanning the artwork. When you do this, a finished preview of what is lying on the scanner's glass will appear on your screen. You can then crop the image so the final scanned image only includes the area you want. Click "Scan" and the image will be acquired and placed into your image-editing program.

One reason that many scanners are designed to work with image manipulation programs is because the color of your digitized image may not match that of your original and you will have to tweak it with the software. This tends to be more of a problem with scanners than with digital cameras, but it is something cameras must deal with too. Even an \$8,000–\$10,000 camera can have a slight magenta or green bias. This is caused by the design of the CCD chip, and since scanners use arrays of CCD chips, you will have similar problems with any scanned image. With a basic knowledge of color and a little practice, none of these difficulties are insurmountable.

Figure 9. This photograph made in Israel was scanned using an Epson ES-1000C
30-bit color flatbed scanner. (Photo © Bill Craig)

Photo CD Access

Kodak's Photo CD system is cross-platform and all of its products and software are compatible with both Windows and Mac OS computers. Most graphics programs allow you to import Photo CD images through their standard "Open" command. I prefer to use Kodak's Photo CD Acquire Module that not only lets you import the images, but also allows you to modify them slightly before they're opened. You can download the latest and a previous version of the Photo CD Acquire module from the Internet at *www.kodak.com/productInfo/technicalInfo/pcdAcquire Download.shtml.*

There are many service providers who will transfer your images onto a Photo CD. Call 800-939-1302 in the United States or visit Kodak's Web site at *www.kodak.com* to find the one nearest you. Prices vary by provider, scan format, and level of service. The price of Photo CD scans from 35mm film range from 50¢ to $4 an image, while medium- and large-format film prices range from $6 to $19. If you want to experiment with the Photo CD process, pick up a copy of Kodak's Photo CD Access Plus Software. It lets you view images, export them in different file format, and only costs ten bucks. A variety of Photo CD–enabled freeware and shareware utilities are available on the World Wide Web at sites like *www.public.iastate.edu/~stark/gutil_sv.html.*

The Realities of Conversion

One of the biggest problems facing photographers when converting to digital imaging is that they get in a hurry to convert everything to digital—right now. By taking your time and phasing in digital imaging to certain, specific aspects of your studio operation, you will gain valuable experience that can be carried over into other parts of the studio. This gradual approach will save you time and money later on.

In this chapter, you will find how even a modest investment in digital photographic equipment—acquisition and output—can pay for itself in less than two years and enable you to respond faster to clients' needs at the same time. Information will also be included to show how to get started by outsourcing some parts of the process to minimize initial capital expenditures.

Let's start at the simplest digital application.

A Few Examples

Let's take another look at the real-world examples discussed in chapter 1 and how they might be handled in a digital way. For the magazine publisher that requires you to drop everything, rush off to shoot an assignment, and FedEx the film to him, you can offer same-day turnaround of digital images. If offering this service doesn't get the publisher's attention, I don't know what will. Here's how it works. After finishing the shoot using a digital field camera, you go back to your studio—or not, depending on the urgency—and download the images from the camera to your hard disk. You can also do it on-site using a laptop computer with a large enough hard drive. You can then send the images to the client over the Internet (more on the World Wide Web in part III). Using a laptop with a cellular modem, you can have these images in your client's office the same hour that you shot them. Using whatever method that suits your work style and equipment budget (and the client's requirements), you can deliver a photograph—or series of photographs—to any magazine or corporate office in the world. This same approach will also work with corporate clients that need images fast.

Portrait photographers who need to deliver public relations glossies on a rush basis can have prints made on a dye-sublimation printer within a few minutes after the portrait session—while the client has a cup of coffee in your waiting room. Since many publications these days can work with digital images directly, you can also offer to deliver the "print" to your client in digital form on removable media, such as Iomega's Zip or even (depending on resolution requirements) floppy disks. The same approach can be used for other public relations assignments such as "grip and grins," ribbon cuttings, and other time-related events that require prints for company publications.

Offer to deliver your images in digital form for other, nonrush projects simply as a convenience for your commercial clients who prefer to work with photographs that way. You may need to have several different kinds of removable-media drives available to deliver the images in a format that clients might need, but this is not expensive or complex. Here's my suggestion for three drives to start with: an Iomega Zip drive (100 MB), an Iomega Jaz drive (1GB), and a SyQuest 200 MB. The SyQuest 200 MB drive reads and writes three different SyQuest formats—44 MB, 88 MB, and 200 MB—so it's a triple-threat device.

These drives give you the ability to write five different formats and will cost less that $1,000 to purchase all three!

One of the best aspects of offering any of these services is that you can forget having to pay photo labs to stay open during extra hours at night and weekends to deliver prints for a meeting and convention. Make the prints yourself on location using inexpensive snapshot printers that are available from companies like Fuji, Panasonic, or Fargo. You will save the dead time of waiting while your prints are made, save the expense of paying premium rates for the prints to be made, and make your client happy at the same time.

These are just a few ideas. You will undoubtedly be able to build on these, customize them to fit your studio's operation, and think of some new ones. The key aspect of offering digital services is to focus on the speed and convenience of digital offering and how you can best employ these characteristics with your client base.

The above outline provides some basic concepts on how to integrate several general classes for photo assignments into your studio's day-to-day operations. To get more specific, the rest of this chapter will take a look at a few simple bread-and-butter services that provide easy entry into digital imaging. Details about what kind of equipment is needed, along with some suggestions on operations and procedures, are also given.

The Digital Headshot

The business portrait is something that both portrait and commercial photographers offer. Many commercial photographers don't like to do them because they can't charge enough to make them profitable. Portrait photographers like doing business portraits because they inevitably lead to other assignments like family portraits or weddings, but they hate the rush aspect they typically entail. It doesn't fit the pace of their operations. Both kinds of photographers will find that doing business headshots using digital technology answers all their questions and solves all their problems. It's a win-win situation for both photographer and client.

Some people call them PR photos or mug shots, while other photographers offer their clients a "three- or four-pose sitting." No matter what you call business headshots in your studio, the goal is the same: a

simple, inexpensive portrait that can be used by business customers that doesn't cost much money to make or take too much time to shoot. All of these parameters, by the way, are not set by the photographer, they are established by the realities of the marketplace. Oh yeah, and by the way, these people are always in a hurry. Almost every photographer is involved in shooting headshots and because of the ever-present rush factor, it is a good place to introduce this service in digital form. Here's what you will need to get started:

Acquiring Images with a Digital Camera

As discussed in the previous two chapters, there are several forms of digital image acquisition, but the fastest is the digital camera. Since some photographers are already using conventional cameras and Polaroid materials for this service, this is an ideal situation for a digital solution. The least expensive camera, for this particular application, is a digital point-and-shoot model. The camera can be any brand, but needs to have two or three important features:

1. It should have a zoom lens so that you can have an image that is taken with a lens that approximates the classic 85mm (with 35mm format) focal length. The lenses on many cameras won't be a perfect match for the 85mm or 105mm, but will be close enough for this kind of work. Exceptions are Olympus's D-500L and D-600L models, which offer a zoom lens that covers the equivalent of 50–150mm. Since they are single-lens reflex "bridge" cameras, priced competitively with digital point-and-shoot cameras, they make an ideal "starter" camera for the studio going digital.

2. It should have a minimum resolution of 1,024 × 768 pixels or at least be in that ballpark. This level of resolution produces an image file size around 1.4 MB, so it can fit on a floppy disk, and will provide adequate resolution for the small-sized photographs typically run in newspapers.

3. (Optional) It should have some form of removable media so the camera can stay in the camera room and the image files can be transported to your computer by themselves. A camera like this will cost $800–$1,000 or sometimes a little more for a "bridge" camera.

For Picky Pixel People

Some digital camera CCD imagers use square pixels, and computers expect digital images to have square pixels. To keep costs down, the CCD chip in the Kodak DC120, for example, uses rectangular pixels and must convert them into square ones. Kodak admits the resultant image is slightly softer in the horizontal direction than an image captured with a CCD that uses a full 1,280 × 960 pixels but can be compensated for with an image-editing program like Adobe Photoshop. I found that applying a 75 percent "Unsharp Mask" filter in Adobe Photoshop worked great with uncompressed images. For more compressed images, Farace's rule of digital sharpness dictates that lesser amounts of unsharp masking be applied as the image size and resolution decrease. A company called Camera Bits (*www.camerabits.com*) makes a Photoshop-compatible plug-in called the Quantum Mechanic, which is designed to improve the quality of images created by professional digital field cameras, such as those in Kodak's DCS series. The company has promised a "lite" version for inexpensive digital cameras but, as I write this, it is not yet available.

Optimizing Image Quality

An often overlooked element of the quickie portrait setup is great lighting. Sure, you can just throw flat lighting at your subjects and they will be happy, but taking the time to create great lighting will make your digital portraits more impressive and, more importantly, more salable. This is where one of the advantages of digital cameras comes into play: It will cost you nothing to experiment! You can fill your camera up with images and it won't cost you a dime extra. There is no expensive Polaroid film, no conventional film costs, and best of all, no lab expense. Take the time to practice with your new camera to create dynamic headshot lighting.

Few inexpensive point-and-shoot cameras will have a PC connection, although some of the more expensive models (and all field cameras) may offer a hot shoe. For cameras with hot shoes, there are hot shoe-to-PC cables available from places like Porter's Camera Store. If the camera you selected does not have a PC connection, it will no doubt have a built-in flash. Cut a neutral density (ND) gel filter to size and tape it over the built-in flash. This will put out enough light to trip a slave that is connected to your existing lighting system.

To produce the best results, select the highest-quality image resolution that your camera is capable of. Usually this involves using a

setting that provides the least amount of compression—even no compression—the camera can produce. The downside of this practice is that you will get the fewest number of images, maybe as few as ten, that the camera is capable of. But you need to be able to wring every ounce of quality the camera is capable of, and not many PR sittings require more than ten shots.

You'll Need a Printer

The choice of printers used for this application will be dictated by your budget. Your best option will be to use a dye-sublimation printer. Often called just "dye-sub" or, more correctly, "thermal dye transfer," this type of printer uses a printing head that heats a dye ribbon, creating a gas that hardens onto special paper. The more heat applied, the denser the color and the image on the paper. Like most printers it does this as "dots" of color, but because these spots are soft-edged—instead of the hard edges created by laser and inkjet printers—the result is smooth, continuous tones. This makes dye-sub printers work especially well with photographs; even 300 dpi, dye-sub output can be more impressive than output from higher resolution devices.

If you plan to keep the print size small, consider a snapshot-sized (4 × 6 inch) dye-sublimation printer, such as those from Fargo Electronics, Panasonic, and Fuji. These printers produce photo-quality output that the person receiving them—either your client or the person he hands them too—won't be able to tell from a "real" photograph. The Fargo FotoFun! snapshot-sized dye-sublimation printer, like some larger Kodak and Sony printers, provides a UV coating that protects against handling.

TIP: Digital Passport Shots

One advantage of the snapshot-sized printer is the potential of using it—and your digital camera setup—to produce digital passport photos. Some photographers I spoke with during the creation of this book are using the Fargo FotoFun! for this application. Occasionally, customs officials reject digital passport photos because they are unfamiliar with them. One enterprising photographer told me he solved the problem by creating a template in a desktop-publishing program like Adobe Photoshop that looked like the two-up photos created by instant passport cameras.

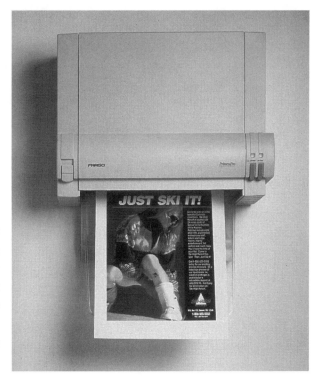

Figure 10. The Fargo
PrimeraPro Elite is a
dye-sublimation printer
capable of producing
8½ × 11 prints or A4
(European)-sized prints.
(Photo courtesy of Fargo
Electronics)

Inkjet is the most popular technology used in color printers. The reasons for this popularity are simple: low price and high quality. In an inkjet printer, a print head sprays one or more colors of ink onto paper to produce output, and the type of methods used to accomplish this affects output quality. Piezoelectric technology is based on the property of crystals to oscillate when subjected to electrical voltage. In Epson's Stylus Color family, mechanical vibration is used to place uniform ink droplets on the paper. This feature allows Epson's printers to deliver output at up to 720 dpi. Another approach is the drop-on-demand method. This method uses a set of independently controlled injection chambers—the newest models use solid ink that liquefies when heated and solidifies when it hits paper. This thermal approach is favored by Canon, Apple, and Hewlett-Packard for their inkjet printers. Another method is the continuous-stream method, which produces droplets that are aimed onto the paper by electric field deflectors. The weak link of all inkjet printers, large or small format, is fading from UV radiation and susceptibility to water damage. These

limitations can be overcome by laminating the finished print. The water-fastness of inkjet-printer output continues to improve, and the quality approximates dye-sublimation output. One recent comparison test I made of a $2,000 dye-sublimation printer and a $500 inkjet printer found the less expensive printer produced results better than the higher-priced model. All the people I showed the prints to preferred the inkjet results.

Most inexpensive inkjet printers output images up to standard letter size, with the possibility of larger output. For the headshot applications, both Kodak and Epson offer 4 × 6-inch inkjet paper. The Epson especially can create an image that is indistinguishable from a silver-based photograph. The inkjet printer is more a multipurpose tool and can be used to print everything from mailing labels to letters.

Digital Test Prints

The best way to make any purchase decision about a printer is to make a test print in the store. You'll have to bring your own because the test images computer stores typically use for demonstrations are designed for tire kickers, not serious buyers like yourself. When it's time to buy a printer, go to your favorite computer store armed with your own test image created by your new digital camera. (This is another reason to shoot some tests to improve your headshot lighting. The resulting images make a test image to find the printer you are looking for.) Copy the image onto a floppy disk, and ask to see your image output on several different printers.

Pricing the Service

The next question you might have is, How much are you going to charge for this service? Pricing digital services calls for a cautious approach. Clearly, there should be a premium for quick delivery of products like this, but it shouldn't be too much higher than your current rates. Why? Because your competition will be able to offer 4 × 5 Polaroid prints just as quickly as your digital services. What they won't be able to offer is fast delivery of multiple prints from the same pose. Here are my recommendations for implementing the system and determining the price:

- Test the system by using "friends of the studio" to get all the kinks out of your internal procedures for shooting and delivering digital prints in a smooth and fast manner. After you have the lighting nailed down, invite a client with whom you are friendly for a complimentary sitting. Create a nice headshot and give her a free 4 × 5 or 5 × 7 digital print. Ask her to show it to her friends. This will create some buzz about your new service.
- When you think you are ready for prime time, post some signs around the studio—or in your window—offering the digital service at the same price as your existing headshot product. Get some gradual experience with "real" customers. Take the time to ask these customers what they like and don't like about the process—these people are going to be your focus group. Use that experience to further refine your operating procedures.
- Launch the product. Send a mailing to your existing customer database, purchase a list of potential clients, and alert the local media about what you are doing. Offer a free headshot to a local celebrity. In short, do all the things that you would do when offering any new photographic service. If you don't have any fresh ideas, consult that most famous of public relations resources, *Paul Castle's Promotional Portrait Photography* or any of Don Feltner's business and marketing books, all of which are available from Studio Press.

At this point, the pricing of the service would still be at the original levels "for a limited time." This offer allows you to refine the cost of the service based on real-world experience. If you find you need to raise your prices (you may not have to), do it in 5 percent increments so you don't give your clients sticker shock.

Digital Delivery

The above pricing scheme is based on delivery of paper prints—either dye-sublimation or inkjet. Sooner than you think, some of you are going to get requests from clients for an all-digital delivery. They may want to use the image on a Web site or send it to a publication that will accept digital images. I can hear readers now: But you're giving them the negative. Technically, you will be delivering a "duplicate" of

the original image, but the point is well taken that the clients will have an image that they could make reproductions with. Pricing for this service should be based on something higher than the average amount of money that you make delivering prints. My philosophy of pricing any service—digital or not—is to keep gradually raising prices until you have slight price resistance; i.e., an occasional customer purchases the service but grumbles a bit about the cost. An even better way is to create a spreadsheet that looks at the actual cost of delivering the product. Here's what might be included in a typical cost analysis:

1. *Amortization of any new equipment.* This includes digital cameras, printers, computers, or upgrades to existing computers. You should also examine the tax benefits of purchasing new equipment—especially using them as 179 class (100 percent write-off) depreciation. I am not an accountant or lawyer—and don't even play one on TV—so you should consult with one. I think you should look for a quick payoff in two years or less for the equipment.

TIP: Accounting for the Small Studio

If you have a small mom-and-pop studio and are not currently producing tax forms using your computer, I recommend that you take a look at it. Programs like MacInTax and TurboTax are inexpensive and easy to use. One of the biggest benefits is that the companies ship early versions of the program in the fall of the year so you can take a preliminary look at your taxes then. That way you can see for yourself any tax advantage of purchasing equipment before the end of the year and using the 179 depreciation deduction.

If you think it's difficult to do your own taxes with a computer, purchase a copy of one of the above-mentioned programs and do your taxes. Take the completed forms— the programs print out official IRS forms—to your accountant and ask him to check them. If there are no problems, start using the computer to do your basic tax work and save your accountant's time (and his bills) for work on important questions.

2. *The cost of digital expendables.* While there is not as much expense in creating a digital image as there is in creating silver-based images, there are still some costs. You need to be able to break down the cost of producing a print to find the cost of sales for outputting a digital print. All printers require paper, but dye-

sub printers also require ribbons and inkjet printers require cartridges. The expendables cost for dye-sub printers is easy to figure out since the ribbons are designed to produce a certain amount of prints. Inkjets are a little trickier to calculate since the amount of ink consumed depends on the kinds of images printed. I asked several printer companies if they had developed any "rules of thumb" about cartridge life, and this is a summary of what they told me: This is not a question that can be easily answered. Cartridge life depends on the size of the photo being printed, what kind of photos (images with more of one hue than another—such as a sunset—create another variable), and the resolution used to print them. On an empirical basis, one glamour photographer I spoke with—he does extensive printing of digital images for fine-art use—found he had to replace both color and black ink cartridges once a month.

3. *Costs of operations using silver-based methods.* If you haven't already calculated the cost of sales for each of your products and services, you may be in for a surprise. Some photographers base their prices on their competitors' rates and have no idea of what their real profit is. When I started my studio and photographed weddings, I used a spreadsheet program to find my actual cost of sales and discovered that each wedding that I photographed cost me $50 more than I was getting paid. A classic example of bad recordkeeping is Pentacon, a camera company located in the former East Germany. When the two Germanys were united and studies were done on privatization of various formerly East German industries, the government found it cost Pentacon $665 to make a camera it sold for $195. Nobody stays in business long with this kind of pricing.

Use any spreadsheet program—or just a pencil and paper—to calculate the cost of operations using silver-based or digital operations. One of the advantages of using a spreadsheet program, like Microsoft Excel, is that once you have created the document, it is easy to update. I think that it is important to update the cost of your sales each year and adjust your price structure accordingly.

Web-Ready Images

One of the ways around the "selling the negative" question is to offer a package that includes prints and a disk with an image formatted for use on the World Wide Web. This provides a marketing opportunity as well and lets your customers know that you are ready to provide twenty-first century services. Many real-estate companies have Web sites. By offering Web-ready headshots, you can save your clients the expense of having scans made from conventional prints. At 72 dpi, a digital image is useful for on-screen use only and represents no threat to future print sales. Moreover, making an image for the Web is fast and easy and can be delivered on a floppy disk. Let me show you how to do it using Adobe Photoshop; the process will be similar with other image-editing programs:

- Step 1: After creating the portrait, acquire the image using Adobe Photoshop's "Import" or "Open" commands.
- Step 2: Use Photoshop's "Image Size" command to reduce the image to approximately 2 × 3 inches. This size is close to wallet-sized images, big enough for any Web site.
- Step 3: Select GIF89a from the Export menu to save the image as a Web-ready GIF file.

Promotional Digital Photography

One question I'm often asked by portrait photographers is, That digital stuff may be interesting but what can I use it for in my studio? For those of you who have wanted to try basic digital imaging and didn't want to make a major investment, this is one way to get started.

Digital Field Assignment: Corporate Christmas Party

Here's the premise: there are many kinds of event photography that only require the delivery of small color prints. It can be a company golf tournament, awards presentation at an annual meeting, or just "couples" photographs at the company Christmas party. In the past, if a photographer needed to produce prints on-site, the only choice was instant processing film. The problems with this method are that film is expensive and you are left without a negative to make multiple prints and, more importantly, multiple sales. The only other choice was to

Figure 11. By using Adobe Photoshop, the author produced a GIF file of a headshot that was only 200k in size. Perfect for the World Wide Web, useless for anything else. (Photo © Mary Farace)

shoot conventional film and wait for the film to be processed. This provides you with a negative, but isn't instant and usually involves rush charges from the photo lab and lots of windshield time. My suggestion is to photograph the event digitally. The tools required for promotional digital photography are simple and relatively inexpensive. All you need is a digital camera, a laptop computer, and a printer. Here is my suggested work kit that can be customized to fit your specific operation.

The Camera

Let's start with a camera. You might want to consider Kodak's DC120 autofocus camera. At less than $1,000, it delivers 24-bit images at a resolution of 1,280 × 960 pixels. Depending on the amount of compression used, the DC120 can store anywhere from two to twenty 1,280 × 960-pixel images in 2 MB of internal memory. Photographers

interested in the best quality will want to use the uncompressed mode, which delivers only two photographs. Images made in the least compressed mode (now you are up to seven shots) will not be disappointing. This uncompressed resolution is the best of the available choices the camera offers and one that you should use for your promotional photography. The DC120 has a built-in flash and a 3× zoom lens that's the equivalent of 39–114mm on a 35mm camera. The infrared autofocus gives a choice of multispot, center-spot, or close-up. The camera has an easy-to-read LCD panel on its back and a tripod socket. In addition to the 1 MB of internal storage, the DC120 includes a slot for removable 10 MB CompactFlash cards that permit the creation of larger numbers of higher resolution images. How many? Using a 10 MB CompactFlash memory card gives you a total of twelve uncompressed images—the same number possible with an A12 back on a Hasselblad camera—or up to 105 compressed ones. A 2 MB card is also available, Using a CompactFlash "Picture Card" with the DC120 allows photographers to treat the card like digital film. Kodak bundles an adapter that allows the Picture Card to be used in any laptop computer that accepts PC cards or a desktop reader.

TIP: The LCD Advantage

The Kodak DC120, like many digital cameras, sports a hinged (so you can get to the batteries) 1.6-inch color LCD video display. It even has a small brightness control located below the screen. The on-board display lets you preview images one at a time, four at a time, or nine at a time—although complex images get a little difficult to evaluate at that scale. Having an LCD preview screen lets you evaluate shots you just made and erase any that are not up to your standards. This is an oft-overlooked advantage of LCD panels on digital camera. They multiply the number of shots you can make. Depending on your shooting ratio (good shots to bad ones), you can triple or quadruple the number of shots that can be stored by just erasing the "outs" now rather than carrying them back to your computer,

The Printer

The Fargo FotoFun! is a snapshot-sized (4 × 6-inch) dye-sublimation printer that uses a three-color (cyan-magenta-yellow) ribbon plus a fourth section that applies a clear UV coating to protect against fingerprints and moisture. The printer is delivered with a thirty-six-print

ribbon and thirty-six sheets of paper. After you give the "Print" command, paper is manually fed in, one sheet at a time, when an on-screen message tells you when to insert it. Print time takes just a minute or two, and output quality from this 203 dpi printer is impressive. This printer can be connected to a laptop computer that will take the PC card adapter.

In addition to 4 × 6-inch images, you can print two 2 × 3-inch wallet-sized photos on the same sheet of paper. Fargo offers an optional photo postcard kit ($39.95 for thirty-six prints) that uses a heavier weight media preprinted with address and postage indictors on the nonimage side. An optional FotoMug kit ($29.95) includes four mugs and a tool that allows users to transfer images onto the mug's surface that are permanent and dishwasher-safe. The FotoFun! costs less than $400.

The Shoot

Here's how it might work—to light your subjects you can either use the DC120's built-in flash or have it trip an optical slave plugged into any professional lighting package. If you use the latter approach, you might want to tape a piece of ND gel filter in front of the built-in flash to minimize its effects. As with any lighting system—digital or nondigital—make sure to do tests using the same setup you plan to use when it's "showtime."

At an appropriate point in the action once shooting begins, remove the CompactFlash card from the camera and pass it to your assistant using the laptop computer and Fargo printer. If this event involves sales of prints to the attendees (as compared with the total cost being paid for by the client or sponsor), the card should be accompanied by carbon copies of a print order along with the exposure number (from the camera's back) written on it. This will help your assistant keep the photographs in order. You can then insert your second CompactFlash card in the camera and keep working. Your assistant copies the image files onto the hard disk and renames them with the customer's name or order number. If more than one pose is ordered, a number can be added after the file name. When that's done, your assistant is ready to make the prints. When the print rolls out of the FotoFun!, the assistant can insert the print into the folder, key chain, or whatever promotional item you are using and hand it to the customer.

In addition to providing a digital "negative" that can produce additional prints from the original image, your file can make prints in different sizes. Using an image enhancement program, photographs can be resized, or you can create a template with your favorite page layout software to print two wallet-sized images on a singe 4 × 6-inch sheet. Having the ability to create prints in any size gives you access to promotional items including everything from key chains to flower pots that are produced by companies like Neil Enterprises.

If you have experience in promotional photography, you probably already have procedures already in place for these activities. If not, use these ideas as a starting point and try an in-studio or on-location promotion. Make sure to test procedures and equipment under controlled conditions before trying them at a dance or a Valentine's Day event. You might want to start with an in-studio promotion for Mother's or Father's Day that lets your customers take prints with them to give as gifts.

I chose these particular products for this example because they represent the lowest cost for getting involved with promotional digital photography. Hardware is a constantly moving target, so the products mentioned are just an example. This procedure will work with any digital camera that uses CompactFlash or PC cards. For example, you can also use the Olympus D-500L. It's similarly priced, delivers high-resolution images, and has the advantage of being an SLR. For output, any photorealistic printer that can be connected to a laptop computer will work in this application.

Image Management

No matter which file format you save your graphic in, the person you give it to will want something different.

—*Murphy's Law of Graphics*

To be useful, digital images—like film-based photographs—need to be stored and retrieved. The ease with which you can accomplish the storage and retrieval process functions will have a large effect on your studio's productivity. In this chapter, I will introduce you to the digital equivalents of a lightbox and 3 × 5-inch file cards. Before I do that, I want to make you aware of a problem that faces all digital imagers: being able to capture and deliver images in the exact file format that the client requires. You can always capture the image in a format that fits whatever method of image acquisition you may be working with; the key to success, however, is being able to deliver the image in a format that the client can use. To do that, you need the right file translation software—plus a few useful utilities. Let's start there.

File Translation

Regardless of whether you're working on a Mac or a PC, sooner or later there will come a day when someone will hand you a disk—or removable-media cartridge—containing files designed for the other computer system. The same process will happen just as often in reverse, when a client asks you to submit a graphics file in a format for a platform other than the one you are currently working on. It could also be a file format for the platform you are using, but made for software you don't have installed. If you have the right tools, dealing with incompatible file formats doesn't have to cause you any distress. As you will soon discover, translating graphic file formats and moving files back and forth between Mac OS and Windows platforms is a lot easier than you might think.

Graphics and digital photographs come in an often bewildering variety of file types. You will find them saved as PICT, TIFF, BMP, PCX, and PCD, along with some file types unique to Windows, DOS, or the Mac OS. Understanding what a particular file format's acronym means can take some of the stress out of the conversion process. A sidebar shows some common graphic file acronyms and may help you understand some of the buzzwords used in this section.

Kodak's Photo CD file format is the closest thing yet to a Rosetta stone for image interchangeability—although FlashPix may be poised to replace it. All the image files stored on a Photo CD disc can be read by any Mac OS or Windows program that's compatible with the PCD format. Even the disc itself is compatible with both platforms, but life is never that simple. Every time a hardware product or graphics software package is announced, the publisher feels obligated to create a new file format. When Apple Computer introduced its original QuickTake digital camera, it also announced a brand-new graphics file format just for the camera. Compounding the file conversion process is the fact that not all software programs write an existing file format in exactly the same way, producing variations or "flavors" of the so-called standard. For example, there are at least thirty-two variations of the TIFF format alone. Adobe Photoshop is as close to a universal graphics file conversion program as there is, but when you run across a file you cannot open, it's time to reach for specialized file translation software.

Reading Foreign Disks (or Discs)

When moving graphic files back and forth between Mac OS and Windows computers, the first tool you will need is software that allows your computer to read (or mount) disks formatted for the "other" machine. Luckily, Mac OS users already have what they need. Apple Computer includes a control panel called PC Exchange with every recent issue of its operating system—including Mac OS 8. PC Exchange lets your Mac OS computer read 720 KB and 1.44 MB DOS-formatted disks as well as disks made for use on Apple II computers. More than that, PC Exchange also lets your Mac OS computer read ISO 9660 format CD-ROM discs and DOS-formatted cartridges used in removable-media drives, like Iomega's Zip and Jaz disks. As a control panel, PC Exchange can also be set to automatically open Windows files that have certain extensions with a user-assignable Mac OS application.

TIP: Disc or Disk?

The round, flat platters used in CD-ROM drives and read with laser technology are properly called *discs*. Magnetic media drives, on the other hand, use the same technology that both hard and floppy disks have used since they were originally introduced by IBM. This technology is often called "Winchester," after IBM's original hard disk that had two 30 MB discs. A disk is coated with magnetic material and a read/write head records the files or images onto this platter. On playback, the same kind of head reads the magnetically encoded data and displays the files on your monitor. These round objects are properly called *disks*.

On the Windows side of the disc/disk compatibility issue, DataViz's MacOpener 2.0 is the best utility of its kind that I have ever found for PC-compatible computers. MacOpener lets Window users use Mac OS floppy disks, CD-ROM discs, as well as removable-media cartridges, such as Zip, Bernoulli, Jaz, and SyQuest. The software does all this transparently, reading or writing to a Mac OS disk without encountering any annoying error messages. MacOpener is also compatible with the beta version of Windows 98 I have been running on my IBM "Stealth" computer. When working with cross-platform programs like Quark-XPress, Adobe PageMaker, and Adobe Photoshop, life has never been better or simpler. This is the best hundred bucks any Windows user interested in file conversion can spend.

File Conversion

Once you have the capability to read media from other computers, the next part of your translation quest involves using the proper file conversion software. Buy file translation software based on your needs. Are they average or heavy duty? If your file translation needs are only occasional, here's all the software you may ever need.

Mac OS users should be sure to get the latest version of DataViz's MacLinkPlus/Translators Pro. Do not confuse the latest version of the program with the "free" copy that is bundled with Mac OS 8 (that version is actually 9.0, an older version that can be upgraded for a modest price). Any OS 8 users reading this should upgrade so they can translate Office 97 files. (That's the biggest difference between the versions, and it's a big one.) The newest version of MacLinkPlus/Translators Pro is not just a Mac OS to Windows translation package. It will also translate Windows to Mac (that's where PC Exchange will come in handy) and Mac OS to Mac OS. In addition to converting graphics files, the package also translates word processing files. I use it all the time to translate both kinds of files for publications that require materials submitted in Windows format. The staff at one of these publications says I'm the only person they work with who supplies trouble-free Windows graphics files. They can't believe I create them on a Mac OS–compatible, but I do. DataViz claims the latest version of MacLinkPlus/Translators Pro supports more than 550 file translation combinations, and many of them are word processing, database, and spreadsheet formats. Using the Mac OS Easy Open feature, MacLinkPlus/Translators Pro makes "foreign" file formats double-clickable for launching. When you try to launch a file type that your computer doesn't recognize, you will see a dialog box asking what program you want to open it with. When you choose the appropriate application, Easy Open remembers that choice, so all you have to do is double-click the icon to open any similar files in the future.

For Windows computers, DataViz offers Conversion Plus, which contains thousands of file translation options and even includes MacOpener. The package also includes a copy of DataViz's e-ttachment Opener, a utility that solves problems that occur when you receive attached files as e-mail. This WYSIWYG utility lets you view and print almost any kind of file—even if you don't have the program that created it. One of my favorite general-purpose Windows-based programs for

graphic file translation is JASC's Paint Shop Pro. Recently the company introduced ImageRobot, a program designed specifically for file conversion. Actually, ImageRobot is more than just an image file-format translation program. It can also make color and palette adjustments, and apply filters and deformations to your graphics file. Best of all, you can collect a group of images that need tweaking and conversion and batch-process them at the same time. All processed images are written to a separate directory, leaving your original files untouched. The program also has a preview function that lets you test a specific command—or an entire script—before running the batch process.

When the file conversion process gets tough, I reach for DeBabelizer 3.0 for the Mac OS and DeBabelizer Pro for Windows. There is not a file type that I know of that either one these two programs cannot open and convert. DeBabelizer 3.0 opens more than seventy different kinds of graphics files and displays them within a large preview window in a somewhat dated-looking dialog box. When you have a group of files to convert, you can collect them into a batch and write a script to convert them as a group. If you are squeamish about doing your own scripting, don't be. The program's "Watch Me" command lets you go through the steps of converting a single file and automatically creates a script based on what you do. DeBabelizer 3.0 accepts Photoshop-compatible plug-ins, and the availability of these plug-ins provides another way of bringing images into the toolbox before retouching, enhancing, and saving in one of its many export formats. DeBabelizer is not really an image-editing program—its tool palette is too limited—but when used with third-party plug-ins such as MetaCreations's KPT Convolver, DeBabelizer provides endless opportunities for manipulation and correction. The program also includes a series of scripts that can be used to automatically process, filter, and color-adjust World Wide Web–oriented graphics. Output can be delivered as GIF or JPEG files that have an optimized color palette for speedier viewing.

Equilibrium offers a more contemporary-looking Windows version of the product called DeBabelizer Pro. It is designed for Windows 95, Windows NT 4.0, and worked just fine under the beta version of Windows 98 that I have been testing. The program translates more than ninety file formats for the Windows 95, NT, and Mac OS environments. It can also translate Silicon Graphics, Atari (no kidding), Sun Microsystems, UNIX, X Windows, and even Commodore Amiga

Figure 12. Equilibrium Technolo-
gies' DeBabelizer Pro is a file con-
version program that offers many
options for digital photographers.
(Photo © Joe Farace)

graphics file format. The first time you launch it, you will notice that
DeBabelizer Pro is a more sophisticated program than DeBabelizer 3.0.
The updated interface features dockable toolbar icons for every menu
command. It can also preview and open more than one image at a time—
something DeBabelizer 3.0 cannot do. DeBabelizer Pro can automat-
ically prepare images, animations, and digital video through
drag-and-drop scripting and perform batch processing, color palette re-
duction, image processing and file-format conversion. Both programs are
must-have for the person that is serious about graphics file conversion.

Conversion: Not Always Easy

All the programs I have mentioned easily handled the many different
graphics files I threw at them, but none of them is perfect. The last time
I counted, there were more than a hundred different graphics file formats
for DOS, Windows, and the Macintosh, and no single program translates
them all. Keep in mind that most Windows-based translation programs
are biased in favor of converting DOS and Windows formats, and the
same is true of Mac OS conversion programs. The only solution for
seemingly impossible file conversions may be to obtain the original
application in which the graphic was created and save the file in a more
"portable" format. As a last resort, you can take the file to a service
bureau, who, for a modest fee, may be able to convert it into a usable
format.

The reality of file conversion is that, like everything else in com-
puting, some file translations are easy and some are not. The best way

to increase your file translation skill is practice, practice, practice. When you get stuck, go back and make sure you understand the basic principles before trying to pound a square file onto a round disk.

If you are interested in creating graphics for the World Wide Web, you may have noticed that I have omitted some details of file conversions to the GIF and JPEG Web formats. If so, you are probably also concerned about creating files in the popular Interlaced GIF and Progressive JPEG formats. Don't panic, I haven't forgotten about you. This will be covered in chapter 10.

Graphics File Formats

When translating image files from one format to another, it sometimes helps to understand what their names mean.

- **Bitmap** Graphics files come in three classes: bitmap, metafile, and vector. A bitmapped (also known as raster) graphic is composed of a collection of tiny individual dots or pixels. The simplest bitmapped files are monochrome images composed of only black and white pixels.

- **CGM** (computer graphics metafile) This is a vector graphics format designed to be portable from one Windows or DOS-based program to another.

- **EPS, EPSF** (Encapsulated PostScript format) A metafile format for graphics that contains two elements: the bitmapped image and the PostScript code that tells your printer or output device how to print the image. This file type is designed to be imported into another application, such as a desktop-publishing program.

- **GIF** (graphics interchange format, pronounced like the peanut butter): Originally developed for CompuServe, it's completely platform independent. The same bitmapped file created on a Mac OS computer is readable by a Windows graphics program. A GIF file is automatically compressed, so it takes up less space on your hard disk. Not all programs read and write GIF files. Adobe Photoshop does, but considers GIF files to be "indexed color."

- **Indexed color** There are two kinds of indexed color images: those with a limited number of colors, and pseudocolor images. The number of colors of the first type is usually 256 or less, adequate for use on the World Wide Web. Pseudocolor images are grayscale images that display variations in gray levels in color rather than shades of gray, and are typically used for scientific and technical work.

- **Metafile** This file type accommodates vector and bitmapped data within the same file. While popular in the Windows environment, Apple's PICT format is also a metafile.

- **PCD** Photo CD

- **PCX** It's not an acronym—it doesn't mean anything. It's a bitmapped file format originally developed for PC Paintbrush. Most Windows and DOS graphics programs read and write PCX files.

- **PICT** Another meaningless acronym, this time for a metafile format. A PICT file contains both bitmap and vector information. PICT files are excellent for importing and printing black-and-white graphics, like logos. When used with continuous-tone images, sometimes they work and sometimes they don't.

- **PostScript** A programming language that defines the shapes in a file as outlines and interprets these outlines by mathematical formulae called Bézier (Bez-e-ay) curves. Any PostScript-compatible output device, whether it's a film recorder or laser printer, uses these definitions to reproduce the image on your computer screen.

- **Raster** See *Bitmap*

- **TIFF** (tagged image file format) A bitmapped file format originally developed by Microsoft and Aldus, a TIFF file (.TIF in Windows) can be any resolution from black-and-white up to 24-bit color. TIFFs are supposed to be platform-independent files, so files created on your Mac OS computer can (almost) always be read by a Windows graphics program.

- **Vector** A vector graphic is defined in terms of shapes. Each file is represented by a mathematical description of the shapes that comprise that image. These graphics are sometimes called *object-oriented*. This is the same technology PostScript fonts use and has the same advantages—you can make any image as big as you want and it will retain the same quality. Vector graphics are displayed as a bitmap on your monitor.

- **WMF** (Windows metafile format) A vector graphics format designed to be portable from one Windows-based program to another.

Storage Options

As the number of digital images you create begins to take a larger and larger portion of your studio's activities, you will be faced with a critical question: Where do I put all these images? The answer to this question is very similar to the dilemma you faced when the number of your negatives and transparencies started to grow. You need to develop a three-part plan of storage, cataloging, and retrieval. Those same functions are needed for storing your digital images.

The first part of the image management process concerns how you will store all of those digital images. No matter how big your hard disk is, it can only be considered temporary storage for digital images. Hard

disks are wonderful devices. They come in an ever-growing number of sizes and as capacities have increased, prices have decreased. But no matter how large a drive you purchase, all hard disks share a common fault: they are fixed drives. Some pundits think they are called "fixed" because they are mounted to the computer chassis, but I prefer to think of them as fixed because their size is fixed and will never get any larger. Sure, there are any number of compression software applications that theoretically increase hard disk size by shrinking the size of the files that are stored on it, but I've never been a fan of these products. All that compression and decompression is asking for problems—especially for graphics professionals that really use their computers. Enter the hard disk that never fills up: the removable-media drive.

Removable Media

Removable-media drives are computer peripherals that use data-storing cartridges that can be easily removed from the drive. These drives have many advantages for computer users—especially digital photographers. Sometimes called removable hard drives, they are more correctly called removable media, since the media being removed might just as well be optical as it is magnetic. People use removable-media drives for many different things: they can make backups of the data on their hard disks and, next to a modem, they're the cheapest way of transporting graphic data from point A to point B. Without removable media, digital photographers and designers wouldn't have a way to take large image files back and forth to their service bureaus. Placing financial data on removable media and locking it in a safe-deposit box provides a level of security even the most ardent hackers can't breach.

The performance of fixed or removable drives is measured by seek time or access time. Seek time is the amount of time required for the arm of a direct-access storage device to be positioned over the appropriate track. Access time is the interval between a call for data and the time at which the data delivery is complete. Some pundits are convinced that the only relevant measurement is sustained transfer rate, which measures the average number of bytes per unit of time passing between disk storage and processor storage. The truth is that a fast drive is usually just as fast no matter how you measure performance.

Magnetic Media

Magnetic-based drives (often called "Winchester") are typically based on the technology that IBM developed for the first hard disk that used two 30 MB discs. This design, using off-the-shelf hard disk components and housed in a proprietary plastic shell, was the basis for the original and wildly popular SyQuest drives. Winchester isn't the only hardware choice for magnetic media. An interesting magnetic alternative is the Bernoulli box. It uses the read/write heads found in a traditional hard disk, but instead of a rigid disk, the Bernoulli disk is flexible (it's made of material similar to what's inside a floppy disk), and at high speeds, bends to be close enough for the head to read it. During a power failure, a hard disk must retract its head to prevent a crash, whereas the Bernoulli floppy naturally bends away.

To me, the most important attributes a removable-media drive should have are small cartridge size (for ease of storage) and low per-cartridge cost. Access time, while important, is less so for most applications—especially for cold storage of graphic images. The current winner in the low-cost removable sweepstakes is Iomega's Zip drive. With a street price around $150, Iomega's Zip drive's Bernoulli design produces an average seek time of 29 ms. Its pocketable, preformatted cartridges scarcely larger than a floppy diskette are less expensive than SyQuest's. As I write this, the street price for a 100 MB cartridge is $19.95, compared to $60 for a 105 MB SyQuest. Bundled software for Mac and Windows includes backup, file cataloging, disk duplication, and management utilities that feature read/write disk locking, formatting, diagnostics, and hard-drive emulation. While the Zip is a new format, it has been widely embraced by service bureaus, printers, and the graphics industry. I have had two Zip drives (one for my IBM; the other for my Mac OS computer) in daily use for more than a year. During that time, the drives—and more importantly, the cartridges—have performed flawlessly and have not been plagued with the kind of data error problems I encountered with early 44 MB SyQuest cartridges.

Not to be outdone, SyQuest announced a similarly low-priced 135 MB removable drive called EZ135 that has an average seek time of 13.5 ms—twice as fast as Zip. The problem was that it was too little too late. Iomega countered by announcing the Jaz drive, a drive using 1 GB cartridges costing less than $500. These high-capacity cartridges use all-Winchester technology and cost around $100. These new cartridges are

Figure 13. The five-inch 200 MB SyQuest Drive reads 44 MB, 88 MB, and 200 MB cartridges. (Photo courtesy of SyQuest Corporation)

not compatible with SyQuest or Iomega's own Zip or Bernoulli drives. SyQuest's response—again a little late—was the 1.5 GB SyJet drive.

Lest you think SyQuest is not a player in the removable-media game anymore, the company is far from dead. It's still a player in the field because of one important fact: there are hundreds of thousands—maybe millions—of 5-inch SyQuest cartridges and drives still in use by artists, designers, and pixographers. Many of these are the original 44 MB format, which was replaced by the 88 MB drive, which in turn was supplanted by the 200 MB drive. The SyQuest 200 MB drive reads the other cartridge formats, and while its design is a little long in the tooth and slower than the now-discontinued, bullet proof, 3-inch 270 MB drive, it is nonetheless popular because it reads all the older 5-inch SyQuest cartridges floating around out there.

The Nomai Alternative

The Nomai 750.c 750 MB removable-media drive is as compact as a Zip drive, so comparisons with Zip and Jaz are inevitable. The 750.c is faster than Zip. Much faster.

Its 10 ms seek time is significantly faster than the Bernoulli-based Zip's 29 ms. The Jaz, whose Winchester-type construction is similar to Nomai's, performs at 12 ms—just a little slower than the 750.c. The cost per megabyte of storage is less than Jaz too: 12.5¢ versus 10.9¢ for Nomai. With a street price somewhere between a Zip and a Jaz, the Nomai drive and cartridges deliver slightly better price/performance.

Other than Panasonic's Phase Change Dual CD-ROM (PD) drive and SyQuest's 200 MB drive, few removable-media drives read and write cartridges in more than one format. Out in the real world, people are used to interchanging floppies and some are frustrated by the lack of removable media compatibility. Well, the Nomai 750.c is compatible. The 750.c accepts Nomai 750 MB and 540 MB cartridges, and two 750 MB carts are included in the package. The 750.c also accepts 135 MB cartridges designed for SyQuest EZ135 drives. The Nomai drive also reads and writes SyQuest 270 MB cartridges. You can use the 750 MB cartridges for data backup and offline storage, and save the inexpensive SyQuest 135 cartridges for delivering files to clients or service bureaus.

Real-world performance matched the specs. Access is accompanied by high-speed whirs and R2D2-like clicks that let you know the drive is working. When a cartridge is in the drive, a green LED lights. I thought that was a pretty cool feature until I realized that, because of the trapdoor, it's a necessity. I tried both SyQuest EZ135 and Nomai 750 cartridges, which are similar in shape but different in profile. Both types of cartridges seem less substantial than the more expensive media used by Zip and Jaz. The storage case in which the media comes is also less sturdy than Jaz and about the same as Zip. This is what you might expect from media that costs less than half of an Iomega Jaz cartridge. Durability is harder to test in a short-term test, but Nomai provides a five-year guarantee on its disks.

Magneto-Optical Media

Optical removable-media drives are more properly called magneto-optical (MO). A laser is used to heat a plastic disc and change its reflectivity, creating media that can be erased and reused. One of the negatives of optical drives is that writing data to optical media typically requires three spins. The first erases existing data, the second writes new data, and the third verifies the data is there. When compared to magnetic drives, all this spinning tends to reduce performance. Typical performance specifications for magneto-optical drives (based on a Fujitsu 230 MB unit) are seek times of 30 ms, access times of 40 ms and an average write transfer rate of 0.44 MB per second. On top of that, the

drives are more expensive than magnetic drives—although the media is less so. Unlike their magnetic competitors, manufacturers have standardized on 230 MB and 640 MB formats.

Until now, the only multiformat removable drive was the ill-fated 20 MB "floptical" drive that read its own special MO discs and conventional floppy discs. All that's changed with the Phase Change Dual CD-ROM (so-called PD) drives developed by Panasonic. The Clark Kent exterior of these drives hides the fact that they are a combination rewritable optical disc and quad-speed CD-ROM drive. The CD-ROM aspect of the drive differentiates between audio CD, CD-R (read only), CD-ROM XA, and multisession Kodak Photo CD discs. The capacity of the disc is not a puny 230 MB, but instead is a solid 650 MB. The writable optical disc uses phase-change dual technology instead of the magneto-optical technique. Under PD, disc writing is accomplished without the use of a bias magnet. Unlike traditional MO, phase-change technology is usually limited to about 100,000 write cycles—about one-tenth as many as magneto-optical. Panasonic's new media overcomes this liability by using a new alloy on the disc's recording layer and has been tested at 500,000 cycles. Improvements are expected to raise that to one million cycles. By combining two different functions in a single unit, Panasonic hopes users won't notice an average seek time of 165 ms for optical disc and 195 ms for CD-ROM. With a street price of $500–$600 depending on manufacturer (they all use the same Panasonic mechanism) and $59 per cartridge, the drives are competitively priced.

Recordable CD-ROM

The sleeper in the removable-media sweepstakes is compact disc recordable (CD-R). Drives and media keep getting less expensive and software keeps getting better. CD-R drives can be purchased for around $500 and media can be as low as eight bucks—for 650 MB. WORM (write once read many times) media doesn't behave like the other media covered in this book. Even mag tape can be erased, but not CD-R. With plunging drive costs and an interest in moderately priced, high-capacity media, CD-R drives are poised to become the next big thing.

A CD-R disc holds less than a 1 GB or new 2 GB Jaz cartridge, but the media costs significantly less. The difference in the cost of magnetic versus CD-R drives is insignificant, but each CD-R disc costs $2.50—

compared to $125 for a Jaz cartridge. This means a cost/megabyte for a 740 MB CD-R is .0033¢, while a 1 GB Jaz cartridge is 12.5¢. Even the new CD-R drives cost about the same as a Jaz drive. Great software such as Adaptec's Toast makes writing data to CD-R as simple as clicking and dragging. Writing a CD-R will take longer than writing magnetic media. A full 740 MB recording and verify—always use the verify option—can take an hour, but you don't have to fill up a disc at one time. Several sessions can be written to the same CD-R. Finally, since a CD-R disc can be read by anyone's computer, you don't need a special drive from Nomai, SyQuest, or Iomega.

CD-RW (rewritable) drives are expected to be the next big thing for computer users and especially for photographers. CD-RW may be the ideal format for photographers because they are, in essence, multiformat drives. You can read conventional CD-ROM discs, write CD-R discs, and write and erase data on CD-RW discs. CD-RW media's durability equals that of any CD, making it an ideal means for transporting files to a service bureau or storing digital images on a location shoot, when used with a portable CD-RW drive and notebook computer. CD-R and CD-RW media are interchangeable in most drives but CD-RW media is expensive, costing about $25 per disc. Less expensive CD-R discs can be used in a CD-RW drive for less than $4 per disc. Photographers simply choose what kind of media suits their needs: CD-R for archiving and sharing on discs that need to be played on existing CD-ROM drives, or CD-RW when creating CDs that can be rewritten up to 1,000 times and are read-compatible with MultiRead CD and DVD players. This gives you the option of using CD-RW discs for day-to-day image making and storage, but saving data to less expensive CD-R media for distribution or creating beta versions of digital stock disks as discussed in chapter 6.

TIP: Archiving Photos

Photographers concerned about the long-term storage of digital images will find that CD-R and CD-RW media make a good choice. CD-R discs have a hundred-year shelf life, and CD-RW discs can store images for up to thirty years.

Because CD-RW drives use a new directory structure and use lasers that have a different reflectivity, discs created with them will not be compatible with current-generation CD-ROM drives. The next generation—some of which are shipping now—of MultiRead CD-ROM drives will be able to read CD-RW discs, along with many other formats. Prices for CD-RW drives are expected to be competitive with CD-R drives.

CD-RW and CD-R media allow photographers to create or download large image files and transport them to and from the studio or service bureau. Hewlett-Packard's (HP) CD-RW media is an example of the type of discs that are compatible with any CD-RW drive. HPs discs, like CD-RW media from other manufacturers, are compatible with any CD-RW drive, as well as any other CD-R drive. The new 650 MB HP CD-RW discs, which employ phase-change recording technology that can be re-recorded up to 1,000 times per sector on a given disc, can be read by any CD-RW or MultiRead-compatible CD-ROM or DVD drive. HP CD-R discs also hold up to 650 MB and can be read by any standard CD-ROM player, CD-R or CD-RW drive, or by MultiRead-compatible DVD-ROM or RAM drives.

Hewlett-Packard is making sure that CD-RW is the next big thing with its introduction of a full-function CD-ReWritable drive that is as simple to use as a conventional floppy-disk drive, but has the qualities of a highly durable compact disc. The HP SureStore CD-Writer Plus drive provides photographers with up to 650 MB of rewritable, removable capacity, while retaining compatibility with the scores of millions of CDs in use today. The SureStore CD-Writer Plus has an IDE interface and installs without an adapter card; it simply plugs into a PC's standard hard-drive cable. The external version plugs into a PC's standard parallel port, which has a pass-through connector that allows the drive and a printer to be attached to the PC. Both versions are bundled as separate products with Live Picture custom software, which allows users to manipulate or enhance digitized photos. The best part of using the HP drive is the software that makes using the drive invisible. You can drag-and-drop or copy and save files to a CD-RW disc much as you would any magnetic media drive. In other words, you don't have to learn how to use the drive. If you already know how to copy and save files to a floppy disk, you already know how to use Hewlett-Packard's CD-RW drive.

As production of newly introduced CD-RW ramps up this year, analysts expect as many as 5.3 million CD-R and CD-RW drives to be shipping in 1998, five times more than in 1996. According to Strategic Marketing Decisions, a Los Gatos, California–based market-research firm, the worldwide market for CD-R and CD-RW discs is expected to jump from around 205 million units this year to nearly 350 million in 1998.

TIP: DVD Talk

DVD drives used for computers are called DVD-ROM, while writable drives and discs are called DVD-R. Erasable, rewritable DVD drives are named DVD-RAM. A single-sided, single-layer DVD-ROM can hold 4.7 GB. A single-sided, double-layer DVD-ROM can store 8.5 GB. A double-sided, double-layer DVD can hold 17 GB. Single-sided DVD-RAM discs hold 2.6 GB, and double-sided versions hold 5.2 GB. The first generation of DVD-

ROM products will be of the single-sided, single-layer variety. Initially, DVD-R drives are limited to 3.9 GB and are expected to be expensive.

Some pundits predict that DVD will replace the CD-ROM format. There's much to like about the new format—a 4.7 GB (that's *giga*bytes) capacity, for one. The success of CD-ROM was built on the runaway hit of CD audio. DVD has been slower to roll out. More importantly for pixographers, not all DVD-ROM drives support the Kodak Photo CD standard. The Toshiba drive used in the Diamond Multimedia and Hi-Val DVD upgrade kits is Photo CD compatible, but digital imagers should make sure the drive they are buying is compatible before buying them. Otherwise, compatibility with existing standards looks good. Just as consumer DVD players are compatible with existing CD technology, DVD-ROM drives are designed to play standard CD-ROM software. They will not, however, read CD-R and CD-RW discs. As I write this, these product announcements are overshadowed by dissension in the ranks. Sony, Hewlett-Packard, and Philips announced that they intend to develop DVD-RAM discs that can store 6 GB of data. Other members of the consortium, such as Matsushita and Hitachi, intend to produce 2.6 GB DVD-RAM discs. What computer users do not need at this time is another format war, but that appears to be exactly what we may get.

In the meantime, CD-ROM is not dead. This year, manufacturers expect to ship 66 million drives, not counting 2.2 million CD-R and CD-RW units. By comparison, the market for DVD-ROM drives is expected to be half a million this year. The speed race is not over in CD-ROM, either. The ongoing introduction of newer, faster models has dropped product life cycles to rival that of digital point-and-shoot cameras. Less than two years ago, 8x drives were considered fast, that quickly rose to 24x, and 32x is expected to be the norm by the end of the year.

As good as the DVD format may be, not every superior technology survives. Betamax videotape immediately comes to mind. While it has survived in a professional form, beta died in the consumer market. The same sad tale is being repeated with Sony's MiniDisc format. The MiniDisc is recordable and erasable, provides superior audio reproduction, but the way Sony has mismanaged its introduction and marketing rivals what it did with Betamax. This P. T. Barnum attitude did not sell Betamax, is killing MiniDisc, and may be the undoing of DVD. Both Music CD and CD-ROM were successes because they provided great value. DVD may survive as a computer format and as a niche market (replacing the laser videodiscs that cannot store a movie on a single disc), but may not survive the marketplace's apathy about yet another new digital format.

Magnetic Tape

For some reason, magnetic tape is more popular with Windows and DOS users than with Mac-heads, but that is changing as multigigabyte drives become less expensive and the thought of backing up huge hard drives sinks in. The cartridges come in many different designations: QIC (quarter inch cassette), XL (long) and QW (wide-long) models, and variations on these names. 3M's Travan technology is the latest iteration of the QIC tape format. It packs from 4 GB of uncompressed data up to 8 GB of software-compressed data onto a tape that costs less than $40. The .0045¢-per-megabyte cost is slightly higher than CD-R, but a single Travan tape can hold the contents of eleven CD-ROM discs. The variety of tape formats may not help acceptance and is further aggravated by the fact that data is stored in serial format, rather than the random method used by other removable media. When coupled with the inherently slower access time, magnetic tape has never gotten the respect it deserves. Tape has one major feature that will endear it to thrifty computer users—it is cheap and provides the lowest cost-per-megabyte storage of any removable media. This makes tape the ideal media for people who use their removable-media drives for backup or archival purposes. Mag tape drives are slow. That's why DAT (digital audiotape) drives are becoming popular for both Mac and Windows users. DAT tapes transfer data at rates up to 9.2 MB per minute and have reliability rates in excess of even the best hard drives.

Image Management Software

Now that you know what kind of media you will use to store your digital image files, the next step is to find software that will help you retrieve those images. A good image database (imagebase) program can be an invaluable tool in keeping a visual catalog of the images you are using for a desktop-publishing project, Web site, or presentation. Image database programs have several simple functions, and how they execute them is vital. First, they must read various graphics file formats and display the results as thumbnails. Second, they have to include a way to add keywords to the images and then search for the images that have those keywords. Third, a good imagebase includes a description field that lets you make notes about the image's format, where it's kept in the office, what kind of media it's stored on, copyright information—you

name it. As I finish this book, there are four major image database programs that are available. Recognizing that changes will occur during the life of this book, the following overviews are provided as a guide to the kind of features that a good image management program should have and how a particular company has implemented them. Here's a quick overview of the most popular image management programs.

Extensis Portfolio

Portfolio (previously known as Fetch) meets and exceeds all the above requirements. For recognizing and displaying different graphics file formats, Portfolio is one of the best imagebase programs I have tested. I threw all kinds of graphics files at the program and couldn't find one the program couldn't read and display. This performance may have been due to the fact that Portfolio includes fifty-three file translators, some of which allow it to create thumbnails for Windows-based files that don't already have this information embedded in them.

Portfolio is cross-platform and Extensis ships both versions in the same box. In case you're interested, Portfolio performed flawlessly on the beta version of Windows 98 that I am currently testing. All the catalog files the program creates are cross-platform too. Any catalog produced with the Mac OS or Windows version of the program can be read on the other platform. I tried it and it works. Extensis has created its own extension (.fdb) for Portfolio catalogs and automatically adds it to any file created in the Windows 95 or Mac OS environments. On the Mac OS version, Extensis goes so far as to include an apology for using the extension (I kid you not) by stating in the Open/Save dialog that the extension "is required for cross-platform compatibility." As a further blow to Mac OS user's egos, only the Windows version includes a toolbar containing buttons that give access to Portfolio's commonly used features. The toolbar also provides a gateway to Portfolio's QuickFind feature, which allows users to find items in a catalog without opening the Find window. Another difference surfaces in the Master Keyword palette that allows users to assign keywords to items in the catalog. The palette has a quick search box and is designed to float above a catalog, but is better integrated into the Windows interface than the Mac OS version—although that might just be my personal taste. No matter what it looks like, the Master Keyword palette works great.

Figure 14. Extensis Portfolio—the Windows version is shown here— is one of the best image database programs available. (Photos © Joe Farace)

Portfolio is multiuser, something that is an extra cost option for imagebase managers like Cumulus. Multiple users can also access and edit a shared catalog over a network at the same time. Four access levels add security to your catalogs. The Administrator controls which users can make changes, add or remove items, or modify keywords and custom fields. Custom fields, in case you're wondering, let you specify additional information about each image, such as artist or photographer, publication date, or catalog number. This is where Portfolio hits a home run with my third imagebase criteria.

Portfolio lets you customize background color, text color, and even thumbnail size. It won't win a beauty contest against Digital Arts and Sciences' ImageAXS and ImageAXS Pro, but beats the other competition hands down. Unlike previous versions of Fetch, Portfolio includes a "Rotate" command that lets you rotate Photo CD images ninety degrees clockwise or counterclockwise. This is a feature Imspace Systems has included with Kudo Image Browser since version 1.0. Why is this important? With the exception of Cumulus, other imagebase programs load Photo CD images in landscape mode—even those with a portrait orientation. A "Rotate" command makes it possible to have all the images in a catalog right-side up. With a list price under a hundred bucks, Portfolio is the best deal in imagebase software available. A sixty-day, fully working demo can be downloaded from Extensis Web site at *www.extensis.com.*

ImageAXS and ImageAXS Pro

Digital Arts and Sciences currently produces two versions: ImageAXS for the Macintosh and ImageAXS Pro for Windows 95. Eschewing Portfolio's lightbox look, ImageAXS uses a dark gray background to surround the image, making it pop off the screen. This makes both versions of ImageAXS the hands-down winner for the coolest interface.

ImageAXS catalogs, retrieves, and displays digital content, including still images, video clips, and audio files. To add images to a collection, you simply drag the file, folder, or volume over the ImageAXS icon. Thumbnails are user-definable, and you can use an 8-bit system palette, 8-bit grayscale, or 24-bit compressed and uncompressed. You can also modify an image by launching your favorite photo-manipulation program from within the program. ImageAXS read and displayed seven of the sixteen different kinds of files I tried. It refused to read anything but TIFF files. The ten-image test version from the company's Web site had the same problems. The program uses what it calls "smart" keywords for electronic cataloging that consists of seven user-definable alphanumeric fields, a 32,000-character text field, and a dozen file information fields. Each collection or catalog can contain more than 16,000 records, and the display size of all the views can be adjusted by the user. The original files can be stored anywhere on your local drive, removable media, CD-ROMs, or on remote volumes, like servers or networked drives. A disk icon in thumbnail view indicates whether the source image file is on- or offline.

ImageAXS Pro is designed for the professional who wants to publish a catalog of images on a CD-ROM or World Wide Web, make portfolios, or catalog photographs downloaded from a digital camera. You can choose among three thumbnail sizes, and the caption can be any one of your cataloged fields. You can compress the thumbnails, but even a mild compression factor seemed to soften the image's appearance too much. The default background color is the cool AXS dark gray, but you can choose any Windows-based appearance. You can have more than a hundred data fields, including text, number, date, and Boolean. A Description field lets you store from 64 KB to 4 MB worth of data. ImageAXS Pro lets you create subsets of records through drag-and-drop into custom folders—and you can sort these records, making it a great way to organize images for presentations. The 32-bit version includes

two additional features. The e-ZCard Export feature lets you share electronic albums combining images and two fields of text data as a self-extracting file that fits on a floppy disk. ImageAXS Pro's HTML capabilities include a Wizard to let you create Web pages.

Cumulus Desktop

Cumulus Desktop is the single-user version of Cumulus, Canto Software's professional image-management program. The program is available in standard or Plus versions. The interface combines the lightbox look of Fetch with the gray windows of Kudo Image Browser, in this case keeping text and buttons on a gray panel on the left of the screen. Three thumbnail sizes are available: 96 × 96 pixels, 128 × 128 pixels, and 192 × 192 pixels; A JPEG compression algorithm is used for better image quality and reduced record size. Supported file formats include TIFF, PICT, JPEG, GIF, EPS, QuickDraw 3D, Photoshop, QuickTime, Photo CD, AIFF, PageMaker, QuarkXPress, FreeHand, and FrameMaker. The program offers multilevel Boolean search, fast retrieval speed, and well-executed integration with desktop-publishing applications including Adobe Photoshop, PageMaker, QuarkXPress, FrameMaker, and Live Picture. With proof of registration, Kodak Shoebox users can upgrade to Cumulus Desktop. Canto has created a conversion utility that allows former Shoebox users to transform their catalogs into Cumulus format.

Cumulus Desktop Plus is designed for professionals who create, output, and distribute digital images and documents. Cumulus Desktop Plus tied with Fetch for reading and displaying fifteen of the sixteen test images. Like Fetch, it choked on the e-mailed CMYK file. Desktop Plus is AppleScript-able to automate workflow. One of the coolest ways it does this is with Vento, a bundled folder-watching utility. Vento watches a folder or nested folder that resides on a local Macintosh volume. If any files are added, changed, or deleted from the folder, Vento triggers an AppleScript updating the related Cumulus catalog. The same script can be modified to perform other tasks and control other applications, like Claris FileMaker Pro. Cumulus Desktop Plus also includes a royalty-free browser and the Cumulus Internet Image Server for distribution of media catalogs. A copy of the Shoebox conversion utility is included on the CD-ROM.

Kudo Image Browser

Imspace System's Kudo Image Browser organizes and manages your image, movie, and sound collections. At press time, the latest version was the first that ran PowerMac native; it provided a substantial boost in speed and performance. Using drag-and-drop, Kudo Image Browser automatically converts digital image collections into thumbnail image catalogs. Thumbnails are stored in a catalog, leaving the original image file untouched. The interface uses attractive gray frames that set off the images well. Kudo automatically adds additional information about each image file, such as name location, path, size, and type. The program also allows you to annotate additional textual descriptions and keywords to the thumbnail record. Kudo Image Browser supports most Macintosh and Windows image file formats, including PICT, TIFF, EPSF, JPEG, QuickTime, and SND. It also catalogs several proprietary formats, including Scitex CT, Adobe Photoshop, Kodak Photo CD, Macromedia FreeHand, and CompuServe GIF, along with thirty-five PC-based formats, including BMP and PCX. Kudo Image Browser read twelve of the sixteen images in my test folder. It choked on four Photo CD images that had been copied from stock image discs onto my hard disk for the test. It did not just refuse to accept the images, it crashed my system. This was strange because Kudo Image Browser has no problem reading images from a "real" Kodak Photo CD disc. The package includes "Place Modules," which enables you to drag-and-place images from a Kudo catalog directly into QuarkXPress, Adobe PageMaker, Premiere, Illustrator, Fractal Design Painter, and Macromedia FreeHand documents. The program includes scripts that automate repetitive tasks such as printing an entire image collection, 35mm slide labels with images, background, and automatic folder management.

Marketing and Management

Better management usually means paperwork, and most photographers would rather be clicking their shutters than filling out forms. Using a computer to produce and complete these forms means that they can be filed, easily accessed, and easily updated when necessary. Professional photography is as much about the creation of income as it is about the creation of art. Photographers must have the ability to produce salable, creative images and, at the same time, the ability to successfully manage the business associated with creating those images. Both skills—creativity and management ability—must be present or the studio will fail.

5

Better Management

Before you can integrate a computer into your studio's operation, you need to establish policies and practices that build a firm foundation for profitable growth. The real secret of any successful photography studio is the establishment of policies that guarantee profitability. The right policies and forms can protect your profitability and help your studio grow. Here are ten policies that will help ensure profitability no matter what kind of studio—portrait or commercial—you operate.

Ten Ways to Increase Profitability

1. Adopt a pricing/packaging policy that ensures you will make money. This seems obvious, but too often new photographers will set their prices based on what their competitors charge, without

an analysis of overhead costs and profitability. For commercial assignments, base all estimates and invoices on a time and materials basis. Business customers understand this method and instead of hoping they'll spend money on reorders, it guarantees you'll make a profit on the job based on the amount of shooting time you spend on it.

2. Think of each different photographic endeavor as a separate "product line." For portrait studios, this would be weddings, family portraits, high school seniors, etc. You get the picture. For commercial photographers, this might include stock photography, advertising work, and business headshots. It's important that every product line in your studio carry its own weight. If you make less money on one product line and the volume of that activity increases, it can create cash-flow problems for you. One way to make sure your studio is operating at profitable levels is to calculate the "cost of sales" for each product line you offer and maintain monthly, even weekly, profit-and-loss statements.

3. People always ask me how to establish their shooting rates and when and how much they should raise them. I always tell them to gradually raise their prices until they get some price resistance . . . then stop. That's when they've reached their market level. For beginning photographers who are unsure of where to start with pricing, one of the best digital sources of information about rates is Cradoc's FotoQuote. This regularly updated Mac OS and Windows software provides a range of rates for photography assignments for advertising, editorial, and corporate assignments. There's even a section on pricing for use on the World Wide Web. FotoQuote can help keep a more established studio's rates up-to-date. That's why it's also important that you maintain an up-to-date Rate Sheet and Schedule of Costs. Another approach is found in PhotoByte, one of the best studio-management programs available for commercial photographers. The program features a fee calculator that helps you find out how much you need to charge to produce a desired annual salary.

4. Most of your work will come to you over the telephone, that's why being able to quote prices quickly and easily is important. I think it's a good idea to keep all your studio's forms and product information in a binder next to the telephone so that anyone

answering it can quote prices and state studio policies to potential clients. Produce an Operations Manual for your studio that anyone can use.

5. Here's one rule you should never forget: Every exception you make to one of your policies costs you money. When someone tells you "give me a deal on this one shoot, and I'll throw a lot of work to you in the future," don't do it. You will be sorely tempted by some juicy assignments, and your resolve will weaken to the point that you'll do anything to get the job. If you're impatient, here's the short version: in our studio, we explain that our policy is to reward old clients for continued patronage, but all new clients go "by the book." This is one of the biggest reasons you need studio policies.

6. Don't begin any assignment without a written agreement specifying what you're going to do and what the client is going to do, including method and timeliness of payment. Every photographer I know who has had major problems, including landmark copyright cases, found themselves in deep doo-doo because they neglected to have any kind of written documents.

7. Get advance payments for all your work involving on-location photography. On commercial assignments, we get 50 percent on or before the day of the shoot. I think wedding photographers should collect 100 percent of the amount due before the big day. More often than not, once the loving couple returns home from their honeymoon, they're broke. Getting paid in full ensures you'll get them to come in to pick up their proofs and make a final order. You may also want to establish a policy that in cases of cancellation "so many days" before the event, the deposit will be kept for liquidated damages. This is true of any kind of location shoot from weddings to bar mitzvahs, parties—you name it. Be sure to establish a policy on collections and follow it consistently.

8. Do not accept third-party billing. Don't sign an agreement with anyone other than the party for whom the work is being done— unless you can bill that party directly. Some photographic consultants may tell you it's OK to wait 120 days to get paid, but my banker disagrees vigorously. If you're willing to live with that kind of payment schedule, so be it, but you should be charging a high enough rate to cover the time value of the money you're

waiting for. Once armed with that information, the final decision is yours.

9. The most powerful word in advertising is "new." Make sure there's always something new going on in your studio. Build a reputation as an innovative studio by experimenting with new, digital ways of doing things, and when you do—tell everybody about it.

10. Be an original; don't be like everybody else. When that happens, it reduces your photographic services to the commodity level, and all commodity purchases are based on price alone. All studios are different, and it's important that you express this difference to potential clients.

Studio Management Software

Some computer users find that Lotus Smart Suite may be all the business software they need, while others discover that having business programs makes them more productive and improves the company's profitability. In the past, many business programs were add-ons to existing word-processing and spreadsheet software, but a new generation of stand-alone programs built on that model can help with your business planning, accounting, and marketing.

The right studio-management software can be an invaluable aid to save time and increase productivity. A good program will let you replace shoeboxes full of receipts and three-ring binders that you can never find when a client is on the phone, but it is not a panacea. Even the best package won't correct poor internal practices or inconsistent handling of client and supplier paperwork. This is why the first requirement for increasing studio productivity is a commitment to running the studio more efficiently. When you have reached that point, you're ready to go shopping for software that will help you operate even better.

Shopping Techniques

There are many different studio management programs available for both Mac OS and Windows platforms. Some of the companies that produce software specifically for photographers are listed later in this chapter; use that list as starting point. Narrow your list by doing

Figure 15. Grip32 from Grip Software is an example of a studio management program designed for commercial photographers.

additional research. Start by asking your photographer friends if they have heard about a specific program. To get a global perspective, post a question about a program you are considering on the Professional Photographer's forum on CompuServe. (Searching for information using online services and the Internet will be covered in part III.) In addition to asking about how well the program's features work, inquire about customer support. Find out if the company charges for it after a certain time and if it provides a toll-free number. Simple questions can be answered by e-mail, but non–toll-free telephone support may be a hidden cost you should consider. If the company has a Web site, visit it to obtain more information.

Companies to Contact about Studio Management Software

Art Leather, Elmhurst, NY 11373-2824. 718-699-6300, fax: 718-699-9339.

Custom Business Databases, P.O. Box 360, Santa Ysabel, CA 92070. 619-782-9000, fax: 619-782-9293, e-mail: *SPS@CONNECTnet.com*.

Database Designs, 11425 8th Avenue, St. Cloud, MN 56303-1906. 302-240-1281, fax: 320-240-1282.

Franklin Service Systems, P.O. Box 202, Roxbury, CT 06783. 860-354-8893.

Grip Software, 420 N. 5th Street, Suite 707, Minneapolis, MN 55401. 612-332-8414.

Hindsight, Ltd., P.O. Box 4242, Highlands Ranch, CO 80126. 303-791-3770

MySoftware Company, 2197 East Bayshore Road, Palo Alto, CA 94303-3219. 415-473-3600, fax: 415-325-0783.

PC Concepts, P.O. Box 277, Battle Ground, IN 47920. 800-364-7953, 800-353-5383.

Perfect Niche Software, 6962 E. First Avenue, Suite 103, Scottsdale, AZ 85251. 602-945-2001, fax: 602-949-1707.

Photo Agora, Hidden Meadow Farm, Keezletown, VA 22832. 540-269-8283.

Retail Merchandise Systems, 8122 S.W. 83rd Street, Miami, FL 33143. 305-271-8941, fax: 305-274-6220.

Studio Organizer Software, P.O. Box 506, Flint, TX 75762. 800-903-3959.

Studio Solutions, 10810 N. Scottsdale Road, Scottsdale, AZ 85254. 602-483-1492, fax: 602-483-7104, *www.pictureyourself.com/PY_Images/Silvio.Silvio_page/html.*

SuccessWare, 3976 Chain Bridge Road, Fairfax, VA 22030. 800-593-3767, 703-352-0296.

Tucker Studios Classic Images, 5162 Puetz Road, Stevensville, MI 49127. 616-429-7673, 616-428-0086.

Vertex Software, 31 Wolfback Ridge Road, Sausalito, CA 94965. 415-331-3100, fax: 415-331-3131.

Verticom Technologies, Inc., 1013 Suffolk Drive, Janesville, WI 53546. 608-752-1583, fax: 608-752-2871.

Visual Horizons, 180 Metro Park, Rochester, NY 14623. 800-424-1011.

When you have narrowed your list, request demo copies. Sometimes, you can download a free copy from a company's Web site. Internet addresses for products that offer this service are listed above. If you are not on the Internet, most companies offer demo disks for a modest fee that is applicable to a purchase. After you install the demo, get input from some of the other people who may have used it—not just the resident wirehead. Don't expect perfection. You may have to change some of your procedures, which may be an improvement over what you are doing—or maybe not. Use this evaluation period to ask yourself one important question: Will this program improve my studio's productivity? An honest answer to this question will determine if the software is for you.

Taking a methodical approach to purchasing any studio-management

program means that when it comes time to implement it, things will go smoother and with fewer glitches.

Managing Data

One of the disadvantages of using studio management programs is that they are not always configured to match the way your studio is organized. Some of the above companies will customize their programs for you for a modest fee or even for free. If that's the case, a studio management program may be the best way to organize or manage your studio. On the other hand, if you want to slowly begin the reengineering of your studio, the best place to start is with a good database management program.

Newcomers to using computers in the studio may be asking, What's a database, anyway? The term refers to a document that is a collection of information stored in digital form. Even before my studio had a computer, we kept information on clients and their histories on 6 × 8-inch cards. We wrote down what kind of jobs they hired us for, how quickly they paid us, and if they had any special requirements for either billing or the way photographs were delivered. When we got our first database program, the now-defunct Main Street Filer, it was a simple matter of transferring the information to my computer. Database programs have two main components: records and fields. A record can be likened to the 6 × 8-inch card. It stores all the data on an individual client. On the record are areas that store specific data—like the client's name—called fields. Thus, a record is a collection of various data fields. This is why database programs, sometimes called database managers or DBMs, may seem a little intimidating at first. Because it's up to you to construct the way records are used, they (initially, anyway) have no form or shape. By carefully fabricating a set of records, you can use this data to help you manage and market better than any single computer tool available to you.

Recently I was speaking with a photographer who had traded in her old Apple II for a new Macintosh. The main reason she bought the new computer, she told me, was to use it for bookkeeping and cost accounting. While I believe it's important to keep on top of your studio's financial status, I think it's even more important to concentrate on

increasing business volume. The best software tool to help you increase your bank account is a good database manager. Database software expedites marketing by allowing you to contact potential clients regularly, and planning opportunity equals increased sales. You probably already have the best possible mailing list sitting there, just waiting, in your files. New clients are exciting, but they're expensive to generate. Existing, satisfied clients make the best "new" clients because they're familiar with your work and are used to working with you. Even if they don't hire you again, they are still in a position to recommend your studio to other clients. Marketing wizards call these people "decision influencers." The best thing about prequalified clients is they never ask, How much? they usually ask, Are you available?

I won't kid you; it won't be easy assembling your first client database. Depending on how extensive your files are, it could take some time to input the data. The most efficient solution, if you can afford it, is to hire a temporary worker to key in the data from your invoice files. If your budget doesn't permit bringing in outside help, you'll have to do it yourself. Set aside a weekend and work, undisturbed by ringing telephones, until you've finished entering the data. Adding new data is simple: each time you send a new invoice, add the new client's name to your list. You may be asking, How much is this software going to cost? You may be glad to hear that database managers don't have to be expensive.

Budget Studio Manager

Insta-Photographer from Chang Labs is a low-cost Mac OS program that's ideal for the new studio owner or the photographer who just purchased her first computer. Priced at an incredible $19.95 (that's not a typo), Insta-Photographer is a relational database, designed for photographers, that also contains a series of WYSIWYG studio forms to simplify common tasks for commercial and portrait studios. The interface is simple to use and consists of two pairs of two large buttons along with four small ones that access all the package's features. To enter a client's or supplier's name, you click the "New Card" button to enter name, address, phone number, and up to sixteen pages of notes onto a "Name Card." Clicking the "Show Card" button lets you see a list of all or

selected name cards in alphabetical order. This file lets you store thousands of names, search them, and print lists and labels. If you have a database in electronic form, Insta-Photographer lets you import any comma- or tab-delimited text file. The two "document" buttons let you transfer data from your name card file to a variety of useful studio forms or documents, such as a phone call log, follow-up letter, fax, or order forms. Clicking the "Show Document" button accesses twenty-two form templates, including Contract, Invoice, Delivery, Estimates, and Quotation. Stock shooters will find a Stock Photography Invoice and portrait photographers should be able to use the three different Wedding Contracts and Portrait Order Form. When working on any of these forms, access to the data in the card files and a calendar is available with a few mouse clicks. And Insta-Photographer is fast. How fast? You'll find it's as fast, or faster, as any program you're currently running on your computer. By comparison, my partner Mary had a consultant design a series of templates for our consumer division based on the Helix Express relational database program. These templates ran so slow that she found it was faster to fill in her forms manually than by using the computer.

Relational versus "Flat File" Databases

You will hear some programs referred to as a "relational" database, while others are a "flat file" database manager. Insta-Photographer, for example, is a relational database. The differences between these two types of database styles may or may not be significant, unless a program can't do what you want it to do. Here's how the two different types function. All the data in a relational database is stored in a series of grids, or matrices, in which the rows contain the information and the columns hold the name of the data fields. What sets relational database managers apart from their flat file kin— where all the data can be found on a single "flat" grid—is that they have the ability to "relate" data found on all of these matrices to one other. Relational databases can, therefore, handle complex relationships between data better than flat field database programs, but that doesn't mean flat file programs are useless. Before Claris FileMaker Pro became a relational database program (with the introduction of version 3.0), it was a flat file program. Many successful studio management programs were built around the program in that form.

Figure 16: Claris FileMaker Pro is a relational database that includes many templates to help get you started creating your own. The Time & Expense template is shown.

Shareware Databases

Because of the head start the IBM-PC had on the Mac, and its larger installed base, many excellent shareware programs are available to users of PCs and compatibles. Shareware is distributed through user's groups, computer bulletin boards, and online services like CompuServe. While browsing the PC forums on CompuServe, I discovered an excellent database program for the IBM and compatible computers called Fast File. It does all the tasks anyone could ask of a competent database manager and does it using only a small amount of your computer's memory. This latter feature makes it excellent for use with laptops. Fast File has a built-in template called "Clients" that you can use as is or customize to meet your specific needs. If after using the program for a while you decide you like it, send the author $70. In return, he'll send you the latest version of the program, a printed manual, and provide three months of free telephone support.

More Reasons for Databases

I've always felt the most powerful management tool a photography studio can have is a strong database. Since 80 percent of a studio's income is typically generated by 20 percent of its clients, keeping track of these clients is important. A good database management program lets you have a readily accessible record of who they are and enables you to do marketing mailings to them. A good database manager also helps maintain records on how much each client contributes to your bottom line. If you discover that any one client contributes more than 30 percent to your net profits, you want to be aggressively marketing to prepare for that day when, for whatever reason, they take their business somewhere else. Maintaining information on stock photographs is another aspect of studio management that is vital, but too many of us rely on our memory to know where slides and negatives are stored or filed.

OK, what if you're a new studio and don't have many existing clients? Or you want to expand your business nationally? You can purchase mailing lists from list brokers, which, if you can afford it, is the easiest route. If you feel this approach is too expensive, look at source books of industries you're targeting or would like to target. These guides usually include a listing of companies working in specific fields and may also cover certain geographic areas. A surprising number of these books are produced by the government, magazine publishers, and association and trade groups. If there's a fee, it's usually quite modest. Then there's the "poor photographer's guide to mailing lists," also known as the phone book. For the past ten years this has been a great source of leads for me. Periodically, whoever in the studio has extra time on his or her hands sits down and calls every business in our area. We ask the person who answers to (please) tell us the name of the person in the company who works with photographers and get the correct zip code. Yes, this is s-l-o-w, and pretty boring too, but it is the absolutely cheapest way to build a database. And yes, you still have to key in the data to your database manager. There are databases of potential national clients that you can purchase. One of the most well known is Creative Access, a company specializing in marketing for photographers.

Using any database allows you access to the demographic infor-mation you need to mail promotional pieces and newsletters on a regular basis. Marketing is the key to avoiding financial difficulties, and periodic mailings help keep your studio top-of-mind with clients and potential clients. How much you spend to collect that data is up to you.

6

Digital Stock

Since publishing a book about stock photography, I'm often asked how to make money with stock photography. Some see stock as a form of additional income, others see it as a way to take a vacation they can write off as an expense against future stock sales. I won't give any advice regarding the last reason—that's between you and the IRS. I've always been interested in stock photography, and each year a modest portion of my income is from stock sales. Stock is one of the few areas in commercial photography where the financial reward is greater the harder you work. Unlike assignment-oriented photography where you have to be on the "top three" list of every fickle art director in town in order to make a buck, stock lets you shoot what you want when you want. The way to financial success is not just in creating great stock photographs, but in how you sell them.

A New Market

While walking from my hotel to Moscone Center for this past year's Macworld Expo in San Francisco, I bumped into a guy from New Orleans who noticed my badge said *Photo>Electronic Imaging*. His first question was, "Did Kodak ever sort out the copy protection feature for Photo CD?" I told him the Pro CD series includes built-in copyright notification, but that I was not sure what he meant by copy protection. "Anything that prevents people from stealing the images," he said.

Although this gentleman was not a photographer, the topic of whether digital stock photography represented a business opportunity or the destruction of civilization as we know it was hotly debated by everyone I broached this subject with at Macworld Expo. During these discussions, I was given several strong arguments against the proliferation of "royalty-free" stock CD-ROMs. Royalty-free broadly means that when you buy the discs, you also buy all the rights to the images on those discs. In the real world, companies that produce so-called royalty-free digital stock photography discs attach strings on how these images may be used. These "strings" will vary depending on the digital stock producer, and can create confusion for photographers and end users alike. Part of the confusion is because large stock agencies often produce sample CD-ROMs that contain a low-res "sample" of some of the images in their collections. The images on these discs are for preview only and (sometimes) for use in creating rough layouts. When you want to use the image, the user must contact the agency and purchase the rights to use the image.

The people I was talking to were convinced that digital stock would bring down prices of "regular" stock, proliferate mediocre photography, and, in general, hurt the industry. Often, the term "clip discs" is used as a pejorative term by people opposed to digital stock photography. As someone who's been involved in professional photography for more than twenty-five years, these arguments sounded familiar to me. They were, in fact, the same rationale assignment photographers had used years ago to describe the emerging stock photography business. I believe digital stock photography will increase opportunities for conventional stock images, as well as assignment photography. Here's why:

The biggest market for digital stock photography is not Fortune 500 companies or major advertising agencies. The buyers of digital stock are the millions of small businesses and nonprofit organizations currently

publishing newsletters, fliers, and other small circulation material. All these QuarkXPress and Adobe PageMaker users would like to use photographs in their publications, but are not used to the process of hiring a photographer or buying stock photographs. Their last contact with a professional photographer was probably at a wedding. Consequently, some of them will unwittingly scan (and steal) images from magazines, but few will or can afford to pay standard stock agency rates. Digital stock photography, therefore, reaches an audience stock photographers normally don't have access to. At a recent Macworld Expo, I spoke with a woman who publishes a newsletter for her family-owned travel agency. In a recent newsletter, she was publicizing a trip to the Middle East and wanted to place a black-and-white image of some of the Holy Land sites that the tour would visit. She contacted several sources asking for free pictures, but they all referred her to stock agencies. When she called the agencies and inquired about the cost of using the images she wanted, she found the prices too high. On the other hand, she found the cost of images from a "royalty-free" stock photography CD-ROM to be affordable. This was a sale nobody would have made unless the images had been available digitally.

Digital Theft

The sad truth is that no matter what method you choose to market your stock images, opportunities exist for theft. Once an image leaves your control, anything can happen to it. If you send a duplicate slide for evaluation, it can be copied or scanned and used without permission. If you provide low-res FPO (for placement only) images on disk, they can still be used because whoever is going to steal your work doesn't care what the photograph looks like anyway. I had one client (that I know of) copy my prints and then complain about the quality until I showed him an original print from my file. Then I gently pointed out that someone in his organization had illegally copied my photographs. You can place a big © symbol in the middle of a digital image, but any competent Photoshop hacker can make it disappear. The sad news is that thieves will always steal; that's what they do. Most clients are honest and want to do the right thing, but often they don't know what "the right thing" is. It's our responsibility to tell them.

Digital Puritans

That's my name for an attitude that some photographers have about digital stock images. They believe that if one of their images appears on a CD-ROM or on the Internet, some hotshot art director from a big-time agency will use it in a major ad campaign. All they can think about is how much money they're going to be losing. Sorry, Charlie. No ad agency will use a digital stock image off of a CD-ROM for a national campaign for the same reason it won't use a tune off of a music library CD. They're concerned that the same piece of music will show up in a local car dealer's TV spot. The same thing is true for image discs. The people who are using images off of CDs are small business who can't afford conventional stock photography. In the past, they wouldn't even use a professional. They might have shot the job themselves or borrowed images from a friendly amateur photographer. Digital stock—for the first time—lets the average small-business owner utilize the services of a professional photographer. Once they see the value of using a professional, it should increase the amount of stock and assignment photography for all of us.

The A-List and the B-List

Part of being a professional is coming to grips with who you are as a photographer. I'm sure Eric Meola and Pete Turner don't stay up nights worrying about the effect my attempts at stock photography might have on their business. It was Joyce Haber, the *Los Angeles Times* successor to Hedda Hopper, who introduced the idea of the A- and B-list. I think we can safely assume that there are also "A" and "B" photographers and photographs. Because stock CD-ROMs eat photographs the way multi-image presentations used to, there are many opportunities for hard-working shooters, who may not be high on the stock photography pyramid, to make a good living. Skeptics may fall back on the "medi-ocrity" argument, but they've already forgotten that the market for these images is different. I think it's important to look at the fact that many shots delivered on CD-ROM are different. Most of my original library came from assignments, but today it's from shooting specifically for stock. When I shoot a roll of film, perhaps (if I'm lucky) one or two of the images will be great. These "A" shots or "selects" can be marketed through normal sales channels. On the rest of the roll, there might be

eight to ten that are technically excellent but not as good as the "A" shots. These "B" shots have a different value and are candidates for CD-ROM. The "outs" are tossed in the recycling bin. Stock photography CD-ROMs are not a replacement for the conventional marketing of your "A" images. To remain profitable, a photographer—or studio—must maintain a mix of different product lines. Diversity in the kind of photography we do and how it's marketed has helped our studio to remain profitable over the last twelve years while others I know have not been as fortunate. Photographers need to be flexible; otherwise, forces of political, social, and economic change could leave them with great pictures nobody wants to buy.

Digital stock photography is a reality. If the concept offends you, don't participate in the process. That's your right as an independent photographer, but whether you like it or not, technology is going to change the way we work. How well we deal with these forces of change will decide our future success.

Marketing Digital Stock

There are two ways to approach the creation and marketing of digital stock photographs. The first is a "market forces" approach that involves researching what photo buyers are looking for, then going out and shooting it. The biggest advantage of this system is that it's always sound business practice to find out what the marketplace wants, then deliver it. But what if a certain salable type of photography doesn't fit your talent, aptitude, or the equipment you own? OK then, let's try something different. The second method is based on fitting yourself to the marketplace. In his bestseller, *Sell and Re-Sell Your Photos*, Rohn Engh encourages photographers to discover their personal photographic marketing strengths and specialize. Engh sets out a technique for establishing a "market list" that matches a photographer's skills and also fits the needs of photo buyers. There's nothing wrong with this formula, but I'd like to suggest a third alternative that blends elements of both methods and throws in a healthy dose of self-determination. I call it "The Art of Stock Photography."

Discovering Your Photographic IQ

Many photographers dream about getting paid to create the kind of photographs they enjoy making. This may sound like a fantasy, but that's exactly how I make my living these days. Using photography as a way of self-expression doesn't mean you have to live the life of a starving artist. The trick to surviving in business is discovering where your interests overlap those of the marketplace. This is a direction I have been moving in for some time, but at the end of last year I made it official. Like many business concepts, this one is quite simple: You take the kind of photographs that you like to produce, then find someone to buy them. The Art of Photography premise is based on creating the photographs first—without considering if there is a market for them—and addressing the marketing of those images afterwards.

The process begins by taking a frank look at what you enjoy photographing as well as what you are good at doing. Finding your own photographic IQ can be an eye-opener and, like the photographic process itself, this search for a unique photographic vision can be quantified. The main advantage of this method is that it is totally self-directed from beginning to end.

Here are six steps to help get you started:

1. Analyze your portfolio. If you don't have one, pull together twenty of your favorite slides and place them in a plastic page. Place them on a lightbox and using a good quality loupe, critically examine each one. Then, make a list of the images in the order you like them and write a short description of why. Is it the subject matter or something else, like the use of color or composition, that draws you to a particular image.

2. Get a second opinion. Talk to other photographers and ask them to evaluate your twenty images in much the same way as you did. You want them to tell you what images they liked, in which order, and why. Belonging to a professional organization like the American Society of Media Photographers (ASMP) or the Professional Photographers of America (PPA) can be a big help in finding someone to help you with this process. If you can get an evaluation from a designer or art director, that helps too. While friends and relatives are usually more than happy to help, don't ask them. Their affection for you makes it difficult for a truly critical appraisal of your work.

3. Combine both lists. Find out what opinions overlapped and ask yourself which images you most enjoyed creating. At the same time, eliminate those that you enjoyed but you were not quite ready to handle, either technically or aesthetically. Keep in mind that this merged list is just a starting point and is not meant to be stagnant. As you grow as a photographer (and as a human being), you should add or subtract items from the list. Make these changes when you want and how often you want.

4. Look at what's out there. Go to a big bookstore or magazine seller and find out what markets there are for the kind of images on your list. Do not be discouraged if there does not appear to be a market for everything you want to photograph. Sometimes you may anticipate needs for images the market doesn't know it wants— at least, not yet. The Edsel was a perfect example of creating a car based only on market research. The only problem was nobody wanted to buy it. The success of the Dodge Viper sports car is built on doing the opposite. If you want to call this step, Build it and they will come, so be it.

5. Be aware of trends. Some people are interested in photographing wildlife or sailboats, but my passion is dinosaurs. When it was originally published, I enjoyed Michael Crichton's book *Jurassic Park*. When I read the book was going to be made into a movie, I traveled around the West photographing dinosaur skeletons, full-sized models, and dig sites. The release of the movie *Jurassic Park* and its sequel *The Lost World* stimulated interest in dinosaurs and magazines wanted photographs to accompany their articles. The same thing happened when *Jurassic Park* was released on videotape, and I expect a similar spurt of activity to accompany the release of the sequel on tape. Meanwhile, I'm still enjoying photographing anything dino-related and making sales of the associated images.

6. Practice, practice, practice. To create art, you have to practice, and the easiest way is through self-assignments. Make it a point to spend at least one or two days a week creating new images, even if it's just to test a new lens or film from Fuji or Kodak. If you don't make photographs, you can't sell them, and those practice images can become salable overnight. A few weeks ago I was testing a new lens by shooting images of the relocated hundred-year-old

Figure 17. The author's favorite CD-ROM recording software for the Mac OS is Adaptec's Toast. (Photo courtesy of Adaptec)

Elitch Gardens amusement park. Within two days of getting the film back from the lab—they were still lying on my lightbox—an airline magazine called to ask if I had any photographs of the park that it could use in an upcoming story on Denver. I told them I had images that were less than a week old and closed the deal.

Create Your Own Art

Most books on stock photography are built around the idea of researching the kind of images the markets want, then shooting them. I think this is backwards since it doesn't address what the market may want tomorrow. Just as some photographers feel their environment limits their ability to make photographs that sell, the truth is just the opposite. Main Street may seem ordinary to you, but not to someone else, somewhere else. Wherever you are is unique. To the Florida-based magazine that wanted photographs of Denver, it seemed like a long way off, but the profitable trip I took to photograph Elitch Gardens took only a few minutes.

Make Your Own Discs

Stock photo agencies are rapidly converting to digital distribution of images, and you'll need to do the same thing to remain competitive. The avalanche of new CD-ROM discs from both major and minor software companies is being fueled by dropping CD-ROM drive prices and acceptance of the CD-ROM format by both PC and Mac OS users. Browsing through the latest Educorp catalog, you'll see ninety-nine pages of CD-ROMs for sale, and one of the most popular categories is stock photography discs. Access to innovations in hardware and software have made us desktop publishers, but the step, beyond ink and paper, will allow us to create digital publications.

Before you can produce your first stock photography disc, you'll have to decide if you want to include full- or low-resolution images of your photographs on the disc. High-resolution files let art directors paste an image directly into their layouts and take it directly to final separations. If selling the disc on an "all rights" basis doesn't appeal to you, the best approach will be to include low-resolution images, suitable for decision making or positioning. Using smaller, low-res files will let you include more images on the disc, giving you more opportunities to make a sale.

Small CD Pressings

You don't have to be Bill Gates to publish your own stock photography CD-ROM disc in quantities from one to a thousand. If you only need to make a few CD-ROMs to promote your stock photography business, you can create everything in-house with a few hardware and software tools. The key to making this work is access to a recordable CD-ROM drive. Prices for CD-R drives have fallen through the floor and models that provide 4× reading capability with 3× writing functions cost less than $400. A CD-R drive can record more than 600 MB of data on WORM (write once read many times) discs. Once you have decided what to include on the disc, it only takes about a half-hour or so to write and verify a disc. You can set the process in motion, go to lunch, and have a completed CD-ROM disc when you get back. CD-R discs sell for $3–$4, so the out-of-pocket cost is negligible.

Unless you're planning on not completely filling the disc, you'll need to make sure you have a hard disk bigger than the more than 600 MB a

recordable CD-ROM holds. There was a time when the price of such a drive would be daunting, but a quick check in the back of a recent *MacWeek* magazine shows a 2 GB hard drive from APS Technologies selling for less than $250. That price will probably be lower when you read this. You may not even need to have any hardware to create CD-ROM discs. Some service bureaus will produce a disc from data supplied on SyQuest or Zip cartridges.

TIP: Portfolio on a Diskette

While CD-ROM publishing might appeal to you, how about placing a small collection of your best images on the most portable of all digital media devices—the floppy diskette? The key to making this work is a handful of digitized images and Kudo Image Browser software from Imspace Systems (see chapter 4). Kudo Image Browser lets you create a catalog with thumbnails of images, along with relevant caption information that easily fits on a 1.44 MB floppy disk. Depending on whether the images are color or black and white, you can produce an Image Browser file containing twenty-five to forty photographs. This amount of images should be enough to arouse the interest of a new client or to preview images for a stock photo buyer. Since the latest version of the program lets you generate a stand-alone application, the person who receives the disk doesn't even have to own a copy of the program. Kudo Image Browser is an inexpensive cross-platform solution for digital stock images.

CD-ROM Publishing

If you need more than a few discs, you'll need to contact a disc manufacturing company to produce larger quantities of discs at affordable prices. You can still use a recordable CD-ROM drive in your studio to create a master that you can beta test before sending to a disc manufacturer. In researching this chapter, I contacted several companies that could handle the volumes most photographers would require, and here's what I found:

DMI, Disc Manufacturing Company, has a sliding price scale for publishing CD-ROMs. It's based on that time-honored combination of "price, speed, or quality—take your choice." The lowest-priced deal includes an $800 one-time mastering fee that all manufacturers charge to produce the glass master from which the discs will be pressed and a per disc cost of $1.30 when ordering a minimum order of 231 discs. This gives you an initial production cost of a little more than $1,100, or $4.76 per disc,

with an insignificant incremental cost for producing extra discs. These prices are based on a turnaround time of fifteen days. If you want it faster, it will cost more. There are, of course, additional charges for packaging options, with a quantity discount for repeat orders. Since buyout CD-ROM discs often sell for $250, you can see that there is profit to be made in creating your own discs. Contact DMI at 800-433-DISC and ask for its package of material that also includes extensive documentation on CD technology.

Making Sales

Not everyone is as enthusiastic about digital stock photography as I am. No less an authority than Rohn Engh of PhotoSource International, disagrees with me about using CD-ROM technology to sell stock photographs. This is especially true, he feels, in the case of potential sales to magazine and book publishers. Engh believes that the key to success in selling stock photographs is targeting the most appropriate method for delivering images to possible buyers. In my own case, I sell few stock photographs to book and magazine publishers. Most of my images are sold for advertising and public relations use. I wonder if the technology of delivering isn't as relevant as the images themselves. If the large stock agencies are using CD-ROM technology to sell their images, what do they know that we don't? As the song from the *Music Man* goes, "you gotta know the territory."

Business Planning

The laborer, selling his labor in competition with other laborers who underbid each other until their wages just barely cover their cost of sustenance, also never gets rich.

—Benjamin J. Stein

When I first read the above words, they seemed to sum up many of the thoughts I've expressed in this photography—and digital imaging—business for years. It's too often true that some photographers think that the only way they can attract new clients is by lowball estimates that undercut other photographers. These people are blind to the fact that this kind of short-term thinking doesn't build client loyalty and serves only to reduce a studio's profitability. That's what Ben Stein's quote is really all about. That quote, by the way, is from the book *License to Steal*. If you haven't already read the story about the Michael Milken/junk bond/savings-and-loan fiasco and how it affects all Americans, pick up a copy. It will open your eyes to many other things, including why it takes some companies so long to pay your invoices. You'll discover the major reason is that they never intended

to pay you in the first place. If you're wondering what all this has to do with digital imaging, read on.

Digital Imaging for the Masses

If some photographers are willing to work for nothing in order to keep busy, what's going to happen when digital imaging finally replaces silver-based photography for the shrinking numbers of advertising and public-relations clients? You may believe that digital imaging will never replace silver-based images, but you'd be wrong. Mathew Brady thought the glass-plate negative would never replace the exquisite quality of the daguerreotype. He was wrong too. Every improvement in imaging technology since the creation of the paper negative has led to increased convenience but decreased image quality. That, as they say, is the way of the world. I recently met a photographer who hasn't shot a single roll of film in over a year. It wasn't that he wasn't busy. Far from it. He creates all his photographs with a Kodak Digital System Camera and tweaks them on his Mac OS computer using Adobe Photoshop before pasting the finished images into an Adobe PageMaker layout. Then he takes the files to a service bureau, which makes them into finished separations for delivery to his clients. If you are wondering where professional photo labs fit into the production of these images, the answer is; they don't.

Increasingly, I find myself shooting images where the clients don't need a transparency or slide—all they require is a digital image. Initially, I shoot these assignments with conventional film and use Kodak Photo CDs as my digitizing medium. The quality of the Kodak scans is significantly better than all but the most expensive scanners, the price is reasonable, and you don't need any more hardware than a good CD-ROM drive. With drive prices dropping fast, there's plenty of bargains to be found.

Flat Rate versus Itemized Invoices

One of the problems facing some digital imagers is how they should bill clients for an assignment. I've always believed that itemized invoices showing all the time and materials involved in an assignment was the fairest way—for the client—to prepare an invoice. I know some

photographers prefer to bill assignments on a flat rate or per-shot basis, and if you're successful with that method, keep it up. If not, keep on reading. One of the reasons I prefer itemized estimates and invoices is because that's what the bean counters in accounting departments prefer. All their other suppliers, from lawyers to plumbers, bill them this way, and I've found if I keep the accountants happy, I get paid sooner. The other reason I prefer this method is that when I started shooting everything in digital format, it kept my billing system consistent.

Billing on a time and materials basis also minimizes negotiating the cost of an assignment. If you tell clients it will cost $600 per shot or $1,200 for a two-shot assignment, they will treat the entire estimate as negotiable. On the other hand, if a potential clients see an itemized estimate showing all the time and materials associated with a shoot, the cost of your time will be more in line (maybe lower) than what they're paying their other suppliers. For me, this kind of estimate eliminates horse trading over the assignment's cost.

Where Are the Materials?

You're probably wondering how I can produce an itemized invoice if, when using a digital camera, the only thing I have invested in an assignment is my time. Obviously, there will be some outside material costs involved. The client may want his images delivered on a Photo CD, Iomega Zip cartridge, floppy disk, or maybe as four-color separations. Including the cost of those materials is obvious, but what about the intangible cost of imaging materials? If I shoot an assignment using a Kodak DCS-460 and download the images to my Macintosh, there's no out-of-pocket costs other than my time. Wrongo! I bill for equipment rentals, instead of film. In the audiovisual and video production world, the daily equipment rental rate is typically 10 percent of the original cost of the hardware. After shooting for ten days, the equipment will have paid for itself, and future rental income can be applied to the cost of acquiring the next generation of digital cameras.

Lastly, here's a message for all the ostrich photographers out there. A few days ago I had a conversation with a representative of one of the world's largest manufacturers of color negative film. She agreed that advertising and commercial photographers would be the first people to make extensive use of digital imaging, but she also thought that people

photographers, like school, portrait, and wedding shooters, will ultimately go digital too. "When," I asked, "do you think that will happen?" Without even blinking she said, "five years." Think about it.

Financial Recordkeeping

One of the most important documents a studio can prepare is a five-year business plan. It's easy to produce a business plan, if you're already keeping accurate records. Do you prepare your own income and expense statement? Maybe your accountant already does this for you, but the problem is that many accountants don't always understand our business (I know they don't understand my business). My philosophy about business is that the owner should know what things cost; how much money she makes; and where it comes from. That way you can take actions to improve things.

When I started my business, our books were kept manually and, to tell you the truth, we could never get them to balance. In 1984, I bought a 128K Macintosh computer to help with the business. We started using two software packages. Maccountant was an easy-to-use accounting package. It helped me produce income statements and get a handle on my overhead and other expenses. Maccountant underwent several changes, became Business Sense, and is now defunct. That doesn't stop me from using the program on a daily basis, although I realize that one of these days the program will not be compatible with the current version of the operating system. The other program we used was a spreadsheet program called Multiplan, produced by Microsoft. It helped me produce profit-and-loss statements and business forecasts. Multiplan ultimately became Excel, the premier spreadsheet program for Mac OS and Windows computers.

Many photographers are afraid of using computers for tracking financial data, and I admit I thought that using spreadsheets was hard and that I wasn't smart enough to use them. When I bought the original spreadsheet software, I also purchased a book that had small-business examples using Multiplan, and spent an hour and a half each night for a week entering the examples into the computer—sitting at my dining-room table. Now, I'm comfortable with spreadsheet programs and use Microsoft's Excel to do all kinds of cost analysis.

A good income statement can spot problems in your business, and

this is where Business Sense shines. You can't effectively control your income, but you can control how you spend your money on expense items—especially overhead. By applying Lisle Ramsey standards of what different expense items are, you can see if you're doing a good job controlling expenses. I got the Lisle Ramsey information from Don Feltner's *MAP* (Marketing, Advertising, and Promotion) book, which I consider the bible of studio management and marketing and is available from Studio Press. I'm not saying you don't need an accountant. We have one, but he serves in a consulting capacity. All the basic bookkeeping functions that many accounting firms produce, we do internally. This not only allows me to keep an eye on what's going on regarding my company's finances, but it also saves me money. One photographer I know pays more than $200 a month to get the same kind of information that I get from Business Sense. And it only takes twenty minutes of my time a week to keep this information current. Moreover, I can get reports from my computer, when I want them!

The other half of expense control concerns capital items like computers, printers, and other digital studio equipment. Equipment has to pay for itself. You can't buy it unless you can justify its cost. To do that, you need to analyze the increased income the new piece of equipment will provide. Accountants call this return on investment (ROI). What is the net profit that this equipment will generate? That net profit should include your labor as a cost, so this is the real bottom line. My accountant advises me not to make an investment if I can't show a 25 to 40 percent ROI each year of the life of the equipment.

The other thing that good recordkeeping will do for you is tell you what it costs to do things. The first question you need to ask is, Do I know what my "product lines" cost me? Yes, "product lines"; customers or clients are familiar with the product concept. Service is hard to define, but products aren't. We keep extremely detailed spreadsheets for our consumer/school photography division. For example, we know our average number of frames shot, what prepay envelopes and the complimentary hair combs we give out cost per school, and what the gross is that we can expect per child enrolled in a preschool. Using a spreadsheet makes it easy to post and update. Once you know what things cost, you are ready to prepare a forecast.

Once you start keeping track of your income and expenses, you should prepare a forecast of income and expenses on a month-by-month

basis. It should be broken down by product lines. You may already notice some trends. Until recently, our commercial photography has tracked the Dow Jones index. And like the stock market, this segment has occasionally been unstable. We're using our business plan to fill in the gaps with an expansion of our consumer division. Most of us aren't mathematicians, but preparing forecasts is easier than you think. You take your best guess at what you expect to gross each month, by product line. That's all a forecast is. Remember, if you guess wrong, that's OK. It's the way everyone learns. The easiest way to do this is to determine your average sale. Then multiply that by the number of sales you expect. By keeping track of the average sale and number of average sales over a year or two, pretty soon you'll have a handle on the forecast. You can also use historical data and base your guess on that. If you're brand new and don't have any records, base you guess on what you'd like to make.

Business Planning

Undercapitalization and poor cash flow cause more small-business failures than any single cause. The best way to stave off those inevitable cash-flow peaks and valleys is to have a sufficiently large line of credit with your bank. The only way you can get a line of credit that's big enough to be useful is to prepare a business plan and present it to your bank's loan officer. When I started my business, I used Microsoft Multiplan for the Mac OS (Excel was not available in those 512K days) and Apple's original MacWrite word-processing program to produce my first business plan. You are luckier. There are many software products available that make creating a business plan from scratch much less work than I spent back in those dot-matrix printer days of yore.

Sooner or later, you'll need to go to your bank and ask (beg?) for a loan or line of credit. If this is the first time you've applied for a business loan, or if the amount you're looking for is larger than you've previously asked for, the bank is going to expect more than a neatly filled-in credit application. Your bank may request that you prepare a formal business plan. Even if it doesn't, it's a good idea to include a business plan when you're asking for money for expansion, new equipment, or to provide a line of credit to help level out the irregular cash flow that seems to be as much a part of photography as bracketing.

If this is the first time you've encountered the term, you may be

asking, What's a "business plan?" A business plan is simply a comprehensive report that tells the bank about your studio's goals, marketing strategies, and financial strengths. Even if you're not applying for a loan, these are things you should put into writing anyway. Sitting down and preparing a formal business plan forces you to do an in-depth analysis of your studio's operation—its strengths and weaknesses. I've always found that writing down plans and objectives makes them easier to accomplish, and my experience has shown that if you do write them down, they will get accomplished.

Some people see a business plan as a destination. It's not; it's a journey. It's also a tool to help you make decisions, but you'll have to supply the vision and the goals. A business plan will help you analyze these goals and let you know if you can make any money doing them. A business plan isn't cast in concrete. Along the way you may uncover information that may cause you to change directions. Don't feel like this is something wrong. It's normal. It's not enough that you have a good idea or want to try something new. Unless you make money with any new venture, it could destroy your core business. Your business plan may tell you something that you don't want to hear. Maybe you need to raise your rates or eliminate some parts of your business. If you're not willing to make the changes that the plan indicates, don't even bother trying to start one in the first place.

The preparation of a comprehensive business plan is not easy. It's a lot of work. Depending on your work schedule, it could take you three months to get your first one completed. But, there are ways you can finish one over a weekend—if you already have the historical financial data. A business plan will help you focus on those profit centers within your studio that will produce the most revenue. It can increase profitability, increase productivity, and help you get the money to accomplish your goals. Presenting your plan to a bank will help you get the money for expansion or the purchase of new or expensive equipment. A business plan shows the bank you've thought about what you're trying to accomplish and have analyzed the profitability of it.

There are several ways you can go about creating a business plan. You can hire a consultant or do it yourself. If you do it yourself, there's two more choices to be made. The simplified approach or a computer-assisted, in-depth plan. Our first try at completing a business plan was to hire a consultant that had been recommended by a friend. This turned

out to be a big mistake. Mary and I were so busy just keeping the business running that we thought it was better to have a professional guide us through the process and do (what we thought) was the hard work. My experience was that using this approach was too slow and much too expensive. After four months into the process, we had barely scratched the surface of getting it done. The biggest stumbling block was that the consultant didn't understand our business, and he kept trying to apply retail or manufacturing standards to our operation. My recommendation: forget hiring a consultant—even if he will do it for free!

Producing an effective business plan for your studio is not difficult, but it will take some of your time. Unfortunately, some of the standard reference books on this subject are written for large, retail-oriented businesses, not photographic studios. One exception is *Developing a Business Plan: A Studio Owner's Reference Guide,* published by the Professional Photographers of America (PPA) in 1992. Depending on when you are reading this, copies may be available from the PPA. Contact information is in appendix B.

The simplified approach is the best way to prepare your first business plan, and it's what we did for the first two times. It enabled us to get a line of credit from the bank, and renew it from year to year. Its strength is that it's relatively easy to do. It shouldn't take more than a day or two if you already have an income statement and a business forecast. To help get you started in creating a simple business plan, I've prepared the following guide to the information and categories that bankers like to see in any company's plan. Your plan doesn't have to be arranged in the order shown. Feel free to resequence the various sections so that you can tell your studio's story to best advantage.

Overview

This section leads off your business plan, and provides the bank— or whoever is reading it—with a brief synopsis of the entire report. It's a good idea to prepare the overview after you've finished writing the entire plan. This makes it easier to write this section and ensures that nothing important is omitted. The overview should feature a short history of your studio, along with a biographical sketch of the owner (or owners). Include an analysis of the photographic markets you serve and the digital service offerings you plan to expand into. Be sure to

mention actual and projected income figures and the percent of income derived from activity in different types of photography. Remember that banks love numbers. Show them you do too!

Wrap up this section with a paragraph that summarizes your studio's business philosophy, and keep it short. Try to limit the entire overview to one typewritten page. If the overview section is well written, the banker may skip directly to the financial data in the back of the report. When that happens, you're well on your way to getting the loan or line of credit.

Glossary

This is something you won't see in most business plans, but I've found that it is important when dealing with bankers unfamiliar with photography. Like other technically oriented professions, photography has its own unique language. Helping your bank understand the jargon and buzzwords will make it easier to understand your business plan. It's a good idea to use this section to explain some of the expense and income categories or accounts that appear in your financial statements. When proofreading a draft of the plan, ask yourself, If I was a banker, would I understand the industry-specific terms used? If the answer is no, locate and explain those terms. If you don't think you're objective enough, ask a friend who's not in your field to review the plan. She will be able find any confusing words or phrases. Don't assume that the bank will understand what you do. Including a glossary of terms in your report directly translates into a better likelihood of getting the loan. One general observation: most banks seem more comfortable with retail-oriented portrait studios than with commercial photographers. For example, my banker once asked me, What is corporate photography? Commercial photographers should use this section to explain their specialty in depth and the interrelationship of photographers, reps, corporate photo buyers, and advertising/public relations agencies.

Management Team

This part of your report should include a detailed biography of the owners of the studio and all key staff members. List everyone's education, business, and photographic experience. Be sure to mention

membership in professional organizations and any special honors or awards you've received. This section's purpose is to prove to the bank that you have the required industry knowledge and experience to successfully operate a business. Let's face it, bankers are conservative and would rather put their money on a winner than an also-ran.

Market Analysis

It doesn't matter whether it's a good thing or not—the truth is, photography is an incredibly easy business to get started in. All anyone really needs is a camera, a business card, and some guts. The banks know this too. This section should include financial data that shows where your income is coming from and is expected to come from. You should show that you know who your competitors are and where your studio fits into the total photographic marketplace. More importantly, you should show that you've thought about the impact of competition on your business and have taken steps to ensure your studio's profitability. This is an age of the specialist, and banks expect that a bulk of your income will come from a specific kind of photography. Make sure that you provide information about what your specialty is and what the growth trends for your chosen market is.

Suppliers/Government Regulations

In most business plans, these headings are usually separate, but their impact on most average to small-sized studios is so small that I've combined them. If the nature of your studio's business requires detailed explanation in either, or both, of these categories, separate them. The purpose of the "suppliers" section is to show the bank you've established a working relationship with your major suppliers, such as labs, printers, and office-supply companies. This lets the bank know who your major suppliers are, and that these vendors trust you enough to extend credit to your business.

Depending on where your studio is located, you may have zoning considerations that need explanation under "government regulations." In our area, this is especially true for photographers with home studios. You should show the bank you have a current state sales tax license, federal employee ID number, and all the required permits to legally

operate a business in the city, county, and state your studio is located in. If you have any kind of darkroom or in-house film processing capabilities, you may be subject to OSHA and local water board regulations. If so, be prepared to explain how you're in compliance with these rules, as well as local water quality/disposal regulations. One of the advantages of the totally digital darkroom is that it doesn't produce any chemical-waste products. Even laser printing cartridges can be recycled.

Strategic Plan

Next to the overview and financial statements, this is the most important section in your business plan. It will also probably be the longest section. The strategic plan should spell out step-by-step how you plan on accomplishing the goals detailed in the financial section. Don't skimp on this section! Show exactly how you plan on reaching your projected income. This section is especially important if you've never prepared a business plan before. Writing the strategic plan will make you think about where your income is coming from, and where it should come from in the digital future. If you've previously been operating from the seat of your pants, putting your marketing plans in writing provides a road map to help you attain your financial goals.

This section should include information of your studio's plan for the next year or so. This can include the penetration of new or more profitable markets, a retreat from less profitable ones, any physical moves to a new location, and planned capital improvements. This lets the bank know if you may be asking for additional funds for these projects.

Financial Data

This section begins the financial information that must be included. Preface these statistics with a short paragraph or two that will help financial analysts to interpret the figures. If you plan on making changes in your markets or marketing, explain any increases, decreases, or omissions in the projections. Attachments in this section should include balance sheets for the studio and yourself. If the studio is small, a personal balance sheet will probably be sufficient. Also include a detailed, twelve-month projection of profit and loss by specific income

and expense category. I use a spreadsheet program to produce this section on my computer.

On another sheet, show the actual past year's and projected future year's income and expenses. This will give the bank some trends to look at. (For some reason, banks seem to like trends.) As backup data, provide complete profit-and-loss data for the past two or three years. When you go to the bank, you may want to bring your past two years' income tax forms. They don't have to be a part of your business plan, but for whatever reason, banks seem to like to see them.

The last part of this section should ask for the loan. Get to the point, ask the bank directly for the money and explain how you plan on using it. Give specific examples of equipment purchases, capital improvements, or whatever you need the loan for. If you're asking for a line of credit, you should also say what the line of credit will be used for. Even if it's just to pay your suppliers in a timely manner, say so.

We're in a visual business, and it's important that your business plan look good too. Prepare a cover sheet that has your studio's name and logo, along with a complete business address and phone number. The report should be neatly printed. Line-and-a-half spacing provides a good compromise between a difficult to read single-spaced plan and a long double-spaced report.

You don't have to be an accountant or a lawyer to prepare an effective business plan. While an accountant may prepare your expense and income statements used in the report, it's up to you as a photographer to express yourself and your studio's goals.

Business-Planning Software

While you can always produce a business plan using word-processing and spreadsheet programs, there are a number of applications that have been specifically designed to produce business plans and include both functions built-in. Business-planning programs often include sample business plans so—if you don't already know what one looks like—you have something to compare your plan against. Business-planning software also includes help routines and question-and-answer formats to help you produce the best possible plan with the least amount of fuss. Here are some of the better programs of this genre that I have tested.

Business Resource Software's Plan Write simplifies business-plan writing by providing a simple interface that creates a dialog between the user and the software. Have a question when writing your own plan? A Business Definitions toolbar button provides explanations to business-planning buzzwords, like "vertical integration." Also included is a sample business plan. An Internet link on the toolbar takes you to Business Resource Software's homepage, which contains one hundred sources of business-planning information. At its Web site (*www.BRS-Inc.com*), you will find guidelines on planning strategy excerpted from a presentation by Charles Neuner of Potlatch Corporation at the U.C. Berkeley's business school. The spreadsheet function creates compatible cash-flow and balance sheet reports, as well as a complete set of financial ratios. Plan Write generates a variety of charts related to customer descriptions, profit and loss, revenue, profit per employee, as well as break-even and cash-flow projections. The program simplifies the business-plan writing process, but lacks some of the ease of use of some the other products from Business Resources Software. The few problems I had, such as being unable to keep two other business programs and Plan Write open at the same time, are probably the result of using beta software. Nevertheless, with its built-in word-processing, charting, and spreadsheet capability, it's a useful program for someone trying to complete a five-year business plan.

JIAN's Biz Plan Builder uses the template approach. Installing the package takes you through a series of steps that ask what kind of word-processor or spreadsheet program you have. After installation, you will not see a Biz Plan Builder icon, so you may want to create a shortcut or alias to the "Top Twenty Questions" file that kicks off the planning process. Biz Plan Builder includes an operating plan and budget, a marketing strategy for a new product or service introduction, and the all-important financial presentation needed for a loan or refinancing. Spreadsheets include sales volume projections, depreciation based on fixed assets, income statement, inventory and accounts payable, and cost of goods sold. There is no learning curve for the software since you're using familiar programs. The "Top Twenty Questions" helps you get focused and the best documentation JIAN has ever produced will make the creation of your first or fiftieth business plan a pleasant process. Biz Plan Builder may just be a collection of templates, but they are darn good templates.

My favorite of the business-planning products is Business Plan Pro from Palo Alto Software. When starting a new plan, a simple questionnaire asks about the type of business you are in (service, retail, distribution, manufacturing, or mixed), and gathers some facts about the kind of plan you are developing. There is even a home office option. The program uses this information to tailor the way it guides you through the rest of the program and selects the outline, tables, and charts you will use. Business Plan Pro combines a built-in word processor with a learn-by-example format. A split-screen technique provides space at the top for instructions or examples. The bottom window provides a space for you to write the text for each section of the plan. When you need to crunch numbers, the instructions will provide the necessary tables and 3-D charts, including income statement, market and sales forecasting, cash-flow balance, break-even analysis, and ratios. All the tables from the built-in spreadsheet automatically link to the charts. When you're finished, the program automatically assembles text, tables, and charts to produce a report that can be used to secure financing for a start-up or expansion, or just as a way to plan for your company's future. Business Plan Pro is the easiest, most painless way I know to produce a business plan.

Using the Internet

Not only have the tools of our profession— cameras, films, and lenses—changed to digital, but so have the ways we communicate with our clients and potential clients. Most photographic studios are small enterprises and the most successful ones are those that maximize the use of technology, especially communications, to market products and services to grow their business. While computers have become popular in studios, they are too often used only for word processing, desktop publishing, and database management. One of the best marketing moves that any studio can do is establish a homepage on the World Wide Web. Many photographers are afraid to do this themselves because they think it's too complicated. It's not. In my research for *The Photographer's Internet Handbook,* I interviewed six successful Webmasters. All but one created their sites themselves using readily available computer hardware and software. The one who didn't had the site created by a twelve-year-old neighbor! Nothing says you are serious about business more than having a Web site. Many local ISPs (Internet service providers) offer low-cost unlimited access to the World Wide Web and will even host your site for you. Bill Craig, a fine-art photographer, pays a flat twelve bucks a month, which includes unlimited Internet access and storage space for his Web site (*www.diac. com/~bcraig*).

An Internet Strategy

Less is more.

—Mies van der Rohe.

Effective communication is one of the key elements in making your studio successful. As we approach the millennium you are going to need to adopt more electronic means of communication with clients and potential clients than what you have done in the past. The three most important parts of establishing an Internet strategy are: e-mail, creating a homepage on the World Wide Web, and marketing your products and services. This chapter will outline a strategy for developing these three areas, and chapter 9 will look at implementation.

Why the Internet Is Important

As stated above, there are three major reasons photographers should discover and exploit the capabilities of the Internet. These are not the only reasons you should go surf the Net, but represent the major areas

in which the Internet will be of value to you—no matter what your field of photography may be. As you become more experienced with the Web and as new services are developed for it, you may discover other uses that affect you and your studio on many different levels.

Photographic Products and Services

All the major camera companies have an Internet Web site. Finding these homepages are easy when you use one of the many subject search engines that are available on the World Wide Web. Since the actual number of Web sites on the World Wide Web is big and getting bigger every day, finding the Sinar homepage might be impossible without a way to search for the word "Sinar." That's the function of search engines: you type in a word or words, and a list of Web sites whose descriptions contain those keywords appears. The Web also provides access to photo retailers, and you can order a new 400mm lens or ask a technical question while visiting a photo retailer's homepage. The World Wide Web also lets you find hard-to-get photographic items. One of the newest features of the Web is that photographic labs and photofinishers are allowing online delivery of digital images from processed or un-processed film that are sent to them.

Worldwide Marketing

Having a homepage on the Web can give a single photographer— working alone—the same online marketing clout that a company as large as General Motors enjoys. The Internet empowers individual photographers to market their images and photographic assignment capabilities on a worldwide scale. Never in the history of art and commerce have tools existed that would allow a small studio to compete with other photographers, no matter how large their operations may be. If you have a studio in Lodge Pole, Montana, you may not be able to open an office in New York or Los Angeles to sell your work, but starting a homepage on the Internet gives you the equivalent of an international office with little of the cost normally associated with opening another studio location. In this way, the Internet is truly the great equalizer. When people land on your homepage, they will judge it by its design and quality of images that are displayed, nothing else.

Figure 18. Using the Excite search engine, the author looks for information about Sinar Bron view cameras and accessories.

The World at Your Modem

One of the most practical aspects of the Internet is the ability to communicate with people around the world—electronically. For the cost of a local phone call, you can send electronic mail to a company in Germany, order camera parts from a firm in Canada, or correspond with a photography professor in Haifa, Israel. Here's some background on the types of electronic addresses that you will find on the Internet.

Sending electronic messages—e-mail—is much easier than writing a letter on your computer, printing it, addressing an envelope, licking a stamp, and dropping it in your mailbox. An e-mail message is usually delivered in minutes, and the cost of sending a message to Tokyo is the same as it is to Toledo. E-mail, therefore, allows photographers to communicate with potential clients as well as suppliers around the world at the same cost, providing access to international photographic markets that were once only the province of well-heeled shooters.

One of the first things you'll need is an Internet e-mail address. This

is accomplished when you sign up with an ISP (covered in the next chapter). Most ISPs allow you to pick your own e-mail address within the basic format of *name@ISP.domain*. As I write this, most ISPs—with the exception of CompuServe, which currently assigns you a cryptic account number—let you pick your own name. In case you want to drop me a note, my current e-mail address is *jfarace@juno.com*.

Domain Names

Here's a quick overview to Internet domains:

- *.com* is a business or commercial Internet user. Photographers using CompuServe, America Online, or NetCom will have a *.com* domain.
- *.edu* is assigned to educational and research users at colleges or universities. Student photographers or photography professors will have an *.edu* domain.
- *.gov* designates government agencies. If you're an in-house photographer at a government agency, your address will end with *.gov*.
- *.mil* is a domain used exclusively by the military. If you're a Photographer's Mate in the Navy, your address will end in *.mil*.
- *.net* is the domain of gateway or Internet host sites.
- *.org* is the domain used by nonprofit organizations, like National Public Radio.

There is a movement to expand the list of acceptable domains to include one like "*.store*" for online commerce, but because there is not one single authority in charge of the Internet, it may take a while to add new domains.

E-mail

For many photographers the Internet means access—being able to communicate by e-mail with suppliers, colleagues, and equipment manufacturers. With more than 35 million users, e-mail is the most popular Internet service. It's even more popular than the World Wide Web, which currently boasts 8 million surfers.

E-mail is better than conventional mail because it can reach the intended recipient in minutes instead of days. The best part of e-mail is that it eliminates "phone tag." You send a message when it's convenient for you to do so and give the recipient the same flexibility. This is especially effective when communicating across different time zones. But e-mail is not perfect. If a person does not want to respond to your letter sent by the U.S. Postal Service—often called "snail mail" by e-

mail aficionados—he can ignore it or throw it away. Like the fax, when e-mail was new, it got answered fast. Now, it can be deleted and ignored just as easily as a paper letter. While letters can be misplaced, once an e-mail message has been deleted, it may be gone forever. I make it a point to click the print button when I receive an important message and file it in a conventional folder. You may think of me as a "belt and suspenders" kind of guy, but nothing in computing is safe. Even if you make backups of your e-mail and other data every day, you will always lose something in a system or hard-disk crash.

E-mail also allows you to send "attachments." An attachment is a file that is attached to an e-mail message. A photographer can send a text file or an image as an attachment, but the software and ISP that you use must support attachments. CompuServe and America Online currently do, but Juno (covered in the next chapter) does not. Attachments allow you to send images to a client. You can attach one or more images to a message to a client showing how you handled similar assignments in the past.

When corresponding via e-mail or posting on Usenet or private newsgroups, certain levels of civilized behavior is expected by the people reading your messages. Instead of referring you to an Internet Emily Post, most people reading your mail/posting will take it upon themselves to educate you in the proper forms of written behavior. One of the most common mistakes newcomers make is typing everything in CAPITAL LETTERS. This is considered a breach of netiquette because the writer is considered to be shouting—and it's also hard to read, too. If you get too loud or profane, expect a stern warning from the Webmaster or Sysop, or you may even find yourself barred.

Spam, Nemesis of E-mail

There is no perfect e-world. Just as your mailbox gets junk mail and telemarketers interrupt your dinner, people who use e-mail get "spam." Named for a Monty Python skit in which the only item on a restaurant's menu was Hormel's meat product, spam is unwanted e-mail—junk e-mail. Spam can fill your electronic mailbox with everything from solicitations to buy products to reminders to visit a certain site on the World Wide Web and, like junk mail, not all spam is bad. Occasionally, you will get junk mail—or spam—about a product or service that you are

Figure 19. Here's a peek at some of the author's favorite Web sites using Microsoft's Internet Explorer. If you use the favorites list instead of responding to an online update request, it will minimize spam.

interested in. Some people get lots of spam and are bothered by the time it takes to go through it, and others, like myself, get very little spam and are not so hot and bothered.

I see the threat of spam as similar to that which a computer virus poses and take steps to reduce my exposure to it. The secret to minimizing the spam that you receive is to minimize spreading your e-mail address around while online. Here's a few tips on how you can avoid a mailbox full of spam:

Don't respond to spam: Some e-mailers get so upset by spam that they immediately fire off a message condemning the spammer. Don't bother to respond. It just gives the spammer your address a second time. An exception to this rule is if the spammer is more benign and gives you a way to respond with a certain text in the subject line of your e-mail, which will cancel all future spam. Always respond to this negatively by using the appropriate text to cancel future spam. The spammer may bury the text in the message, but take the time to search for it and

respond. I have never gotten more spam from the same person when I have responded in that way.

Don't sign up for anything online. Many homepages on the World Wide Web allow you to sign up to be notified if the page changes. While convenient, posting your name on some—not all—Web sites exposes your name to the software "spiders" that spammers use to round up e-mail addresses while online. Instead of posting your e-mail address, add the site's URL (Universal Resource Locator) to your browser's favorites list.

While I am careful what I respond to, I found myself on the list of a spammer who sold autographed photos. I have a small collection of autographs (although I never mentioned it online to anyone) and was pleased to be on this gentleman's mailing list announcing online sales and auctions of autographed photos. I even purchased an autographed photograph of Dennis Miller (my wife's favorite comedian) because of the spam. I expect that something similar may happen to you if you get spam from an individual or company specializing in products that you are interested in.

What's the World Wide Web?

Much of the real action on the Internet—for photographers anyway—is centered around the World Wide Web, sometimes just called the Web, or WWW. While the Internet contains a wealth of information, the Web contains everything you ever wanted to know about anything. While there are special-interest groups on the Web featuring everything from cameras to film to digital imaging, there is plenty of marginal information there too. One of the most popular aspects of the Internet, the World Wide Web uses a set of conventions for publishing and accessing information that provides point-and-click access through a graphical user interface like Netscape Navigator or Internet Explorer. The Web's technology provides photographers with the ability to treat visual data, like photographic images, as if they were text.

The World Wide Web is really a collection of Web sites stored on computers and responds to requests from browser software. The first screen that you see on a Web site is called the homepage; some people incorrectly use the terms "Web site" and "homepage" interchangeably. Common gateway interface (CGI) scripts are programs that run on a Web

server to process all this activity and extend the capabilities of the server. Browser software enables computer users to view homepages. The glue that holds all this together is called HyperText, a computer language that enables Web surfers to move between Web sites by selecting (clicking) on links. The ability to link one Web site to another is one of the reasons it is called a Web. A Web site consists of several parts. A homepage is the launching point for any Web site. You can consider it the table of contents because it lists the various items or images that can be found at the site. Web sites are really collections of Web pages—individual files that make up a Web site. The pages within a Web site are linked together so that surfers can move easily between them, often in a nonlinear fashion. Web pages are usually written in HyperText Markup Language (HTML), a simple, yet powerful, programming language, which allows you to structure your Web site to include:

1. Links to other Web sites
2. Links to other Web pages (within your Web site) or even to a specific element within a page. (For example, to provide a large version of an image displayed on a Web page.)
3. Structural elements such as pricing tables or client lists
4. Graphic elements, like photographs
5. E-mail link. Visitors to your site should be able to click on a link on your site that activates their browser's e-mail feature and lets them write to you while they are looking at your work. The time to get their business is when they are most interested. Don't forget to add this feature to your homepage design.

Marketing Your Products and Services

Your studio should have a Web site for one major reason: it is the simplest, least expensive way to reach the largest number of potential clients.

One of the simplest ways to think about establishing a Web site is to think of it as an electronic version of the same kind of print-oriented material you've been showing and mailing to clients and prospective clients. The homepage is your welcome mat; it says, Welcome to my site—my studio. A well-designed homepage typically contains a table of contents or a summary of the kind of information that anybody visiting your site will find. This listing can be as simple or as complex

as your operation is. If you sell assignment photography, you want to show the breadth of the work you do—location work, for example. If you also do on-location executive portraits, include a section on that too. In other words, a Web site is a reflection of the work you do—or want to do. There is no rule stating that your Web site cannot be used to promote a service of your studio that you want to increase. If you want to move your operation from assignment-based to stock photography, focus the Web site on the stock images you have already made and show a few samples. On the other hand, stock shooters might want to include a little blurb (or even an image or two) that says, Oh, by the way, I do assignments too. You still have to make a living and pay the bills, so never miss a chance to plug your bread-and-butter work.

A homepage on the World Wide Web has many advantages over a conventional portfolio or printed promotional piece. First, a Web site is less expensive to create and update than conventional, nonelectronic media. Four-color printing is expensive and if you order 5,000 brochures, it may take some time to distribute all of them. By the time you're down to brochure number 4,989, you've probably created even better images than are shown on the brochure. Changing the images on a Web site is a matter of scanning the new images (or having someone do it for you) and posting them on your homepage. By comparison, have you checked the prices to have a custom print made and laminated? Second, you only need one Web site. There's no need to print 5,000 brochures or to have duplicate portfolios made so you can ship the images to several different places at the same time. Your single Web site will be accessible to thousands of photo buyers around the country—even around the world.

Before you construct a Web site, you need to first establish the parameters for the site—what you hope to accomplish and how you intend to accomplish it. Without clear goals, a Web site will be just as wasted as a brochure that's full of pretty pictures but doesn't ask for the sale. Here are a few ideas on ways to establish the content and orientation of a Web site.

Picture du Jour

When photographers tell me it's too complicated for them to produce a Web site, I tell them four words: "picture of the month." This type of

homepage can consist of a simple photograph along with some basic information about the image and contact information—including e-mail address—for the photographer. This kind of homepage has two edges. Since it contains a single image, the Web site is easy to set up and maintain. Because it is easy to set up and maintain, the images can be changed on a regular basis, allowing you to always have something fresh for potential buyers to see. One of the best ways to think about Web sites is to compare them with a daily newspaper that has new information in it each day, instead of a brochure that is updated once a year or less often. You don't have to make changes every day, but try to make changes once a month at a minimum.

If you have several fields of concentration, I would suggest you use a "picture of the week" concept and feature each specialty once a week. A variation of this theme is to add additional pages to your Web site that would archive previous pictures of the week (or month) so that you can tell buyers, Oh, you want a ski shot? That was my picture of the week on October 2nd. Make sure you advertise the fact that your Web site has a featured picture that changes regularly and include that information on your business card, letterhead, source book ad, and any verbal communication you have with potential photo buyers.

Assignment Photography

Assignment photographers will need more depth than the average stock shooter—who tends to be more specialized. An unfortunate reality of this business is that you constantly have to prove to potential photo buyers that you can produce—and have already made—images just like the one they need right now. Therefore, an assignment shooter's Web site should reflect his ads in source books and his laminated portfolio; it's even possible to combine both kinds of images in a well-designed Web site. That means more photography, but be careful of how many images you show; too many images diminish the effect, because they have to run smaller. You might be better off with a few images that occasionally change on the first page, along with a listing of your specialties—such as food or architecture. Browsers would then click a button to go to another section of your Web site to find examples of images along with tearsheets and lists of awards won for particular images. Caution is needed to keep from overdoing it.

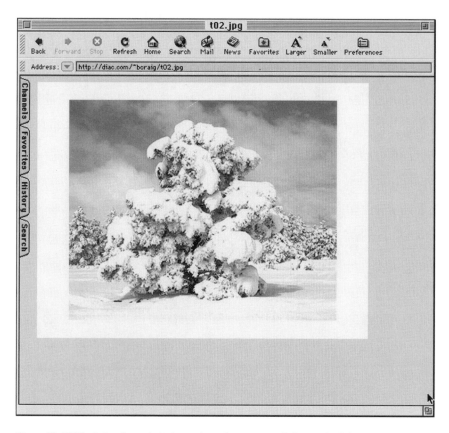

Figure 20. Bill Craig is a fine-art photographer who uses a variation on the "picture of the month"
theme to display his ten most popular images, like this Snow Tree. Visit his Web site at
www.diac.com~bcraig.

Fine-Art Photography

What the fine-art photographer's Web site needs is, in many ways, similar to the stock shooter. The images both sell have already been created. Unlike assignment shooters, who are always pitching their next shoot, the fine-art image creator is selling existing photographs. A Web site can be an extension of an existing print brochure or can even be a replacement for it, since color JPEG images are less expensive to produce than four-color separations. A good way to establish a homepage for the fine-art photographer is the "picture of the (whatever)" concept. One of the differences in this homepage is that galleries and art purchasers are

often interested in a photographer's background and pedigree, so there should be an extensive section on degrees and awards so that potential buyers know they are getting "the good stuff." This homepage should feature elegant simplicity.

9

Internet Implementation

Using the Internet as a communications and marketing tool for your studio doesn't have to be complex or expensive. In this chapter, I will provide an introduction on how to implement the Internet strategies that were introduced in chapter 8. Let's start with a five-point checklist of questions that will help you position your digital photography products and services for roll-out on the Internet.

Make a List

1. Is your product more of local interest than national? One of the advantages of using the Internet to sell photographic products and services is that it expands your reach beyond your local geographic market. Wedding photography is local. Nobody in Boston is going to hire a wedding photographer in Albuquerque. While

you can include a page on your Web site about wedding photography, it will not typically generate the kind of referrals that you will get from typical sources such as jewelers, bakeries, and gown shops. On the other hand, if you specialize in on-location executive portraiture, the Web is a great way to advertise. Companies all over the country are always looking for a photographer—no matter where he or she is located—that can bring a fresh look to their portraits of executives used in company publications, press releases, and annual reports. The same is true for a stock photographer; location is less important than the photographer's vision.

2. Is your stock photography unique? Pretty sunsets and cute kids won't make a big sale on the Internet. But if you have photographs of nuclear power plants, microphotography of cells, or images of Siberia or any other remote location, the Internet is the very best place to sell stock photographs. Make sure that your specialty is prominently featured in both text and photographs on your site so that a photo buyer using one of the Internet search engines, looking for photographs of manta rays in their native environment will be able to find you. Rohn Engh, noted stock photo marketing guru, says you have to determine your PMS (photographic marketing strengths) and specialize. If you do, the Internet provides the best way to market your images worldwide.

3. Are you afraid of digital theft? Your images are no more safe—or unsafe—on the Internet than they are whenever you let prints or transparencies leave your studio. If you are concerned about someone copying your images off your Web site, then you should rethink your Internet strategy. Since the images you will post on the Web are small in size and have resolution designed for on-screen viewing, they are almost useless to anyone who would try to steal them. I say "almost" because only a psychiatrist under-stands why people steal. The Digimarc copyright system built into Adobe Photoshop (versions 4.0 and later) can embed an invisible copyright notice as part of the image. If the thief tries to open it using Photoshop or any other Digimarc-aware, image-editing program, he will receive a notice that it is a copyrighted image. Digimarc also offers software and a service that lets you search the Internet for anyone using your copyrighted photographs.

TIP: FlashPix Images Copyright

Live Picture, Inc. and Digimarc Corporation announced they will extend the FlashPix format's capabilities to support Digimarc's digital watermarking technology that embeds copyright information throughout an image. This process allows a digital image to contain copyright and ownership information that is linked to contact details about the image's creator. Adobe Photoshop already includes the Digimarc copyright plug-in in version 4.0. Other programs, such as Corel Photo-Paint, CorelDraw, and Micrografx's Webtricity, also use Digimarc.

4. Are you willing to make a commitment to update your Web site on a regular basis? A Web site is more like a daily newspaper than a brochure. It needs to be updated periodically. Even if all you do is change a single photograph on the homepage, it will keep the attention of someone who may be visiting your site a second or third time. A Web site needn't be complicated or fancy. It just should display your work in an attractive fashion and let everyone know who created the images, *but* you need to update the site more often than you would update a print portfolio. And why not? It's much cheaper to do digitally.

5. Know what you want to say and how you want to present your studio. There was a time when just having a Web site was enough to impress a client, but no more. The appearance of your Web site says a lot about you and your studio. That doesn't mean you need to create an elaborate site. Far from it. Later, I will give some guidelines on how to construct your site, but speed of loading is important. That means a clean, simple page with not too many pictures—it takes longer to load—and supporting text is necessary to get the attention of visitors to your site. Once the homepage quickly loads, and they want to see or learn more, provide additional images and information on other pages that are linked to your homepage.

E-mail

If there is one item that prevents more photographers from going online, it is the cost. It's not hardware cost; modems keep getting faster and cheaper. My 28,800 bps (bit per second) Supra FaxModem 288, from Diamond Multimedia, cost less than a 300 bps Apple Computer modem

I bought many years ago. More and more companies are including modems as part of the equipment bundle. My PowerTower Pro 225 included a 33,600 bps Global Village modem. It's the additional expenses that add up. First, there is the cost of buying and upgrading software. Second, there are the costs associated with opening and maintaining an account with a local or national ISP. ISP's have not started calling your house and interrupting dinner with a discounted sales pitch, but maybe we will see that time in the not-so-distant future. In the meantime, you have to spend your time shopping for the best ISP deal. For those of you who have been waiting for some kind of price breakthrough, I would like to introduce you to a free Internet e-mail service.

Hard as it may be for all the skeptics out there to believe, Juno Online Services offers a free Internet e-mail service. There are no monthly fees, no hourly fees, and no sign-up fees. The software is free and Internet access is free through a local telephone number. What is the catch? So far there are only two, and both of them seem relatively minor. One, the free software is designed only for Windows-based computers. Juno currently has no plans for a Mac OS version. Two, the software displays commercial messages. Anyone who has ever surfed the Internet knows there is nothing unusual about seeing your ramblings interspersed with ads for everything from diet colas to sneakers to automobiles—and computer stuff too.

The software is yours for a free phone call to 800-654-JUNO. It comes in a CD-ROM-like envelope containing a floppy disk and all the information you need to get started. Establishing an account and installing Juno's software was a snap on my IBM Aptiva "Stealth" computer. After running the setup program, Juno's software asks for some basic information about your computer and telephone setup, then automatically configures itself. The installer took a guess at the kind of modem I have inside my PC and the guess was correct. I clicked OK and moved to the next step. At this point you get to pick your e-mail address and a password. The e-mail address format is "*whateveryouwant @juno.com.*" You are on your own for the password but don't—whatever you do—use "password."

Next, you get the "member questionnaire." If you have ever filled out a warranty card for your computer or VCR, you will recognize this for what it is: market research. None of the questions seemed particularly

intrusive to me, but they did want to know my annual household income and how many stock or bond trades I made over the past year. This might bother the security-minded among you, but not me. All this information is easy to obtain from other sources. If you are wondering what Juno needs this data for, the company uses these profiles to decide what commercial messages it displays for you. After filling in this information, it's a matter of launching and using the software.

If you have ever seen or used any company's online software or browser, you will be amazed at the ease of use of Juno's software. At the top of the screen there are two large "folder" tabs that let you switch back and forth between the service's main functions: reading and writing e-mail. After that, everything has been designed to make the e-mail process an intuitive one, beginning with spelling. There is a truism that goes, Nobody can spell while online. That's usually because replies are written in much the same way as conversations and tend to be less structured. One victim of this lack of structure is spelling. Some companies have developed plug-ins and add-ons (that you have to pay for) to add spell-checking capability to Internet browsers, such as Netscape Navigator. A spellchecker is built into the free software Juno provides, so you can quickly check your reply before driving off onto the information superhighway.

Juno's software also contains an address book that allows you to build a personal mailing list of friends, colleagues, suppliers, and clients. If you like, you can set it to automatically log the address of anyone to whom you send e-mail. In addition to being able to send a message to people on the Internet, you can also send e-mail to anyone using a major online service such as America Online. When incoming mail arrives for you, it's stored in a folder and you can read it, respond to it, forward it, or file it in another folder.

It's customary to append an electronic "signature" at the end of the e-mail message. Most users use this to add their name and some additional information about themselves, such as their street addresses. Some users use it to call attention to their achievements, such as a listing in Who's Who Online, the awarding of a master's degree in photography, or just to add a pithy saying.

Weaving a World Wide Web

Web pages can be written in HyperText Markup Language, HTML, but most photographers will be more comfortable using a WYSIWYG editor like Claris Home Page or Adobe PageMill.

Designing a Web site for the World Wide Web introduces variables into the design process that do not affect other media. One of the most dramatic differences is that you no longer have control over how a viewer sees your artwork. Some things that affect preparing artwork for the Web are viewers' display systems, the speed of their modems, and their Internet service provider connections. Since you have no control over these variables, all you can do is take a few steps to prepare your image for the Web that will minimize download time and display well on the most systems.

Web Site Design Parameters

The overriding concern when designing graphics for the World Wide Web is loading time. All other design parameters are secondary to the amount of time it takes a graphic to display on-screen. Because surfers have the attention span of a Honduran water moth, if something does not display fast, you lose them. If you want to increase the likelihood that search engines will find your site or rank it first, use Meta Tags. Bury white-on-white (or whatever color) text inside your Web site so search engine robots will pick your site faster than others in a given category. If you view my Web site in HTML mode, you will see "digital image" written a hundred times at the bottom of the page. Search engines often use software "spiders," which look for new sites and register the number of times a certain word appears in a Web site and ranks it as a "positive match" for certain subject matter accordingly. Thus, when people go searching for sites about digital imaging, mine is usually among the first that they find because it's a more "positive" match than other sites that only have "digital imaging" once in their text. Be careful how you use Meta Tags. While my site uses generic terms, some sites have used trademarked terms in their Meta Tags to lure surfers. Three separate court cases have found that such usage is considered trademark infringement. Be careful out there!

Figure 21. A look at the HTML code behind the author's Web site.

TIP: Get Back!

Be sure to put a "Back" link that will take visiting surfers back to your homepage. Believe it or not, this is something that's easy to forget when designing your first Web site. Why do I know this? Visit my homepage to find out.

GIF or JPEG?

Other design concerns include limiting your graphics to 256 colors. This makes it easier to translate into the popular GIF format that, in most

Figure 22. What visitors to the Web site will see if they are using Microsoft's Internet Explorer.

cases, will load faster than JPEG-formatted files. Among Web designers there is some controversy over which graphic file type is best to use: JPEG or GIF. As with everything else in digital imaging, there are trade-offs with each file format. A GIF file works best when there are few colors in the image. If your image contains fewer than sixty-four colors, a GIF will be smaller than a JPEG file. If your site has a hand-drawn illustration, chances are it, too, is using less than 256 colors, making it a great candidate for GIF-dom. If you are using buttons on your Web site—they probably contain only a few colors—GIF format would be a good choice. The same is true if you are using splashes of color. Most of these decorative files contain only a few pixels and use very few colors. Because JPEG is a "lossy" compression method, text can become blurry when displayed. That's why GIF is the best choice if your graphic contains text or sharp edges.

In general, use JPEG when saving photographic files. JPEG allows the use of more colors, but depending of the viewer's graphics, they can be

wasted on the viewer and can take longer to display because the files tend to be larger than GIF. On the other hand, GIFs have less on-screen quality, but often display faster. JPEGs make good backgrounds. Because of the low contrast and similarity of colors required for a good background, the larger number of possible colors available make JPEG a good bet.

Unlike other compression systems, GIF was designed specifically for online viewing. If your image was stored in noninterlaced form, when half of the image download time was complete, you would see 50 percent of the image. At the same time in the download of an interlaced GIF, the entire contents of the image would be visible—even though only one-half of the image data would be displayed. An alternative to using interlaced GIF is progressive JPEG. This file format rearranges stored data into a series of scans of increasing quality. When a progressive JPEG file is transmitted across a slow communications link, a decoder generates a low-quality image very quickly from the first scan, then gradually improves the displayed quality as more scans are received. After all scans are complete, the final image is identical to that of a conventional JPEG file of the same quality setting. Progressive JPEG files are often slightly smaller than equivalent sequential JPEG files, but the ability to produce an incremental display is the main reason for using progressive JPEG. Many Web browsers support progressive JPEGs, including Netscape 2.0 (or later), Enhanced Mosaic 2.1f5 (or later), OmniWeb 2.0 (or later), and Wollongong Emissary 1.1 (or later).

To see the on-screen difference between sequential and progressive JPEG files, visit inTouch Technologies' Web site at *www.in-touch.com/ pjpeg.html*. It displays two identical images side by side: one progressive, one sequential. You can watch as the images fill the screen and make your own decision about using progressive JPEG files. While there, you can download a thirty-day version of the JPEGiT! Photoshop-compatible plug-in. While you are on the Web, surf on over to my Web site at *www.hyperzine.com/writers/joef.html* and look at two images. My portrait was tweaked using Auto F/X's Photo/Graphic Edges and converted to a GIF file with Adobe Photoshop. The text of my name was produced with Kai's Power Tools controlled by KPT Actions, then converted to a GIF file also using Photoshop. Look and decide. It's up to you.

File Translations

Before you can integrate a graphic element into a Web site design, you need to translate your original file into a format that can be read by most Web browsers. For many users, their choice is GIF. Unlike JPEG, the compression used by GIF is lossless, which means that nothing is discarded during the compression procession. In Photoshop, Adobe includes two methods for preparing images for the Web. One of them, JPEG, is a file format plug-in. The other is an export plug-in.

If you would like to convert your images to GIF or JPEG format but are looking for "more power" than is provided by Adobe Photoshop's built-in capabilities, it's time to look at a pair of plug-ins from Digital Frontiers. Digital Frontiers's base technology was developed for high-end UNIX workstations and was ported to the Mac OS and Windows platforms. Some of the technology includes color space reduction based on the human visual system (HVS), which allows the creation of 8-bit images indistinguishable from images with millions of colors. HVS is similar to Dolby noise-reduction technology for audiotapes; it's a proprietary signal-processing mechanism that provides superior quality even when information is lost through compression. HVS is the heart of two high-performance plug-ins that allow you to create great-looking and compact images for the World Wide Web. Digital Frontiers's ColorGIF includes two versions of the plug-in: a filter and a file export module. Few paint programs support the export plug-in standard. If you do not have Adobe Photoshop, you will probably only be able to use the filter version of the plug-in. ColorGIF has been designed to produce small, high-quality GIFs. Depending on the original image, you can expect up to a 70 percent reduction in file size. You can even reduce different portions of an image to different color depths. Netscape, Mac OS, and Windows palettes are built-in for fixed palette reduction. The final kicker is that the plug-in displays size and download time estimates with each change of settings, so you will never have to guess what the effect of any changes may be. Digital Frontiers does not recommend ColorGIF with less than 16 MB RAM, or on a non-FPU 68K Mac OS computer. Without either a floating-point processor or a PowerPC chip, adaptive reductions will be quite slow—although the product is still useful for high-quality fixed palette reductions. HVS JPEG is another tool that incorporates Digital Frontiers's HVS

technology. Unlike HVS ColorGIF, HVS JPEG is a filter plug-in and is, therefore, found in your image-editing program's filter menu.

More File Translations

Ulead System's PhotoImpact is a Windows-based image-editing program that accepts Photoshop-compatible plug-ins. The company also produces several packages of plug-ins for making photographs and graphics images ready for the World Wide Web. Recently, the company combined its GIF SmartSaver and JPEG SmartSaver plug-ins into a single one that optimizes GIF, JPEG, and PNG images by providing a balance between file size and image quality. In the plug-ins dialog box, there are three buttons—one for each file format—that allow you to move between tabbed menus specific for each file format. Ulead Smart-Saver 3.0 provides optimization options that let you set the desired file size and appearance. To see how these changes affect the image file, two large preview windows show before-and-after comparisons. Tools are provided for zooming, scrolling, and centering, so you can examine your image in detail. Above the previews you will see a size comparison of the compressed and uncompressed image. An "options" tab lets you choose interlaced GIF or progressive JPEG options. JPEG compression controls allow you to find the best quality at the best compression. You can change quality settings by dragging on the quality slider and choosing between various types of compression. If you do not have Ulead's PhotoImpact 4.0 or any other Photoshop-compatible program installed on your computer, you can use the SmartSaver plug-ins along with Windows Explorer to optimize existing images. Just right-click on an image and choose "open to SmartSaver" from the Explorer pop-up menu. You can download a fifteen-day trial copy from Ulead System's homepage at *www.ulead.com*.

Ping!

When CompuServe and Unisys started charging royalty fees for the compression algorithm in the formerly free GIF file format, a group of independent graphics developers formed a coalition to create an improved royalty-free file format. The result their efforts was PNG (pronounced "ping"), a flexible and open format for storing bitmapped graphics images. PNG offers several benefits over GIF, starting with the fact

that PNG's compression method was thoroughly researched and judged free from patent problems. PNG's feature set allows compatibility with GIF files and provides support for true color and alpha channel storage. In general, PNG files are also smaller than GIF files. The format also offers a new and what the developers feel to be a more visually appealing method for progressive display. The format has been slow to be adopted, but more and more graphics programs and converters like Ulead's SmartSaver plug-in support PNG. What's more, fewer new image-editing programs, such as KPT Photo Soap, support GIF.

Ulead's WebRazor for Photoshop is a package of Windows-based filter and acquire plug-ins that provide easy-to-use tools for creating Web graphics—including animations. Some of WebRazor's features include seamless Web page tiles for backgrounds, drop shadows, colorful frames, fractal designs, irregular-shaped image maps, and Shift Image, which can be used with graphics to create backgrounds. The plug-ins add a Web menu item to your menu bar and allow you to easily access all the plug-ins. WebRazor also includes Button Designer to create 3-D beveled buttons and add embossed and 3-D effects to text and selections.

Web Site Case History

Tom Chambers has more than twenty years' experience in the media/communications field and as a visual artist/documentary photographer. He has had thirty-three exhibitions in the United States, Zimbabwe, and South Korea. "I make documentary images," he told me, "and from time to time, combine the medium of photography with other media to offer a conceptual study. I do mostly documentary portraiture/street shooting of people, such as my 'Dyer Street Portraiture' (listed in the 'Notable Exhibitions' section of *American Photo* magazine, March 1986), 'Descendants/350' (accepted as a part of the Rhode Island State Archives), 'Southwest of Rusape: The Mucharambeyi Connection' (accepted as a part of the U.S. Information Service Archives), and 'People to People' (accepted as a part of the Kumho Art Foundation Archives series).

Tom has only a recent involvement in the Internet, setting up his Web site in the summer of 1997. He created his homepage through a desire to project and share his projects with other people. The computer he used was an Acer 486 IBM-PC compatible computer with 64 MB RAM.

Figure 23. Tom Chambers's Web site (www.geocities.com/SoHo/Studios/2841/index.html) provides a look at his documentary photography.

"I learned HTML," he told me, "through study and trial and error, and I continue to learn and upgrade my homepage." It took him two months to create and have his Web site up and running. He makes changes and upgrades almost on a daily basis to present his visual and textual information as best as he can.

He was honest in telling me that it takes time to make a Web site fully functional. "I average probably four to five hours a day working on the site, and also surfing the Web to make connections." It does take time, but he admits, "this is due to my constant grooming of and addition of information to the site." The site had only been active for two months when we spoke, but he is satisfied with the results so far. "In just two months, I'm listed/linked with several search engines; linked with numerous colleagues; listed visually/textually with several sales photo art sites; linked with PhotoForum, which has culminated in two online exhibitions; linked with Photo Request, which will culminate in a 'Featured Photographer' page about me this coming October; linked with PhotoFlex, and ongoing discussion has resulted in the possibility of me

becoming a faculty member to teach documentary photography as a part of their curriculum online; and linked with ExpatExchange, and ongoing discussion has resulted in the possibility of me collaborating to offer photographic information for Expat students worldwide. As I continue to surf the Web, I foresee the possibility for more involvement and consequently, exposure."

I asked him if he was pleased with the results. "Yes, I'm pleased, and I'll definitely expand my current 2 MB (Web site size) to 10 MB so I can continue to expand my visual/textual information. The Internet is definitely a constructive and productive tool to project and market a product—and in my case, it's visual arts and documentary photography." You can visit his site at *www.geocities.com/SoHo/Studios/2841/index.html.*

Sites Mentioned by Tom Chambers

- PhotoForum: *www.rit.edu/~andpph/photoforum.html*
- PhotoRequest: *www.photorequest.com/*
- ExpatExchange: *www.expatexchange.com*
- Photoflex: *www.photoflex.com*

Blowing Your Own Horn

If you think that all you need to do is create an attractive Web site and the phone will start ringing off the hook with assignments or stock photo sales, you're in for a big surprise. Having a Web site can help increase your sales, but you can't expect potential buyers to find your site among the two thousand created each hour. The next step after creating your Web site is getting the message out to the world that you have a storefront open and alive on the Internet. This has to be followed with regular maintenance of the Web site and an active program of letting search engines companies know about your new homepage.

TIP: The Photo Request Web site

By registering as a photographer on the Photo Request Web site, not only are your photographic images posted on the site, but registered photographers also have access to the request board, where they may pick and respond to requests made for certain types of photographs. A profile of each photographer is also posted on this Web site. Registered photographers are also able to enter photography contests,

Figure 24. Take Tom Chambers's advice and register your images with the Photo Request Web site at www.photorequest.com.

become judges for these contests, become the featured photographer of the month, and have their articles posted on Photo Request. The photographer's profile and photographs are available to viewers around the world, twenty-four hours a day, seven days a week. Registered viewers can submit requests to Photo Request for a particular photograph or photographs. There is no charge for making this request. Registered viewers are also able to enter contests and submit articles dealing with photography.

Your new Web site is, in effect, a new office location; you should start by using the same kind of marketing techniques you would do if you opened an office out of state. You should send out a mailing specifically informing existing and potential clients about your Internet presence. The first group to receive notification should be your existing client database. If you don't already have such a database, now would be the right time to start one. (See chapter 5 on setting up a client database.) As mentioned earlier, 80 percent of your business typically comes from twenty percent of your customers, so your Web site should introduce your existing clients to the new digital services you are offering. If all

you're doing is studio portraits but would like to expand your service offerings, make sure the Web site features on-location work. Existing customers are the easiest group to sell to. They already know you, like you, and have proven it by paying for your services.

The next group to send announcements to consists of potential clients that you may have pitched but haven't taken the plunge yet. An Internet homepage may provide them with the reason to take another look at you and your work. Finally, there are those potential clients you don't know. These names can come from purchased mailing lists, chamber of commerce membership rolls, or "lead" groups such as Le Tip.

A new Web site is a great excuse to update your business cards and letterhead to feature your new Web site URL and e-mail address. While this sounds like a seemingly obvious point, I am often given business cards on which people write their Web site address on the back with pencil. Spending money on new cards is a small investment for a small piece of advertising that tells people about your new Web site. Want to design good-looking business cards or promotional materials? Stop by PaperDirect's Web site at *www.nyca.com/paper.html*. You've already got a computer and if that's connected to a laser or inkjet printer, you can create professional-quality marketing material on your desktop using PaperDirect's paper products and software templates. Be sure to add your Web site URL to anything that bears your name and address. This includes assignment confirmation/estimate forms, rate sheets, price lists, packing lists, and transmittal forms.

Take an ad out in local business publications announcing your Web site is in operation and inviting people to come see for themselves the kinds of images you can create. This technique may allow you to get potential buyers looking at your work who may never have seen your images using conventional print portfolio methods. Don't forget to include it in your Yellow Pages ad!

Your homepage must be dynamic. Next to not publicizing your Web site, the worst thing you can do is not make changes to your site. No matter how great the first images potential buyers see when they reach your homepage, if they visit more that once—and are on the edge of becoming a paying customer—they need to see something different the next time. That's one reason why it's a good idea to include a tagline on your Web site that states "Last updated" If the date is a recent

one, second visitors are more likely to give you a second look. Why not create an archive of past images? That way new visitors can also see some of these images. Providing access to past images is simple. You only need to create a link to a new page that has small images from previous months, and give viewers the ability to double-click on the small image to take them to another page containing a larger version of the image.

The Internet and World Wide Web are subjects too big to be covered completely in these two chapters. If you are interested in having the Internet become an important part of the reengineering of your studio, you might want to pick up a copy of my book *The Photographer's Internet Handbook,* which is also available from Allworth Press.

The Final Word

I would like to end the book with some advice that will help you climb the ladder of success. Don't think of them as rules, think of them as "rungs."

There comes a time in every studio's life when its business growth curve starts to flatten. Maybe you've experienced it already? If not, sooner or later you'll reach a plateau where you seem to be doing the same things over and over again. The danger with being in this position is that if you allow complacency to take over, you'll find yourself losing clients with no plans on how to replace them. When my own studio ran into a slump, I developed a five-rung success ladder that I used to increase my business's growth. Nothing that you will find in the ladder is really new or revolutionary. It contains the kind of basic promotions or business practices you should already be doing, but have either been too busy or perhaps, too lazy to do. Here they are in no particular order of importance:

Rung one: keep your customers satisfied. You don't need a Harvard M.B.A to know that it's a lot cheaper to keep your existing clients than to go out and find new ones. My first step of this rung was to send a thank-you letter to all of those clients who had spent any money with our studio during the past eighteen months. Although generated on our Mac OS computer, this was not a form letter. Each letter was individually addressed to a specific client, and included a handwritten P.S. In the letters, I told the clients how important they were to the studio

and how much I appreciated their business. I also used this opportunity to tell them about what was new at the studio, such as our recent move into digital imaging. While a letter like this may seem to be no big deal, ask yourself when was the last time one of your suppliers told you how much it appreciated your business? This has become part of our ongoing program of doing some kind of reminder ("Hey, we're out here") mailing to our existing client base every six months or so.

Rung two: a new look. One of the best ways to pull yourself out of the emotional side of a slump is to change the way your studio visually presents itself to existing and potential clients. When was the last time you updated your studio's letterhead and business cards? In our case, it was four years ago, and our logo started looking stale. For our new look, we hired a designer. All our previous designs involved a trade-out (photography for artwork) with a friendly art director. While we always got a good job, it seemed that this designer worked harder when the payment involved real money. The new look was used on obvious things like letterhead, envelopes, business cards, and originally on the Web site. The artist delivered the design in digital form, so I could add it to computer-generated documents like invoices, assignment confirmations forms, and proposals.

Rung three: increase your sales force. Hire a salesperson. In most small studios, sales ends up being handled on a part-time basis by one of the owners. Having someone who is not the photographer make sales calls adds a touch of credibility when talking with perspective clients— which is usually not the best use of a studio owner's time. Moreover, having someone selling 100 percent of the time can smooth out the roller-coaster cash flow that seems to plague most small photographic studios. Hiring a salesperson isn't easy, but it's not impossible.

Rung four: begin a PR blitz, and keep it up. There is an old Southern expression that goes, It's a poor dog that won't wag its own tail. Get in the habit of sending monthly press releases to local print media. It can be anything from the announcement of hiring of a new employee to the receiving of an award from your peer group. Be sure to include photographs! That will increase your chances that the publication will run the release, and give you more page space when they do.

Rung five: branch out! If your local economy is in the doldrums, you don't have to consider opening an office in another city or state. Open a Web site.

Afterword

Several Words You Can't Say to Photographers

George Carlin built a career talking about the "seven words you can't say on TV." Howard Stern later made them part of his film *Private Parts.* Over the years, I acquired a smaller reputation by publicizing the phrases—clichés you may call them—that have become ingrained in contemporary business language. When they are used against photographers, it is always to take advantage of our generally obliging nature.

You are already familiar with the three biggest lies. Well, one of them is the best and most abused example, The check is in the mail. As creative types, it's important that we be aware that many of these statements, even if said in good faith, harbor deeper meanings. All of this was running through my mind when our sales rep was telling me about a meeting with a potential client. "It'll be good exposure," the guy told Lenny. To me, "good exposure" is f/8 at ⅛ of a second. To Lenny, good

exposure means possible future commissions; but what the client really meant is, We're trying to get the job cheap, and maybe if a miracle happens you might get another job from us. Here, then, is my version of Business English 101 with translations thoughtfully provided by me with the hope that you will know what they mean when someone uses these phrases on you.

- *We're a nonprofit organization, so we expect a discount.*

 I heard this one just today. He did not say, "It'll be good exposure," but the translation is the same. I think I'll try this one on my photo lab when we're having a slow month: Hey, Kevin, we're not making much money this month. Why don't you cut our lab bill? I can hear him laughing now. Yet this same argument has been given to me over and over—with a straight face. Sometimes when the person speaking these words is sincere and business is slow, you give in. But every time I have gone against my instincts on this one, it's taken a long time to get paid. So what do you tell this person? I start by telling him that more than half of our clients are nonprofit organizations, so we know how to work with them. If he persists in trying to beat us down on price, I tell him that he may be a nonprofit organization, but we're not. At that point, be prepared for that individual to lose his sense of humor.

- Here's one for visual communicators: *I need to have the presentation done in the next two days. I'll have everything you need for it by the end of the day.*

 What is really meant is that he has not started working on the project yet, and talking to you is the first step. Unfortunately, at this point, the client usually feels he has done everything he needs to, and will get his presentation ready the night before the showing.

- *I need this job shot today, and the negatives sent to me overnight.*

 This statement has many ramifications—all of them bad. While this seems an ideal application for digital cameras, what the client may mean is, We want to buy all rights to the assignment without paying for them, and you have to wait 120 days to get paid. Here's how I protect myself in this situation. "All rights" assignments are expensive, so I double my day rate. If a new client wants negatives or digital files, they are C.O.D. with payment made by check or credit card. If you are not sure about a new client's

financial accountability, ask for a bank or certified check. Under this kind of deadline, I fax an agreement to the client, which states payment would be C.O.D. by credit card. If the client really wants the work done, he or she signs it and faxes it back. Even though we rarely use our Visa or MasterCard merchant account, it pays off every now and then.

I can hear some of you now: If I do all this, I'll upset the clients— then they'll take their business elsewhere. That's true, and maybe that's the best thing that could happen to you. Nobody ever made any money (or even a living) doing work for free or cheap. Clients are not always right. Too many corporate types are insulated from the real-world financial demands of what it's like to own one's own business. Some of this businessspeak is intentional, but an equal amount is naïveté. It's up to all of us to educate clients about the realities of business. You do not have to be a S.O.B. to do this; all you need to do is explain your policies simply and politely, up front. Another thing that would help is speaking in plain English. Skip the buzzwords. Clients don't care about short lighting, TIFF files, or chromogenic film. They only care about what the finished product will look like. It's up to us to explain our implementation of their projects in our verbal and written communications. To test yourself, try talking to a friend who is not in the business the way you talk to a client. If your friend understands you, that's great. If not, it's time to evaluate your communications skills.

Appendix A

The Home-Based Digital Studio

If success in real estate is based on three factors (location, location, and location), success in the home-based studio or small office/home office (SOHO) environment is based on four. Those factors are finance, organization, communication, and marketing. It is not enough to be the master of just one or two of these areas, the truly successful SOHO business owner must be able to conquer all four. The rest of the book addressed most of these four areas. In this appendix, I want to share some tips involving communication and provide tips on making your home studio not only successful but livable.

In the wake of corporate downsizing, working at home is a dream many Americans harbor, but not everyone is suited to having a home office. Some find there are too many distractions—lawns to cut, cleaning to do, and errands to run. On the other hand, to those that revel in doing spreadsheets in sweats and word processing in pajamas, and can handle

the diminished human contact, there is no better life. Sure, there are challenges. One of the biggest will be how to handle the lack of personal interaction without becoming agoraphobic. This is easier to fall prey to than you might think; I watched a dear friend succumb to this mania.

Communications

The most important aspect of a successful work-at-home career is communications. Effective communication is your only link with other human beings and will have a major impact on the success of the marketing and operational aspects of your business. You need it all—voice, data, fax, and e-mail, but you do not have to go broke doing it. The following suggestions are based on the least-cost ways of accomplishing the best possible communications flow.

Let's start with your telephone. Bite the bullet and have a second line—a business line—installed. This will get you listed in the Yellow Pages and keep the kids from tying up your line when they are home from school. Even if you do not have any children, having a dedicated business line provides additional flexibility for your communications system. Get an answering machine or voice mail. Your telephone should be a cordless model, so if you briefly leave your home office—for any reason—you can carry the phone and still answer any important calls you are expecting. Do not get call waiting. It says to your clients, Excuse me, I have to take a call from someone who may be more important than you are. Do get caller ID. It allows you to screen calls and can be programmed to divert telemarketing calls that will be the main source of incoming calls during the early months of your new at-home business. Caller ID also lets you answer the call with the person's name or just be prepared for who is calling.

TIP: Get a Yo-Yo

Big Island's YoYo is a telephony tool that connects to the serial port of a Windows 95 or ADB port of a Mac OS computer. YoYo works with POTS (plain old telephone service) that has Caller ID service. One of the biggest problems facing work-at-home people is interruption by people they do not want to be interrupted by. YoYo's Caller ID feature tells you who is calling before you pick up the telephone. YoYo displays the Caller ID information on your computer screen—instead of a little box with a LCD panel. This allows you to prepare for the call before picking up the phone or ignore it, allowing it

to go to an answering machine or voice mail. (Telemarketers never leave a message.) YoYo can also play custom ringing sounds depending on who's calling, or send a message to your pager with the caller's number (and name, if you have an alphanumeric pager). YoYo lets you dial from a list of important phone numbers with the click of a button, using either the YoYo software or any one of a number of contact management applications. Every incoming call is also logged to a file that can be printed or sorted to account for time spent on the telephone. This logging feature can be valuable for time management and for client billing. The newest version of YoYo Telephone Manager software (Mac OS only, as I write this) includes multiline support allowing up to six telephone lines to be managed by a single Mac OS system. Unlike a modem, YoYo has flash memory in its hardware that can log up to a hundred calls, can forward calls to a pager or alternate telephone, and control the ring of the phone during certain hours—even while the computer is off.

Unless you expect to receive very few faxes each day, purchase a separate fax machine. Fax modems are just too slow for incoming use and can tie up your computer. Buy a combination fax/answering machine that automatically recognizes the difference between a voice or fax call. Have the telephone installer (or yourself, if you are handy) install a jack for the home line in your office when they are installing your business line. Even inexpensive fax/answering machines, like the Sharp UX-255, can be programmed not to ring so the ringing will not interfere with any telephone conversations you might be having on your business line. If a fax comes in outside of business hours and someone answers the home line only to hear fax tones, pressing *5* transfers the fax to the Sharp UX-255.

You are going to need a modem for e-mail and Internet access. Get the cheapest, fastest, no-frills model you can. Forget voice mail features and other bundled software. All it does is bottle up your computer—who needs it? Go for the hardware. The model half-life of modems is fast approaching that of digital cameras—four and one-half months—so save your money. The speed of transmission will, in most cases, be limited by the analog network you are connected to, not the modem. Using a "splitter" you can purchase at Radio Shack lets you plug your modem into the same line your fax machine is using.

Develop a Healthy Work-at-Home Attitude

Your office should have a window so you can see what is going on outside. This feature is important to maintaining a healthy emotional outlook, but your choice of available space may be limited to what space is available in your house. If you don't have any windows, make some. Hang large prints or posters on the wall. While your lab is cranking them out, go to the nearest "Posters 'R' Us" store and pick up travel posters from England, Germany, Hawaii, or Colorado to create your own "window on the world."

Set office hours and develop a routine. You used to have regular office hours, so you need to develop a schedule for your home office. Stick to it, but recognize that just as in your old office job, some overtime may be required from time to time.

Get the best ergonomic chair you can afford. A chair that provides the best back support will keep you comfortable, healthy, and productive.

Listen to your favorite kind of music during the day. Don't use a radio because commercial interruptions will, well, interrupt your mental activities. Instead, use your computer's CD-ROM player to play music CDs. Connect a set of speakers to the computer to make it sound better. As I write this, I am using Bose MediaMate speakers to listen to Carly Simon sing "Nobody Does It Better" (no kidding).

Schedule occasional breaks too. Don't lock yourself in the office all day, get out to meet people—even if just to go to the local post office or Wal-Mart. Schedule visits to pick up office supplies, send mail, buy stamps, or visit the local FedEx drop-off point to break up your morning or afternoon activities. You will accomplish something, get some fresh air, and human interaction, all at the same time.

If you are not allergic, get a dog or cat to keep you company during the day. Having a pet will lower your blood pressure. Staying healthy is important for the at-home worker because it's more difficult to "call in sick." Having a dog is also an excuse to take advantage of my next suggestion.

Take a two- to three-mile walk each afternoon or morning. A walk helps clear the mind and, at the same time, when your mind relaxes, you will manage to get some of your best ideas. A regular walk will get you outside to smell the fresh air and provides the benefit of a regular exercise program. That's one of the best ways to help you live longer and prosper.

Appendix B

Glossary

Like other technical and artistic disciplines, professional photography has its share of jargon. As photographers, we "shoot" brides and kids, "bracket" these shots, and apply "Zone IV" interpretations to an image on "sheet" film that's processed using "N + 1" development. Yet surprisingly, when digital photography became practical, we could not even agree on a name for it. Was it digital imaging, digital photography, or as one wag put it, pixography?

Digital imaging is the next logical extension of the kind of camera and darkroom techniques that photographers have been using for over a century. The tools may appear different, but they are no more of a radical change than late-nineteenth-century daguerreotypists encountered when they switched from dipping their silver-plated copper sheets into mercury vapor to using glass-plate negatives coated

with albumen. Here's an abbreviated look at some digital imaging terms, ranging from analog to Zip.

Aliasing Sometimes when a graphic is displayed on a monitor, you will see jagged edges around some objects. These extra pixels surrounding hard edges—especially diagonal lines—are caused by an effect called aliasing. Techniques that smooth out these "jaggies" are called antialiasing.

Analog Information presented in continuous form, corresponding to a representation of the "real world." A traditional photographic print is an analog form, but when this same image is scanned and converted into digital form, it is made up of bits.

Archive To copy any kind of data from the media on which it is stored (typically a hard disk) to a removable-media cartridge or tape for backup purposes. Archive and backup software often compress data to maximize the capacity of that storage media.

ASCII American Standard Code for Information Interchange. ASCII is a standardized computer code for representing text data. The code has ninety-six displayed characters (characters you see on the screen) and thirty-two nondisplayed characters (some of which you can see, others that you cannot).

Binary A mathematical system based on the numbers 1 and 0. This is ideal for computers, because electrical signals can be represented by electrical current being positive and negative, on and off.

Bit Binary digit. The smallest unit of information with which a computer can work. Computers are digital devices because they represent all data—including photographs—using numbers, or digits, that are measured in bits.

Bitmap The three classes of graphic files are bitmap, metafile, and vector. A bitmap (sometimes known as "raster") is any graphic image composed of a collection of tiny individual dots or pixels—one for every point or dot on a computer screen. The simplest bitmapped files are monochrome images composed of only black and white pixels. Monochrome bitmaps have a single color against a background, while images displaying more shades of color or gray need more than one bit to define the colors.

Byte Each electronic signal is one bit, but to represent more complex numbers or images, computers combine these signals into larger 8-

bit groups called bytes. When 1,024 (not one thousand) bytes are combined, you get a kilobyte, often called KB.

Calibration A term used in color management systems (CMS). Calibration stabilizes the inevitable variables in the way devices reproduce color. To produce optimum results, all color-reproducing devices must maintain a consistent, calibrated state. A variety of calibration products are available depending on the device and manufacturer. Some monitors, such as the Radius PressView include the necessary hardware and software to maintain color calibration.

CCD A charged-coupled device is the kind of light-gathering device used in flatbed scanners, digital cameras, and video camcorders to convert the light passing through a lens into the electronic equivalent of the original image. Some small-format digital cameras use a full-frame 24 × 36mm CCD imager to deliver 36-bit color (12 bits per RGB color) digital images. The Sinar/Leaf CatchLight large-format back uses a 1.2 × 1.2-inch (3 × 3 cm) CCD chip to capture color images at 14 bits per pixel or 42-bit color. For pixel counters, this generates an image containing 4 million pixels at a resolution of 2,048 × 2,048 pixels.

CD-R Compact disc recordable. CD-R media is write-once-read-many-times (WORM). WORM media is different from the other media covered in this book because it cannot be erased. Writing a CD-R will take longer than writing magnetic media, but you don't have to fill up a disc all at once. Several sessions can be written to the same CD-R. A CD-R disc can be read by anyone's computer.

CD-ROM Compact disc read-only memory. This is a disc that resembles a musical CD-ROM but contains all kinds of data—including photographs. The drives that use CD-ROM discs are called CD-ROM drives.

CD-RW Compact disk rewritable. CD-RW drives are expected to be the next big thing for computer users and especially for photographers. CD-RW drives are, in essence, multiformat drives. You can read conventional CD-ROM discs, write CD-R discs, and write and erase data on CD-RW discs. CD-R and CD-RW media are interchangeable in most drives and the durability of CD-RW media equals that of any CD.

CGM Computer graphics metafile. This is a vector graphics format designed to be portable from one Windows or DOS-based program to another.

CLUT Color lookup table. A table—it can be in hardware or software

form—that contains information on the mixing of red, green, and blue color intensities in a palette.

CMYK Cyan, Magenta, Yellow, and Black. Blame this acronym on the same printing industry that saddled us with "picas." When added together, the primary additive colors of red, blue, and green produce white light. In the areas they overlap—red and blue form magenta, green and red produce yellow, and green and blue create cyan. These resulting colors are subtractive, and filters using varying intensities of the colors are used when making Type C prints from color negatives. When the subtractive colors are added together, they form, not black, but a dark brown. That's why black must be added for accurate photographic reproduction. For reproduction, an image must be separated into varying percentages of cyan, magenta, yellow, and black, which is why CMYK film output is called separations.

Compression Compression is a method of removing unneeded data to make a file smaller without losing any data, or in the case of a photographic file, image quality. There are many techniques and technologies for compressing graphics, and how well each works depends on what is more important to you: file size or image quality. JPEG was designed to discard information the eye cannot normally see and is what the techies call a "lossy" method. By comparison, LZW compression is lossless—meaning no data is discarded during the compression process.

Cookie Whenever you visit a World Wide Web site, a short message may be left behind on your browser. The message, called a cookie, resides on your browser to be read by the Web site when you call back. The cookie tells your e-mail address, where you've been on the Internet, and how often you've been there. A cookie stores information on user's Internet activities, often without their knowledge or approval. This can be a source of e-mail addresses for sending unwanted e-mail or spam.

CPU Central processing unit. There are two basic families of CPUs: Intel and Motorola. Intel and similar chips are used in IBM-compatible PCs, while Motorola makes the chips for Mac OS machines. How well a chip processes data is determined by how many bits of information it can process at one time. The larger the number of bits a chip can process simultaneously, the faster it can process. Think of it as a highway. The more lanes you provide, the more cars can

travel on it at one time. A 32-bit CPU, for example, processes data twice as fast as a 16-bit model. The next most important aspect of the CPU is how fast it processes data. This is measured by the CPU's clock speed. If the path defines the number of lanes on the highways, the clock speed defines how fast the cars can travel on those lanes.

Device resolution Refers to the number of dots per inch (dpi) that a device, such as a monitor or printer, can produce. Device resolution for computer monitors varies from 60 to 120 dpi. Do not confuse this with screen resolution, which refers to the number of dots per inch in the line screen used by printers to reproduce a photograph. Screen resolution is measured in lines per inch (lpi). Image resolution refers to the amount of information stored in a photograph and is expressed in pixels per inch (ppi). The image resolution of a photograph determines how big the file is. The higher the image resolution, the more disk space it takes and the longer it will take to output.

Dither A graphics display or printing process that uses a combination of dots or textures to create the impression of a continuous-tone grayscale or color image.

DRAM Dynamic random access memory. *See* RAM.

Drum scanner When quality is most important—and cost not an object—drum scanners will produce the highest possible resolution from your photographs. The photomultiplier tube used in drum scanners is more sensitive than the CCDs used in flatbed scanners, and can produce resolutions up to and beyond 8,000 dpi. An original is attached to a drum that is spun, and a scanning head travels along the length of the image. Light is directed from the center of the cylinder when scanning slides and transparencies. For opaque items, a reflective light source is used. Because of their high cost, you are more likely to see a drum scanner at a service bureau or printer than at a photographer's studio.

Dynamic range This is a key feature to look for in a scanner or digital camera. A scanner's dynamic range depends on the maximum optical density that can be achieved and the number of bits captured. In simple terms, the greater the density range, the better the scanner. Until recently, only expensive slide scanners offered a density range over 2.5, but now more affordable scanners perform at 3.0 or higher. By comparison, a Photo CD scan has a dynamic range of 2.8.

EDO DRAM Extended data output DRAM is popular in Windows-based

computers. EDO DRAM sends out data—even if a controller loads more data in vacant addresses.

EMF Electromagnetic field. If you spend more than a few hours at your computer a day, you should be aware of the potential problems caused by the electromagnetic fields that computer monitors produce. All monitors emit some kind of very low frequency (VLF) and extremely low frequency (ELF) radiation, and color monitors emit more than monochromatic ones. A cathode-ray tube (CRT) releases most of its radiation from the sides and back of the monitor. That's why it's a good idea to sit four or five feet away from your monitor. For most people, that's not possible, but you should at least keep it at arm's length. You will sometimes see screen filters that purport to block radiation from computer monitors, but even lead cannot stop some ELF and VLF waves.

EPS, EPSF Encapsulated PostScript format. A metafile format for graphics files that contains two elements: the bitmapped image and the PostScript code that tells your printer or output device how to print the image. This file type is designed to be imported into another application, such as a desktop-publishing program.

Film recorder Color film recorder, sometimes called CFR. A desktop film recorder is essentially a camera enclosed in a small box and focused on a very high-resolution, black-and-white monitor. The CFR makes three exposures of the image through separate red, blue, and green filters to produce the final image. If this sounds slow—it can be.

FPM DRAM Fast page mode DRAM is the most common type that is used in Mac OS systems because it speeds the overall readout of data but does introduce a wait state.

Gamma All photographs have a characteristic called gamma. The amount of gamma present in an image is measured as the contrast that affects the midlevel grays (the midtones) of an image. The good news for digital imagers is that this gamma is adjustable by most image enhancement programs, and you aren't stuck with the gamma that is present in the original negative or print.

GIF (pronounced like the peanut butter) Graphics interchange format developed by CompuServe is completely platform independent: the same bitmapped file created on a Macintosh is readable by a Windows graphics program. A 256-color GIF file is automatically compressed making it ideal for use on the World Wide Web.

Gigabyte A billion bytes or (more correctly) 1,024 megabytes.

Grayscale Refers to a series of gray tones ranging from white to pure black. The more shades or levels of gray, the more accurately an image will look like a full-tone black-and-white photograph. Most scanners will scan from 16 to 256 gray tones. A grayscale image file is one-third the size of a color one.

GUI Graphical user interface

Halo When using a selection tool in an image-enhancement program to select certain kinds of objects, a halo can appear around part of that selection. These extra pixels are created by the program's antialiasing feature. Most image-enhancement programs have a built-in antialiasing function that partially blurs pixels on the fringe of a selection and causes additional pixels to be pulled into the selection.

Indexed color Indexed color images either have a limited number of colors or they are pseudocolor images. The number of colors for the first type is usually 256 or less. Pseudocolor images are grayscale images that display the variations in gray levels in colors rather than in shades of gray, and are used for scientific and technical work. CompuServe's GIF format uses an indexed color scheme. Before image-enhancement programs, like Adobe Photoshop, can use GIF files, they have to be converted into RGB.

Inkjet In an inkjet printer, a print head sprays one or more colors of ink onto paper to produce output. The type of methods used to accomplish this has an effect on output quality. Piezoelectric technology is based on the property of crystals to oscillate when subjected to electrical voltage. This allows a printer using this technology, such as Epson's Stylus Color family of printers, to place uniform ink droplets on paper and deliver output at up to 1,440 dots per inch (dpi) resolution or higher. The drop-on-demand method uses a set of independently controlled injection chambers—the newest of which use solid ink—which liquefies when heated, and solidifies when it hits paper. This thermal approach is favored by Canon, Apple, and Hewlett-Packard. Another method is the continuous-stream method, which produces droplets aimed onto the paper by electric field deflectors. The weak link of all inkjet printers, large or small format, is fading from UV radiation and susceptibility to water damage. These limitations can be overcome by laminating the finished print.

JPEG An acronym for a compressed graphics format created by the Joint Photographic Experts Group within the International Standards Organization. Unlike other compression schemes, JPEG is what the techies call a "lossy" method. By comparison, LZW compression used in file formats such as GIF is lossless—meaning no data is discarded during compression. JPEG achieves compression by breaking an image into discrete blocks of pixels, which are then divided in half until a compression ratio of from 10:1 to 100:1 is achieved. The greater the compression ratio, the greater loss of sharpness you can expect.

K In the computer world, K stands for 2 to the 10th power, or 1,024. A Kilobyte (KB) is, therefore, not 1,000 bytes but 1,024 bytes.

Landscape (mode) An image orientation that places a photograph across the wider (horizontal) side of the monitor or printer. A photographer would call this a horizontal image, but a computer user would say "landscape." Antonym: portrait or vertical. Most computer screens are horizontal, but Radius makes a monitor, called the Pivot, that uses a mercury switch that changes the orientation as the user physically rotates it from portrait to landscape.

LZW Lempel-Ziv-Welch. A compression algorithm used in the GIF format that is currently owned by Unisys.

Macintosh The two general classes of small computers are those built to the IBM standard and those that comply with the Mac OS standard. Apple Computer's personal computer, introduced in January 1984, was the first popular computer—the ill-fated Xerox Star was probably the first—to use a graphical user interface and mouse-pointing device. Beginning in 1995, Mac OS computers were built by other companies, such as Power Computing, that have licensed Apple's technology, although Apple has since chosen not to renew those licenses.

Mask Many image enhancement programs have the ability to create masks—or stencils—placed over the original image to protect parts of it and allow other sections to be edited or enhanced. Cutouts or openings in the mask make the unmasked portions of the image accessible for manipulation while the mask protects the rest.

Megabyte When you combine 1,024 kilobytes, you have a megabyte (MB) or "meg."

Memmaker Memmaker is a utility that optimizes memory on 386-based

computers (and newer machines) by determining the best order to load Terminate and Stay Resident (TSR) programs and drivers in the upper memory area (UMA).

Metafile This file type accommodates vector and bitmapped data within the same file. While popular in the Windows environment, Apple's PICT format is also a metafile.

Moiré (pronounced "mwah-RAY") Moiré patterns are an optical illusion caused by a conflict with the way the dots in an image are scanned and then printed. When scanning an original photograph or artwork, a single-pass scanner is all most people require, but when scanning material that has previously been printed, a three-pass scan (one each for red, green, and blue) will almost always remove the inevitable moiré or dot pattern. Moiré is a French word that means "zis pattern zat drives ze eyes crazy!"

Nano- A prefix that means one-billionth.

Netiquette Etiquette on the Net. When corresponding via e-mail and messages posted on online services or the Internet, a certain level of civilized behavior is expected. If you get loud or profane, expect a stern warning from the Sysop or you may be barred from the forum or BBS. Sending Spam is considered the most major violation of netiquette. *See* Spam.

One-off A CD-ROM that is made one at a time instead of being stamped from a glass master disc the way discs are usually made in volume. When a new CD-ROM is in production, a test disc—or one-off—is created for approval purposes. CD-ROM recorders (CD-R) are sometimes called one-off machines because they write a single disc— one at a time.

PC-compatible A personal computer compatible with IBM-PC standards. Originally used in the early years of personal computing when the amount of compatibility varied greatly. Today's PC-compatibles conform to standards originally set by IBM, but over time have been modified by the industry itself. Sometimes you will hear such computers called "clones," but that term has taken on a pejorative tone as computer makers, such as Compaq, outsell IBM brand computers.

PCX Is not an acronym—it doesn't mean anything. It's a bitmapped file format originally developed for PC Paintbrush. Most Windows and DOS graphics programs read and write PCX files.

Photo CD Kodak's proprietary process that places digitized files of photographs onto a CD-ROM. Photo CD facilities can digitize images from color slides and black-and-white or color negatives. A Photo CD transfer station converts your analog images into digital form by using a high-resolution film scanner, a computer, image-processing software, a disc writer, and a color thermal printer. Each image is adjusted for color and density, compressed to 4.5 MB using Kodak's Photo YCC format image, and written to a CD-ROM. A thermal printer creates an index sheet showing the images transferred to disc and is inserted into the cover of the CD's jewel case. Initially there were six different kinds of Photo CDs, now there are two: the Photo CD Master disc and the Photo CD Portfolio II disc. The Photo CD Master disc format holds one hundred high-resolution images. The disc writer writes five different file sizes (and five different resolutions), which Kodak calls Image Pac, onto the CD:

- Base/16— 128×192 pixels
- Base/4—256×348 pixels
- Base— 512×768 pixels
- Base*4— $1,024 \times 1,536$ pixels
- Base*16— $2,048 \times 3,072$ pixels

A subset of this disc type is the Pro Photo CD Master disc, which accepts images from 120 and 70mm rolls and from 4×5 sheet film. The Pro disc includes built-in copyright protection and offers a sixth, Base*64 resolution image that yields a size of $4,096 \times 6,144$ pixels.

PICT Another meaningless acronym, this time for a metafile file format. A PICT file contains both bitmapped and vectors information. PICT files are excellent for importing and printing black-and-white graphics, like logos. When used with continuous-tone images, sometimes they work and sometimes they don't.

Pixel *Pixel* is an abbreviation for *picture element*. A computer's screen is made up of thousands of these colored dots of light that, when combined, can produce a photographic image. A digital photograph's resolution, or visual quality, is measured by the width and height of the image measured in pixels. When a slide or negative is converted from silver grain into pixels, the resulting image can be produced at different resolutions.

Plug-in The open-ended design of Adobe Photoshop allows it to accommodate small software modules called plug-ins that extend the

program's features. The judicious use of plug-ins increases the functionality of off-the-shelf graphics programs and allows users to customize them to fit the kind of projects they work on. A plug-in host is responsible for loading plug-ins into memory and calling them when needed. Adobe Photoshop is a plug-in host and there are many others. Most hosts are application programs, but a host may be another plug-in. Plug-ins are typically stored in a specific folder or directory that your image-editing program checks each time the software loads. That's why, when you launch a host program, you typically see the names of the plug-ins briefly displayed on its "welcome screen." What happens during that time is that the host program is loading plug-in "descriptors" that tell the host what each plug-in does and where it will appear in a menu. The plug-in itself is not loaded and executed until you need it. Once the plug-in has done its job, it is cleared from memory.

PostScript A programming language that defines the shapes in a file as outlines and interprets these outlines by mathematical formulae called Bézier (Bez-e-ay) curves. Any PostScript-compatible output device, whether it's a film recorder or laser printer, uses these definitions to reproduce the image on your computer screen.

QIC Quarter-inch cassette. For some reason, this tape is more popular with Windows and DOS users than with Mac-OS users. This is changing as multigigabyte drives become less expensive and the thought of backing up these huge drives sinks in. Cartridges come in different designations: there is QIC, XL (long) and QW (wide-long) models, and variations on these names that sound more like the latest model BMW. Data is stored on the tape in serial form instead of the random method used by all other forms of removable media. This produces inherently slower access times, which prevent magnetic tape from getting the respect it deserves.

RAM Random-access memory (sometimes more correctly called DRAM for dynamic random-access memory). RAM is that part of your computer that temporarily stores all data while you are working on it. Unlike a floppy disk or hard drive, this data is volatile—if you lose power or turn off your computer, the information disappears. Most contemporary computer motherboards feature several raised metal and plastic slots that hold RAM in the form of SIMMs (single inline memory modules.)

Raster *See* Bitmap.

Resolution A digital photograph's resolution—or image quality—is defined as an image's width and height as measured in pixels. When a slide or negative is converted from silver grain into pixels, the resulting digital image can be made at different resolutions. The higher the resolution of an image—the more pixels it has—the better the visual quality. An image with a resolution of 2,048 × 3,072 pixels has better resolution and more photographic quality than the same image digitized at 128 × 192 pixels. Unfortunately, a rule of thumb is that as the resolution of a device increases, so does its cost.

RGB Red, green, blue. Color monitors use red, green, and blue signals to produce all the colors that you see on the screen. If you have ever made Type R prints from slides in your darkroom, you are familiar with working with the additive color filters of red, green, and blue.

Saturation Often referred to as "chroma" by show-offs, saturation is a measurement of the amount of gray present in a color.

SDRAM Synchronous DRAM. Used as a substitute for video RAM (VRAM).

Shareware Shareware is a creative way of distributing software that lets you try a program for up to thirty days before you're expected to pay for it. The registration fees for shareware are usually quite modest, ranging from five to a hundred bucks. (Some authors just ask for a postcard, or "beer and pizza money," or donations to a charity.) As a thank-you for your payment, authors often will send you a printed manual, an enhanced version of the program or a free upgrade—or, at no charge, additional products they've developed. Freeware is a form of shareware that is just what it sounds like—it's free.

Snail mail A pejorative term used by e-mail fans to describe letters delivered by the U.S. Postal Service. Originally, it was called "U.S. Snail" but quickly became "snail mail."

Spam (not to be confused with the Hormel meat product) Spam is unwanted, unrequested junk e-mail. Spamming is named for a Monty Python routine about a restaurant where all dishes include Spam and a hearty chorus repeatedly sings a song of praise about Spam! One person tried to make it an acronym but the best they could do is Simultaneous Off-topic postings to Multiple Usenet newsgroups. Direct e-mail advertising on the Internet has traditionally been considered a breach of netiquette, but some companies are selling

mailing lists, and others are transmitting spam. If companies engage in direct marketing on the Internet, they should make it easy for recipients to get on and off their mailing lists. If you're a member of America Online and receive spam from another AOL member, forward the message to the company's Terms of Service staff at "tosemail1" or "tosemail2." AOL will terminate the spammer's membership after three complaints. On CompuServe, forward the message to "csi:ecgintern."

SRAM Static random-access memory typically is used in caches.

Thermal dye-transfer (often called dye-sublimation) A printer type utilizing a head that heats a dye ribbon to create a gas that hardens into a deposit on the special paper used by the printer. Like most printers, it forms dots of colors, but because these spots are soft-edged (as opposed to the hard edges created by laser and inkjet printers), the result is smooth continuous tones.

TIFF Tagged image file format is a bitmapped file format originally developed by Microsoft and Aldus. A TIFF file (.TIF in Windows) can be any resolution from black-and-white up to 24-bit color. TIFFs are supposed to be platform-independent files, so files created on your Mac OS computer can (almost) always be read by a Windows graphics program.

Unsharp mask This oddly named function is a digital implementation of a traditional darkroom and prepress technique in which a blurred film negative is combined with the original to highlight the photograph's edges. In digital form, it's a more controllable method for sharpening an image.

UPS An uninterruptible power supply can provide backup power when electrical power fails or drops to an unacceptable level. Depending on their size—they vary in capacity—UPS systems can provide battery power to your computer and monitor for a few minutes or an hour or more. This additional time will enable you to save the project you are working on and shut down the computer in a proper manner.

Vector Images saved in this format are stored as points, lines, and mathematical formulae that describe the shapes that make up that image. When vector files are viewed on your computer screen or printed, the formulae are converted into a dot or pixel pattern. Since these pixels are not part of the file itself, the image can be resized

without losing any quality. Photographs are not typically saved in this format. Some computer users, especially Mac OS users, call vector-format files "object oriented," and you will often see the term used on graphic drawing programs. Vector files use the same technology that Adobe uses with its PostScript fonts and has the same advantages—you can make any image as big as you want, and it retains its quality. Vector graphics are displayed as bitmapped graphics on your monitor.

Wax thermal Most dye-sublimation printers also support printing with wax thermal materials. This process uses a coarser waxlike ink in its ribbon. During printing, wax thermal paper is pressed against each color in the ribbon as it passes the printer's heating element, transferring the ink onto the paper. The results are inferior to a dye-sublimation print, but the material is much less expensive, making it an option for proofing a layout or image.

Windows More properly called Microsoft Windows, this was an attempt to make the DOS (disk operating system) command-line interface more user friendly by providing a graphical user interface (GUI). The original Windows was announced in 1985, but this operating environment didn't become the de facto standard for IBM-compatible computers until the creation of Windows 3.0 in 1990. Unlike the Macintosh GUI, Windows is more accurately an operating environment instead of an operating system, since it requires users to have Microsoft's DOS installed. This requirement vanished with the introduction of Windows 95, which no longer requires DOS (after installation), but does provide access to a DOS-like environment for use of older non-Windows applications.

WMF Windows metafile format is a vector graphics format designed to be portable from one Windows-based program to another.

WYSIWYG (pronounced "wissy-wig.") What You See Is What You Get. This term refers to the ability to view text and graphics on-screen in the same manner as they will appear when printed. While most text- and image-editing programs have WYSIWYG capabilities, not all do. Read the fine print when you think about purchasing any program. A graphical user interface (GUI) is useless unless the apps that run under it are fully WYSIWYG .

XGA A type of video adapter developed by IBM for its PS/2 computers.

XGA displays a resolution of 1,024 × 768 pixels with 16-bit colors, allowing it to display 65,000 colors.

YCC The color model used by Kodak's Photo CD process. It is the translation of RGB data into one part of what scientists call luminance but the rest of us call brightness. This is the Y component that is added to two parts—the CC—of chrominance or color and hue. This system keeps file size under control while maintaining Photo CD's "photographic" look. Sony uses a similar system in its professional Betacam video system.

Zip Iomega's Zip removable-media drive has a street price of around $150, and uses a combination of conventional hard-disk read/write heads with flexible disks and produces an average seek time of 29 ms. Pocketable Zip cartridges, scarcely larger than a floppy disk, are less expensive than other removable media.

Appendix C

Directory

Access Computer Software Systems, P.O. Box 70067, Eugene, OR 97401. 503-367-8851, fax: 503-367-4549.

ACECAD Inc., P.O. Box 431, 2600 Garden Road, Suite 121, Monterey, CA 9392-0431. 800-676-4ACE, fax: 408-655-1919.

Adams Media Corp., 260 Center Street, Holbrook, MA 02343. 617-787-8100.

Adaptec, Inc., 691 S. Milpitas Blvd., Milpitas, CA 95035. 800-934-2766, 408-945-8600, fax: 408-262-2533, *www.adaptec.com*

Adobe Systems Inc., 345 Park Avenue, San Jose, CA 95110-2704. 408-536-6000, fax: 408-537-6000, *www.adobe.com*

Advanced Micro Devices, One AMD Place, P.O. Box 3453, Sunnyvale, CA 94088-3453. 800-538-8450, 408-732-2400, telex: 34-6306, *www.amd.com*

Agfa Division of Bayer Corp., 100 Challenger Rd., Ridgefield Park, NJ

07660-2199. 800-227-2780, 201-440-2500, fax: 201-440-8187, *www.agfahome.com*

Allegro New Media, 16 Passaic Avenue, Fairfield, NJ 07004. 973-808-1992, fax: 973-808-2645.

Apple Computer, 1 Infinite Loop, Cupertino, CA 95014. 408-996-1010, *www.apple.com*

Art Leather, Elmhurst, NY 11373-2824. 718-699-6300, fax: 718-699-9339.

askSam Systems, P.O. Box 1428, Perry, FL 32337. 800-800-1997, fax: 904-584-7481.

Big Island Communications, 2581 Leghorn Drive, Mountain View, CA 94043. 415-237-0350, *www.big-island.com*

Boeckeler Instruments, 3280 East Hemispheres Loop, Building 114, Tucson, AZ 85706-5024. 520-573-7100, fax: 520-573-7101.

Brother International Corp., 200 Cottontail Lane, Somerset, NJ 08875-6714. 908-356-8880, fax: 908-356-4085, *www.brother.com*

Business Resource Software, 2013 Wells Branch Parkway, Suite 305, Austin, TX 78728. 512-251-7541, fax: 512-251-4401, *www.BRS-Inc.com*

CalComp Digitizer Division, 2411 W. LaPalma Avenue, Anaheim, CA 92801-9808. 800-932-1212, fax: 714-821-2832.

Camera Bits, 3705 NW Columbia Avenue, Portland, OR 97229. 503-531-8430, fax: 503-531-8429, *www.camerabits.com*

Canto Software, Inc., 330 Townsend, Suite 212, San Francisco, CA 94107. 415-905-0300, fax: 415-905-0315, *www.canto-software.com*

Ca$hGraf Software, Inc., 2901 58th Avenue North, St. Petersburg, FL 33714. 800-872-0405, fax: 813-528-2671, *www.cashgraf.com*

The Chip Merchant, 4870 Viewridge Avenue, San Diego, CA 92123. 800-808-CHIP, *www.thechipmerchant.com*

Chang Labs, 10228 North Stelling Road, Cupertino, CA 95014. 408-727-8096.

Chisholm, 910 Campisi Way, Campbell, CA 95008. 408-559-1111, fax: 408-559-0444.

Cies-Sexton Photographic Imaging, 1247 Santa Fe Drive, Denver, CO 80204. 303-534-4000, fax: 303-534-4064.

Compaq Computer Corp., 20555 State Hwy. 249, Houston, TX 77070-2698. 800-345-1518, 713-514-0484, fax: 713-514-4583, *www.compaq.com*

Connectix Corp., 2655 Campus Dr., San Mateo, CA 94403-2520. 800-950-5880, 415-571-5100, fax: 415-571-5195, *www.connectix.com*

Cradoc Corp., 145 Tyee Drive, Suite 286, Point Roberts, WA 98281. 206-842-4030, fax: 206-842-1381.

Custom Business Databases, P.O. Box 360, Santa Ysabel, CA 92070. 619-782-9000, fax: 619-782-9293, e-mail: *SPS@CONNECTnet.com*

Dantz Development Corp., 4 Orinda Way, Bldg. C, Orinda, CA 94563-9919. 800-225-4880, 510-253-3000, fax: 510-253-9099, *www.dantz.com*

Data Technology Corp., 1515 Centre Pointe Dr., Milpitas, CA 95035. 408-942-4000, *www.datatechnology.com*

Database Designs, 11425 8th Avenue, St. Cloud, MN 56303-1906. 302-240-1281, fax: 320-240-1282.

DataViz, 55 Corporate Drive, Trumbull, CT 06111. 800-733-0030, fax: 203-268-4345.

Dicomed Inc., 12270 Nicollet Avenue, Burnsville, MN 55337. 612-95-3000, fax: 612-895-3258.

Digital Arts & Sciences Corporation, 1301 Marina Village Parkway, Alameda, CA 94501. 510-814-7200, fax: 510-814-6100, *www.dascorp.com*

Digital Frontiers, 1206 Sherman Ave., Evanston, IL 60202. 847-328-0880, fax: 847-869-2053, *www.digfrontiers.com*

Eastman Kodak Company, 901 Elmgrove Rd., Rochester, NY. 14653-5200. 800-235-6325, *www.kodak.com*

Epson America, Inc., 20770 Madrona Ave., P.O. Box 2842, Torrance, CA 90509-2842. 800-289-3776, 310-782-0770, fax: 310-782-5220, *www.epson.com*

Equilibrium, 475 Gate Five Road, Suite 225, Sausalito, CA 94965. 415-332-4343, fax: 415-332-4433, *www.equilibrium.com*

Extensis Corporation, 55 SW Yamhill Street, Fourth Floor, Portland, OR 92704. 503-274-2020, fax: 503-274-0530, *www.extensis.com*

Fargo Electronics, Inc., 7901 Flying Cloud Dr., Eden Prairie, MN 55344. 800-327-4622, 612-941-9470, fax: 612-941-7836, *www.fargo.com*

Fractal Design Corporation, 510 Lighthouse, Suite 5, Pacific Grove, CA 93950. 408-655-8800, *www.fractal.com*

Franklin Service Systems, P.O. Box 202, Roxbury, CT 06783. 860-354-8893.

Fuji Photo Film USA, Inc., 555 Taxter Rd., Elmsford, NY 10523. 800-

755-3854, 914-789-8100, fax: 914-789-8295, *www.fujifilm.com*

Gateway 2000, Inc., 610 Gateway Dr., P.O. Box 2000, North Sioux City, SD 57049-2000. 800-846-2000, 605-232-2000, fax: 605-232-2023, *www.gw2k.com*

Gistics Incorporated, 524 San Anselmo Ave., Suite 111, San Anselmo, CA 94960. 415-924-3703, fax: 415-927-4337, *www.gistics.com*

Grip Software, 420 N. 5th Street, Suite 707, Minneapolis, MN 55401. 612-332-8414.

Hewlett-Packard Co. (Colorado Memory Systems Division), 800 S. Taft Ave., Loveland, CO 80537-9929. 970-669-8000, fax: 970-667-0997.

Hewlett-Packard Co., 3000 Hanover St., Palo Alto, CA 94304. 800-752-0900, 800-387-3867, *www.hp.com*

Hindsight, Ltd., P.O. Box 4242, Highlands Ranch, CO 80126. 303-791-3770.

Hitachi Digital Graphics, 250 E. Caribbean Dr., Sunnyvale, CA 94089-1007. 408-747-0777, fax: 408-746-2323.

Houghton Mifflin Interactive, 120 Beacon Street, Somerville, MA 02143. 617-351-3333, fax: 617-351-1110, *www.hmco.com/hmi*.

IBM, Old Orchard Rd., Armonk, NY 10504. 800-426-3333, 914-765-1900, *www.ibm.com*

Imspace Systems Corporation, 2665 Ariane Drive, Suite 207, San Diego, CA 92117. 619-272-2600, fax: 619-272-4292, *www.imspace.com*

Inforite Corp., 1670 Amphlett Blvd., Suite 100, San Mateo, CA 94402. 800-366-4635.

Intel Corp., 2200 Mission College Blvd., Santa Clara, CA 95051. 800-548-4725, 408-765-8080, fax: 408-765-1821, *www.intel.com*

inTouch Technologies, 415-366-2482, *www.in-touch.com*

Intuit, Inc. (Tax Division), 6330 Nancy Ridge Dr., Suite 103, San Diego, CA 92121-3290. 800-964-1040, 619-453-4446, fax: 619-453-1367, *www.careermosaic.com/cm/intuit*.

Iomega Corp., 1821 W. Iomega Way, Roy, UT 84067. 800-697-8833, 801-778-1000, *www.iomega.com*

iXMicro, (formerly Integrated Micro Solutions), 2085 Hamilton Ave., 3rd Floor, San Jose, CA 95125. 408-369-8282, fax: 408-369-0128, *www. ixmicro.com*

JIAN, 1975 W. El Camino Real, Suite 301, Mountain Road, 94040-2218. 415-254-5600, fax: 415-254-5640.

Kurta Corp., 3007 E. Chambers St., Phoenix, AZ 85040. 800-445-8782.

Live Picture, 5617 Scotts Valley Drive, Suite 16, Soquel, CA 95073. 408-464-4200, fax: 408-464-4202, *www.livepicture.com*

Macromedia, Inc., 600 Townsend St., Ste. 180, San Francisco, CA 94103-4945. 800-326-2128, 415-252-2000, fax: 415-626-1502, *www. macromedia.com*

Microfield Graphics, 503-626-9393, fax: 503-641-9333.

Mind Path Technologies, 12700 Park Central Dr., Suite 1700, Dallas, TX 75251. 800-736-6830, 214-233-9296, fax: 214-233-9308.

Minolta Corp., 101 Williams Dr., Ramsey, NJ 07446-1293. 800-9MINOLTA, 201-825-4000, fax: 201-818-3240, *www.minolta.com*

Motorola Computer Group, 2900 S. Diablo Way, Tempe, AZ 85282. 800-759-1107, 602-438-3000, fax: 602-438-3370, *www.motorola.com*

Muton America, 800-996-8864.

MySoftware Company, 2197 East Bayshore Road, Palo Alto, CA 94303-3219. 415-473-3600, fax: 415-325-0783.

NEC Technologies, Inc., 1414 Massachusetts Ave., Boxborough, MA 01719-2298. 800-615-5566, 508-264-8000, fax: 508-264-8488, *www. nec.com*

Neil Enterprises, 450 E. Bunker Court, Vernon Hills, IL 6061#. 800-621-5584, fax: 847-549-0349.

Nomai, 4301 Oak Circle, Suite 20, Boca Raton, FL 33431. 800-55-NOMAI, 407-367-1216, fax: 407-391-8675, *www.nomai.com*

Numonics Corp., 101 Commerce Dr., Box 1005, Montgomeryville, PA 18936. 800-247-4517, fax: 215-361-0167.

Orange Micro, 1400 N. Lakeview Avenue, Anaheim, CA 92807. 714-779-2772, fax: 714-779-9332, *www.orangemicro.com*

Palo Alto Software, 144 East 14th Avenue, Eugene, OR 97401. 800-229-7526, fax: 541-683-6250, *www.palo-alto.com*

Panasonic Communications & Systems Co., 2 Panasonic Way, Secaucus, NJ 07094-9844. 800-742-8086, 201-348-7000, fax: 201-392-4441, *www.panasonic.com*

PC Concepts, P.O. Box 277, Battle Ground, IN 47920. 800-364-7953, 800-353-5383.

Perfect Niche Software, 6962 E. First Avenue, Suite 103, Scottsdale, AZ 85251. 602-945-2001, fax: 602-949-1707.

Phase One United States, Inc., 24 Woodbine Ave., Northport, NY 11768. 800-972-9909, 516-757-0400, fax: 516-757-2217, *www.phaseone.com*

Photo Agora, Hidden Meadow Farm, Keezletown, VA 22832. 540-269-8283.

Philips Electronics, 20999 Gateway Place, Suite 100, San Jose, CA 95110. 404-453-5129, fax: 408-453-0680.

Pioneer New Media Technologies, Inc., 2265 East 220th St., Long Beach, CA 90810. 800-444-6784, 310-952-2111, fax: 310-952-2100, *www. pioneerusa.com*

Piptel, 3430 S. Dixie Drive, Suite 301, Dayton, OH 45439-2316. 513-294-6566, fax: 513-294-4390.

Polaroid Corp., 565 Technology Sq., Cambridge, MA 02139. 800-225-1618, 617-386-2000, fax: 617-386-9339, *www.polaroid.com*

Porter's Camera Store, Box 628, Cedar Falls, IA 50613. 800-553-2001, fax: 800-221-5329, *www.porters.com*

Professional Photographers of America (PPA), 57 Forsyth St. NW, Suite 1600, Atlanta, GA 30303.

Radius, Inc., 215 Moffett Park Dr., Sunnyvale, CA 94089-1374. 800-227-2795, 408-541-6100, fax: 408-541-6150, *www.radius.com*

Retail Merchandise Systems, 8122 S.W. 83rd Street, Miami, FL 33143. 305-271-8941, fax: 305-274-6220.

Sharp Electronics Corp., P.O. Box 650, Sharp Plaza, Mahwah, NJ 07430-2135. 800-BE-SHARP, 201-529-8200, fax: 201-529-8413, *www.sharp-usa.com*

Sharp Electronics Corp. (Microelectronics Group), 5700 N.W. Pacific Rim Blvd., Suite 20, Camas, WA 98607. 800-642-0261, 360-834-2500, fax: 360-834-8984.

Sinar/Bron Imaging, 17 Progress Street, Edison, NJ 08820. 908-754-5800, fax: 908-754-5807.

Studio Organizer Software, P.O. Box 506, Flint, TX 75762. 800-903-3959.

Studio Press, 4330 Harlan Street, Wheat Ridge, CO 80033. 303-420-3505.

Studio Solutions, 10810 North Scottsdale Road, Scottsdale, AZ 85254. 602-483-1492, fax: 602-483-7104, *www.pictureyourself.com/PY_Images/Silvio.Silvio_page/html*

SuccessWare, 3976 Chain Bridge Road, Fairfax, VA 22030. 800-593-3767, 703-352-0296.

Summagraphics, 8500 Cameron Road, Austin, TX 78754-3999. 512-835-0900.

Symantec Corp., 10201 Torre Ave., Cupertino, CA 95014-2132. 800-441-7234, 408-253-9600, fax: 408-253-3968, *www.symantec.com*

SyQuest Technology, Inc., 47071 Bayside Pkwy., Fremont, CA 94538. 800-245-CART, 510-226-4000, fax: 510-226-4100, *www.syquest.com*

Tucker Studios Classic Images, 5162 Puetz Road, Stevensville, MI 49127.
616-429-7673, 616-428-0086.

Ulead Systems, Inc., 970 West 190th St., Suite 520, Torrance, CA 90502.
800-858-5323, 310-523-9393, fax: 310-523-9399, *www.ulead.com*

UMAX Computer Corp., 47470 Seabridge Dr., Fremont, CA 94538. 800-
232-8629, 510-659-8500, fax: 510-623-7350, *www.supermac.com*

Vertex Software, 31 Wolfback Ridge Road, Sausalito, CA 94965. 415-331-
3406.

Verticom Technologies, Inc., 1013 Suffolk Drive, Janesville, WI 53546.
608-752-1583, fax: 608-752-02871.

Visual Horizons, 180 Metro Park, Rochester, NY 14623. 800-424-1011.

Wacom Technology Corp., 501 SE Columbia Shores Blvd., Suite 300,
Vancouver, WA 98661. 800-922-6613, fax: 360-750-8924, *www.
wacom.com*

About the Author

Joe Farace's first published magazine story about digital imaging appeared in the January 1990 issue of *Photomethods* when nobody even knew what to call this emerging technology. Was it digital photography, digital imaging, or, as one pundit put it, pixography? In fact, his editor at the time wasn't sure readers would be interested in working with photographs using a computer and added a disclaimer at the beginning of the story. Yet, less than two years later, the publications name was changed to *Photo>Electronic Imaging.*

While completing this book, Joe's number of published magazine articles about graphics, photography, and digital imaging exceeded seven hundred. He is the author of twenty books, including *Stock Photo Smart* and *Plug-in Smart* in Rockport Publishers SmartDesign series. He is contributing editor for *ComputerUSER* magazine, where his monthly column called "Graphics" aimed at digital designers and artists appears. Joe is also contributing editor for *Professional Photographer Storyteller* magazine, where his column on digital imaging titled "Pixography" appears monthly. He is a regular contributor to *The Press, Shutterbug,* and *HyperZine* (*www.hyperzine.com*). Joe lives in northeastern Colorado with his wife Mary. You can visit his Web site at *http://www.hyperzine. com/writers/joef.html.*

Index

Page numbers in italics refer to illustrations

Books from Allworth Press

The Digital Imaging Dictionary
by Joe Farace (softcover, 6 × 9, 256 pages, $19.95)

The Photographer's Internet Handbook
by Joe Farace (softcover, 6 × 9, 224 pages, $18.95)

ASMP Professional Business Practices in Photography, Fifth Edition
by the American Society of Media Photographers (softcover, 6¾ × 10, 416 pages, $24.95)

The Photographer's Guide to Marketing and Self-Promotion,
Second Edition *by Maria Piscopo* (softcover, 6¾ × 10, 176 pages, $18.95)

Business and Legal Forms for Photographers
by Tad Crawford (softcover, 8½ × 11, 192 pages, $18.95)

Pricing Photography, Revised Edition *by Michal Heron and David MacTavish* (softcover, 11 × 8½, 144 pages, $24.95)

Stock Photography Business Forms
by Michal Heron (softcover, 8½ × 11, 128 pages, $18.95)

The Law (In Plain English®) for Photographers
by Leonard DuBoff (softcover, 6 × 9, 208 pages, $18.95)

The Business of Studio Photography: How to Start and Run a Successful Photography Studio *by Edward R. Lilley* (softcover, 6¾ × 10, 304 pages, $19.95)

Arts and the Internet: A Guide to the Revolution
by V. A. Shiva (softcover, 6 × 9, 208 pages, $18.95)

The Internet Publicity Guide: How to Maximize Your Marketing and Promotion in Cyberspace *by V. A. Shiva* (softcover, 6 × 9, 208 pages, $18.95)

The Business of Multimedia *by Nina Schuyler, Attorney-at-Law* (softcover, 6 × 9, 240 pages, $19.95)

Please write to request our free catalog. To order by credit card, call 1-800-491-2808 or send a check or money order to Allworth Press, 10 East 23rd Street, Suite 210, New York, NY 10010. Include $5 for shipping and handling for the first book ordered and $1 for each additional book or $10 plus $1 for each additional book if ordering from Canada. New York State residents must add sales tax.

If you would like to see our complete catalog on the World Wide Web, you can find us at ***www.allworth.com***